ALSO BY RUTH GRUBER

Virginia Woolf: The Will to Create as a Woman

Inside of Time: My Journey from Alaska to Israel

Ahead of Time: My Early Years as a Foreign Correspondent

"Exodus 1947": The Ship That Launched a Nation

Rescue: The Exodus of the Ethiopian Jews

*Haven: The Dramatic Story of 1,000 World War II Refugees
and How They Came to America*

Raquela: A Woman of Israel

They Came to Stay

Felisa Rincon de Gautier: The Mayor of San Juan

Israel on the Seventh Day

Science and the New Nations

Puerto Rico: Island of Promise

Israel Today: Land of Many Nations

Destination Palestine: The Story of the Haganah Ship "Exodus 1947"

Israel Without Tears

Alaska

I Went to the Soviet Arctic

Virginia Woolf: A Study

WITNESS

WITNESS

RUTH GRUBER

One of the great foreign correspondents
of the twentieth century tells her story

With 190 of her own photographs

FOREWORD BY
RICHARD HOLBROOKE

SCHOCKEN BOOKS ■ NEW YORK

Library of Congress Cataloging-in-Publication Data
Gruber, Ruth, 1911–
Witness : one of the great correspondents of the twentieth
century tells her story with 190 of her own photographs / Ruth Gruber.
p. cm.
ISBN-13: 978-0-8052-4243-0
1. Documentary photography. 2. Gruber, Ruth, 1911– I. Title.
TR820.5.G78 2007 070.4'9092—dc22 [B] 2006028597

www.schocken.com
Book design by Anthea Lingeman
Printed in the United States of America
First Edition
2 4 6 8 9 7 5 3 1

To my four grandchildren,
Michael Evans and Lucy Evans,
Joel Michaels and Lila Michaels,
who give me more joy and pride
than I can tell them.

Contents

Foreword by Richard Holbrooke *ix*

Preface *xv*

1. The Soviet Arctic / 1935–1936 3

2. Alaska / 1941–1943 33

3. World War II and the Oswego Refugees / 1944–1946 65

4. The Anglo-American Committee of Inquiry on Palestine and the Nuremberg Trials / 1946 87

5. UNSCOP, the *Exodus*, and Prison Camps in Cyprus / 1947 115

6. The Birth of Israel and the War of Independence / 1947–1948 157

7. The Yemenite Jews Fly to Israel on "Wings of Eagles" / 1949 179

8. Operation Ezra and Nehemiah: 120,000 Iraqi Jews Secretly Escape to Israel / 1951 195

9. The Ingathering of Jews from Romania, the Soviet Union, and Ethiopia / 1951–1986 215

Foreword by Richard Holbrooke

You could not invent Ruth Gruber, not even in a movie (although Natasha Richardson did play her in *Haven,* a movie based on her efforts to save refugees in the middle of World War II). But Ruth Gruber is very real; she is ninety-five, and she lives in a splendid apartment on New York's Central Park West.

Visitors to apartments on Central Park West usually look first at the magnificent views of the great park. But a visitor to Ruth's apartment will hardly look outside. It is what is inside the apartment that commands attention. The walls are covered—and I mean covered—with art and artifacts from her life: folk art and mementos from Alaska and Ethiopia and Israel; works of art by Chagall and Miró; photographs of Ruth with Eleanor and Hillary and Golda, with FDR and Ben-Gurion and Hammarskjöld and Truman and Ickes; letters from grateful people who owe their lives to Ruth; testimonials and awards from the great and near-great; pictures of her children and grandchildren. And at the center of all this history is an astonishing sight: a tiny, ninety-five-year-old dynamo who rushes around answering the telephone, opening the door, quickly finding exact passages from books in her vast library to illustrate specific points. She remembers everything, swiftly correcting me, for example, on how we first met (through my wife, Kati Marton, she reminds me, who interviewed her for a book on George Polk, the CBS correspondent murdered in Greece in 1948).

If our nation had officially designated living national treasures (as Japan does), Ruth Gruber would certainly be among them. Her career has spanned eight decades, and while she proudly broke the gender barrier time and time again, she never sought recognition simply for being a woman; as her niece, Dava Sobel, wrote in the introduction to the 2000 reissue of *Haven*, "Ruth pioneered without even realizing that she was spearheading a movement." (Sobel was referring to the fact that Ruth had her first child when she was forty-one, at a time when late motherhood was considered dangerous and in slightly bad form.) Ruth could have been a big star, in the modern sense of the celebrity-journalist, but she never sought personal publicity, although as an attractive and very young woman who many thought resembled Myrna Loy, she got a lot of attention— which she knew how to use to gain often unprecedented access to people and stories.

But Ruth's primary interest was the fate of the people she covered. She was invariably drawn to the downtrodden, the forgotten, the drive-by victims of history. When she heard in January 1944 that President Roosevelt would finally permit one thousand refugees into the United States, she was a special assistant to the legendary Harold Ickes, FDR's secretary of the Interior, working first as his field representative for Alaska and then as his special assistant. Within hours she was in Ickes's office, asking to be sent to Italy to escort the refugees on a secret convoy across the Atlantic. Thus the experiences that became the book, and later the movie, *Haven.*

Her fearlessness had been established long before that. She had gone to Germany to study in the early 1930s, seen the rise of Hitler, and returned to New York at the age of twenty a minor sensation, billed by *The New York Times* and other newspapers as "the world's youngest Ph.D." She wrote her doctoral thesis for Cologne University on Virginia Woolf; it was probably the first scholarly study done on the great British writer. (For this achievement she was summoned to a meeting with the mayor of Cologne, a man named Konrad Adenauer, and three years later she met the great writer herself, who described the meeting in her own diaries and letters in vaguely anti-Semitic and highly snobbish terms.) Her thesis was finally published in the United States in 2005. Unable to find a full-time job despite her achieve-

ments, she talked her way into "special assignments" for the *New York Herald Tribune.*

In 1935 and 1936 she managed to visit the closed Soviet Far East, penetrating the local branch of Stalin's secret police in Yakutsk, in the heart of the gulag, to the amazement of her jealous male colleagues. Her articles changed her more than they changed the gulag or her readers; they unleashed her lifelong concern for the oppressed, the voiceless, the homeless.

But Ruth Gruber was Jewish, and after her early experiences in Germany—even though she had originally loved Germany, its language, and its culture—the mid-century crisis of the Jews gradually became her primary concern. Starting with her covert mission for Ickes and FDR nine years later, Ruth would become *the* chronicler of every major Jewish emigration to Israel—from North Africa, Yemen, Iraq, Romania, Russia and Ukraine and the rest of the Soviet Union, and finally from Ethiopia, where, in her mid-seventies, she scrambled up and down muddy fields to find Jews living in dangerous and terrible conditions in the highlands. As well, she would witness the struggle of the Jews to create their own homeland, and she would become a passionate supporter of Israel.

If Ruth had done nothing else in her remarkable life, she would still be remembered, of course, for her book on a desperate group of Jews who kept trying to get into pre-Israel Palestine on an aging ship they had renamed the *Exodus 1947.* From her journalistic, factual account (which she originally called *Destination Palestine*), Leon Uris got an unforgettable title and the general plotline for his famous novel and the film that followed. Uris's one-word book title took on a new meaning in English, a shorthand for the painful, seemingly endless quest of Jews for a homeland.

In the book you hold in your hands, Ruth has chosen the best photographs of her long career. The selection, her editor, Victoria Wilson, has told me, was extremely difficult and often painful. The pictures of the Soviet Arctic and the gulag and Alaska record a world gone forever. And the photographs of the terrible ordeals suffered by Jews trying to make their way to Israel, from the *Exodus* to Ethiopia, bear essential witness to the painful birth throes of the Jewish state. But in the end, Ruth and her editor made a brilliant selection. Scenes that once

seemed ordinary have taken on, with the passage of the years, an iconic character, summing up lost worlds. Look at them again: they are anything but ordinary. Study the faces—whether of Eastern Europeans who survived Hitler's death camps, or of young, confident Israelis ready to fight for their country, or of Ethiopian Jews yearning for their children who have made the dangerous voyage to Israel. Ordinary people, fighting for dignity and survival. Ruth Gruber's lens also captures the greats, especially the leaders of Israel, as they begin their fight for survival. Side by side, the ordinary and the great: the effect is powerful.

A few years ago, Ruth asked me to write a preface for the reissue of her book on the *Exodus*, but when I became the American ambassador to the United Nations, the State Department told me to withdraw the preface on the grounds that it might be of commercial benefit to her publisher. At the time I told Ruth that while more and more books were coming out about the Holocaust and about Israel, the three-year period between the end of World War II and the creation of the state of Israel was a dark hole in history. Ruth has done an immense amount to lift the curtain. In the four months she spent covering the Anglo-American Committee of Inquiry on Palestine in 1946, and again with the UN Special Committee on Palestine (UNSCOP) in 1947, Ruth preserved essential history in her notebooks and photographs. Look again at her famous photograph of the Nazi swastika, painted by angry Jewish refugees over a British Union Jack. Look at it, and weep.

Of course one cannot leave the sunny apartment on Central Park West without asking the obvious questions. Ruth knows what they are, and her answers are quick, decisive, and to the point. Most impressive person she ever met? That's easy—David Ben-Gurion: "both a dreamer and a practical man." Most exceptional woman? Even easier—Eleanor Roosevelt: "such simplicity and humility." What about Franklin Roosevelt? Ruth pauses for a moment. "He was a great president," she says, "in so many ways. But he was bad on refugees." She smiles and tells a story about how reporters covering the White House, knowing FDR did not permit women to attend his press conferences, pushed her to the very front of the group surrounding the president's desk (presidential press conferences were then just a group of reporters milling around the president's

desk) in order to make FDR squirm. "I was so close I could see his crooked teeth." And, after another pause, Ruth said to me, "Franklin and Eleanor could not have been less alike."

It is time for me to go. The phone is ringing, and someone is at the door. But the apartment is filled with things that I have not yet sufficiently examined. There are still so many stories to hear. Ruth has a lot more to teach us, not only about the great people and historic events that she has seen but also about how to live a rich and fulfilled life, a life that has made a difference.

Preface

There are so many people to whom I owe gratitude, and so many organizations that have helped shape the contents of this book, that I believe the best way to start is to thank the Institute of International Education for giving me an exchange fellowship from 1931 to 1932 to the University of Cologne. My search for knowledge, my love of adventure, and my passion to fight injustice were fueled in that fateful year, attending Hitler's rallies and watching his rise to power.

I owe special thanks to the American Arctic explorer and anthropologist Vilhjalmur Stefansson for his letter of recommendation in 1935 to the leaders of the Soviet Arctic, which helped me cover that little-known part of the world.

My gratitude and love go to Helen Rogers Reid, the owner of the *New York Herald Tribune*, for appointing me the paper's special foreign correspondent covering the Soviet Arctic.

My five years of working for Harold L. Ickes, secretary of the Interior, from 1941 to 1946, changed the course of my life. Ickes gave me assignments that I shall always cherish, such as the opportunity in 1944 to help rescue one thousand refugees while war and Holocaust raged. Through that experience I realized that from then on my life would be inextricably bound up with rescue and survival.

In 1942, after returning from an assignment in Alaska and attending Eleanor Roosevelt's press conferences for women only, I began to draft answers to the

poignant letters she was receiving from soldiers still serving there, who wanted information on how to homestead when the war ended. Our friendship continued when she came to the refugee camp in Oswego, New York, with her friend Elinor Morgenthau, the wife of Henry J. Morgenthau, Jr., secretary of the Treasury. It deepened in 1952 when I shepherded her in Israel to a development town where the refugees greeted her as "the Queen of America." She wanted to learn firsthand how the new state was absorbing the new immigrants in these first hectic years of Israel's life. I will never forget how the immigrants responded to her compassion.

No one has done more for this book than Victoria (Vicky) Wilson, vice president of Alfred A. Knopf. We first met on December 1, 2004, when a documentary on Eleanor Roosevelt, in which I appeared, was being shown at the United Federation of Teachers headquarters in New York City. Allida Black, project director of the Eleanor Roosevelt Legacy Foundation, asked me to participate on a panel with the two other women in the film. I have warm memories of working with Maureen Corr, who was Eleanor's private secretary for the last ten years of her life, and with Charlotte Klein, a well-known public relations executive.

"How many people do you expect?" I asked Allida.

"We've had about thirty-five responses."

I wondered if I could give up an evening working on my Virginia Woolf book for an audience of thirty-five people. But for Eleanor? Of course I would do it.

When I taxied down to the teachers' union headquarters, I discovered there were not thirty-five attendees. There were more than a hundred Eleanor Roosevelt scholars and aficionados.

The three of us from the film sat with the audience, watching and nodding at one another occasionally as if to say, "This is pretty good."

When the movie ended, we were invited to the stage to answer questions. They came from people who obviously adored Eleanor and who knew much of her writing, of her struggles, and of her commitment to human rights. At the end, the audience gave us a standing ovation. We were walking down the steps of the stage when a tall, handsome woman stopped me.

"I'm Vicky Wilson," she said. "You made me cry twice, first during the docu-

mentary and then during the questions and answers. You're a good storyteller. Have you ever written a book?"

I looked up at her and mumbled, "I'm working on a book about Virginia Woolf. It's my eighteenth." (In Hebrew, the number eighteen means "life.")

"I would like to do a book with you," she said.

I shook my head. "Sorry, I'm loyal to my editor, Philip Turner, at Carroll and Graf."

" 'Loyal,' " she repeated, as if she were holding an archaeological artifact in her hand. "I would never want to interfere with you and your editor."

My friend Patti Kenner, active in the Eleanor Roosevelt Legacy Foundation, leaned across me, her face close to Vicky's. "Why don't you do a book of Ruth's photographs?"

Later Patti told me that she had been standing in the back of the room with Regina Tierney, the videographer who had made the documentary. Regina had told her, "You see that woman talking with your friend Ruth? She does the best photography books in the country."

Patti continued talking to Vicky excitedly. "Ruth has some wonderful photographs. Some were even in *Life* magazine and in their Time-Life war books."

"I want to see those photos. Give me your phone number."

By the time Vicky arrived at 3 p.m. the following Tuesday afternoon, my research assistant, Maressa Gershowitz, had covered a long coffee table in my living room with photo albums, Kodachrome slides, and a stack of labeled file folders filled with hundreds of black-and-white photos.

Vicky began sorting through them with the expert eye of a seasoned editor. With a little red label she marked each picture she wanted to consider. At the same time, she kept making remarks that made the blood rush to my head. "Look at the eyes of those children. How did you capture that? Your pictures are filled with life. Some of your children's pictures are classic. We've got to do a book of these photographs."

She came to my apartment nearly every Tuesday afternoon for six months and selected more than a thousand photographs. Then she began the task of winnowing them down to 190.

Several months later, she called me from her farm in the Catskills. "You

should be flattered. I'm down to 450, and I'm having a hard time. Every time I put a child's photo aside, I pull it back. 'No,' I tell myself, 'I have to have it in the book, I just can't take out any more." She paused. "There will be too many photos if we have 450."

Finally she made her selection of the 190 photos that fill this volume.

Some editors can be warm, wise, and encouraging; others can be hard, arrogant, and pretentious. Most of my editors, especially my two present ones, Philip Turner, at Carroll & Graf, and Victoria Wilson, at Alfred A. Knopf, are among the most skillful and knowledgeable people I know. When Philip heard that Vicky was working on this book, he told me, "You have my blessings. I'm delighted you're doing this. You know how many years I've been telling you I wanted to do a photo book of your mothers and children, but we couldn't afford to."

Vicky's great skills have been honed by decades of editing and publishing. Further, she is so generous that she is constantly filling my apartment with books she knows I will love and with flowers and Viennese chocolate.

Patti Kenner brought this book to the attention of the New York Museum of Jewish Heritage—A Living Memorial to the Holocaust. She, as one of the museum's trustees, persuaded them to celebrate the book's publication with an exhibition of these photos. The museum's gifted and beloved director, Dr. David Marwell, has become the book's official sponsor, and Ivy Barsky, deputy director for programs, has worked tirelessly to set up the exhibition.

My gratitude also goes to Maressa Gershowitz, a professional photographer who became my archivist, and who spent days searching through filing cabinets and innumerable bins to find most of these photographs. One of my nephews, Mark Gruber, generously took time from his art gallery in New Paltz, New York, to straighten more than a hundred photos from the 1930s that had curled up with time.

Working side by side with Maressa were three brilliant young women who, as my assistants, can type as fast as I can dictate. An ad on the Barnard bulletin board in the fall of 2004 caught the eye of Leah Krauss, a freshman, whom I promptly hired. Leah proved invaluable when she found an entire plastic bin hiding against a wall beneath a stack of miscellaneous cartons. It held most of the photos of the Oswego, *Exodus,* and Yemenite experiences. I also dictated

a good part of the book to Laura Palotie during her summer vacation in 2005. Jennifer Lai worked with me almost daily for seven months while I wrote the book.

Others to whom I'm indebted include my stepdaughter, Barbara Seaman, the prominent author and women's health activist; and her sisters, the artists Jeri Drucker and Elaine Rosner. My two surrogate daughters, Doris Schechter, who came when she was five years old among the one thousand refugees to a safe haven in Oswego, New York, and Patti Kenner, a Renaissance woman, gave me unlimited encouragement.

My heartfelt thanks go to Zachary Wagman, former able assistant to Vicky Wilson, and to the nine authors and poets of my writing group, who critique one another's work without malice. Others who have been helpful include my good friend Barbara Ribakove Gordon; the playwright and author Dan Levin; Michael Patrick Hearn, the author and critic; Leah Rabinowitz, Petrina Crockford, and Zachary Sussman, who all helped copyedit the book; and my children, Celia Michaels-Evans and Dr. David Michaels, whose constant faith in me has been a great source of comfort and gratitude.

I cannot end these acknowledgments without telling my daughter; her husband, Stephen Evans; their children, Michael and Lucy; and my son; his wife, Gail Dratch; and their children, Joel and Lila how thankful I am that they are my children and grandchildren, and how I hope that they will help make ours a world at peace.

WITNESS

The Soviet Arctic

1935–1936

In the summer of 1935, I traveled through Europe and Siberia on a fellowship given at the recommendation of the Guggenheim Foundation, studying what was happening to women under Hitler's fascism, Stalin's communism, and European democracy. At the same time, I was taking photographs and writing articles as special foreign correspondent for the *New York Herald Tribune.*

My last stop in Europe ended in Moscow, where I was granted an interview with Professor Otto Yulyevich Schmidt. He was the chief of the Soviet Arctic, which stretched from the Atlantic to the Pacific across eleven time zones and from the Arctic Circle to the North Pole. There were rumors that the Russians were secretly preparing for war by using settlers and political prisoners to build up their Arctic empire. Those rumors were not unknown to me, since I had spent months translating German documents on the Arctic for the American Arctic explorer and anthropologist, Vilhjalmur Stefansson. Stef, as we all called him, was preparing a report for our War Department on the whole Arctic world. When Stef heard that I was going to be in the USSR, he gave me the letter of introduction that opened Professor Schmidt's door.

"So you know Stefansson," said Professor Schmidt, who looked like a modern-day prophet in his white naval uniform and his white beard. "We consider him the greatest Arctic explorer in the world. What are you doing in Moscow?"

I launched into my study of women: What was his opinion of women in the

Arctic? Why were they going? What was their status? What of the old sex prejudices—the dangers, the hardships, the cold? Did they belong?

Professor Schmidt laughed. "Do women belong in the Arctic? Why not? We have destroyed sex prejudice in industry and in politics, why not in the Arctic, too? You ask me why women are going north. For the same reasons that men are going north. I guess most people don't know this, but we have women working as mayors of cities, meteorologists, and radio operators, doing practically everything men do."

Suddenly he looked at me as if he were seeing me for the first time. "How old are you?"

"Twenty-four," I said, hoping I looked older and more worldly.

"How would you like to see what our women are doing up there?"

My heart was pounding. "It—it would be very interesting."

Back in my hotel room, I telephoned Ralph Barnes, chief of the *Herald Tribune* bureau in Moscow. He couldn't believe that I'd met Otto Schmidt. "Don't you know every journalist in Moscow has been trying to see him? He won't see any of us, not even journalists who've been here for years.

"It's the biggest story in Moscow today," Ralph went on. "They're sending one of their best pilots, Sigismund Levanevski, to fly from Moscow to California across the North Pole. We suspect Schmidt doesn't want to talk to reporters about the flight in case it turns into a disaster. Maybe that's why he chose to send you, to show the world that if a young woman can safely fly alone through the Arctic, they're solving one of their biggest problems: transportation. I'll write New York that you'll be cabling stories to me as you travel around, and I'll forward them to the *Paris Herald Tribune,* and then to the *New York Herald Tribune.*"

In the next days, my journalist friends began showering me with sweaters, scarves, long underwear, mittens, wool hats, and even a hot-water bottle. I packed what I could in a duffel bag, slung my camera bag over my shoulder, and, carrying my little Hermès typewriter in my hand, took off from Moscow.

Flying by commercial planes and spending nights in hotels in towns along the Siberian route, I met with people who were curious to know what an *amerikanskaya jurnalistka* was doing more than six thousand miles from her native Brooklyn.

A week later, I reached Irkutsk, boarded an open-cockpit seaplane, and flew to Igarka (pronounced ee-GAR-kuh), a boomtown north of the Arctic Circle. It was autumn, late afternoon, and the sun had already set on a town of one-story wooden houses stained brown with weather and smoke. Ships were in the harbor, loading lumber. Logs were floating downstream.

Because there was no hotel, I was given a small room in the port administration building. It had a bed, a desk, a chair, a nail on the wall to hang clothes, and an electric light. Outside the kitchen door was the outhouse.

It was diplomatically important that I call first on the mayor, a woman named Ostroumova, who sat at the foot of a long conference table. Her black hair was cut short; she wore a white shirt, a tie, and a blue jacket, looking more like a naval officer accustomed to giving orders than the head of a new town. When she saw me resting my camera on the table, she barked, "No pictures! Put that thing away!"

I wondered if she hated to see pictures of herself. I put the camera in my bag and handed her the letter Professor Schmidt had given me to use as I traveled. It was to inform his people that I was a journalist for the "New York Gerald Triboon." (In Russian, the *H* is almost always turned into a *G*.) I could feel her contempt for me as her eyes swept across the letter.

"I don't know why Professor Schmidt sent you. I have no time for you, but you can ask me one question."

The first question popped into my head: "What is the importance of your city?"

She answered as if she were making a speech: "Igarka is important economically and industrially. Here we cut Siberian lumber, which many experts consider the best in the world. Then we export it through the Kara Sea into the Arctic Ocean on ships that come from England, Germany, Scandinavia, and of course from Siberia."

She stood up.

"If you want anything, call me or write me a letter and I'll see that it's arranged."

One morning, with the temperature close to freezing, I slushed through mud and tundra to reach the chief agriculturalist of the Polar State Farm, Maria Mitrofanovna Khrenikova. She was waiting for me in her doorway, dressed in a

sweater and long skirt. She had a cigarette in one hand and a pencil in the other.

Unlike the mayor, she greeted me warmly. "I'm happy to show you how we grow vegetables in the Arctic, but I don't want you to take any pictures of me."

"Why not?"

"I'm an old lady of forty-three, and I don't like the way I look."

"You look fine to me," I said, once again putting my camera back in my bag.

She looked grateful as she took my arm. "Let me show you my polar farm."

We trudged through the fields and greenhouses in which she was experimenting with vegetables. "We try about five hundred experiments each year," she said, "and so far, about thirty or forty have been successful. One of our real successes is kohlrabi. It's a turnip cabbage. It's delicious, even uncooked. It has more vitamin C than lemons. We no longer have to worry about people dying from scurvy up here. I call it the 'Arctic apple.' Here, try one." She handed me a round, reddish vegetable the size of an apple. It tasted like a combination of cabbage and apple. It was delicious.

She continued, "We're even having success with wheat growing taller than you. That's what we're doing here—feeding the people with fresh vegetables and grains and keeping them healthy."

She invited me into her kitchen and served me hot tea with lemon.

"You must be cold," she said. "What are you really doing up here so far from home? You're such a young woman. Aren't you homesick?"

"Not at all. I'm fascinated by people like you and your mayor, who are doing in 1935 what most of the world considers men's jobs."

My stay in Igarka ended when I was invited to embark on the SS *Anadyr*. The ship had come to Igarka from Vladivostok, the major Soviet town on the Pacific Ocean. It was attempting to open the Northeast Passage from the Pacific to the Atlantic across the Arctic Ocean. The captain invited me to join the voyage.

"It's a historic trip," he told me on the deck one day. "No commercial ship has been able to do it in one summer. Every other ship that has tried was caught in the ice floes and the fog. Yes, fog and ice. Those are our two enemies."

He maneuvered the ship through the fog and ice until we reached our goal,

Murmansk, where crowds waved and cheered, calling out in Russian, "Heroes of the Arctic!" Ships blared their welcome. Banners blew in the wind.

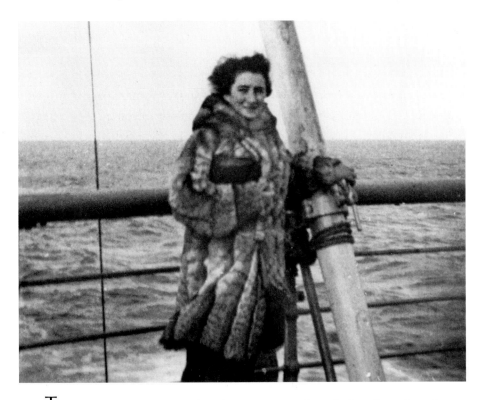

The *Anadyr* stopped at Igarka to bring new people and take others aboard. I heard about the ship and hurried to the harbor to watch it enter. Later, the captain invited me to come aboard. "Have a meal with us," he said.

I was given my own stateroom and I ate with the officers. Among the passengers were two polar bears who had been picked up at one of the polar stations and were being brought to Murmansk. On board the ship, an older officer and a younger one began to fight over me. Rudolph Samoilovich, a renowned geologist and explorer, had told me in Leningrad that they never took a Caucasian woman on an expedition because if she became interested in one man, the rest of the men would be so jealous that they might do terrible things to one another. When the officer told me he was in love with me, I said, "I don't even know you." He said, "You're not in love with me, you're in love with him, because he's so handsome and young. And what does he talk to you about, how deep he can go under the ice? I want to talk to you about love."

Everything Samoilovich had warned me against, I had done unknowingly. I felt I was doing my job as I went around the ship interviewing everybody, writing their stories. I explained that to the older officer, but he didn't believe it. "You're in love with him. I can see. But I'm the one who really loves you. He's not interested."

I said good night and avoided both men for the rest of the journey.

My bag was full of unprocessed film and dozens of notebooks as I left Murmansk, traveled across Europe by train, and stopped off in London to interview Virginia Woolf.

Three years earlier, as an exchange student at the University of Cologne, I had written the first doctoral thesis analyzing the writing of Virginia Woolf. When the thesis was published in Leipzig, Germany, in 1935, I mailed it to Mrs. Woolf and was invited to tea. It was a magical day. Dressed in a long gray silk gown, she lay in front of the fireplace with a cigarette between her fingers, looking elegant and graceful. My thesis was published for the first time in the United States in 2005 with a long preface, when three of her letters to me turned up.

In New York, Helen Rogers Reid, the owner of the *Herald Tribune,* invited me to her office to discuss a series of articles. I started by telling her about VW when she interrupted. "That's not what we're interested in. We want you to write a four-part series about the Soviet Arctic. We're going to syndicate them. Ruth, you've scooped the world."

NANA (the North American Newspaper Alliance) then asked me to write even more articles on the Soviet Arctic, which they sent to newspapers around the world. I laughed as I read some of the headlines. The *Milwaukee Journal* took three lines to tell its readers, "American Girl First Correspondent to Study Soviet's Arctic: Dr. Ruth Gruber Flies to 'Waste' Places of North, Finds Thriving Towns." The *Boston Globe's* headline was more hilarious: "ROLLING BACK THE ICE AGE: American Woman Flies to Land of Long Nights and Long Days where Time Has Stood Frozen at Dawn."

. . .

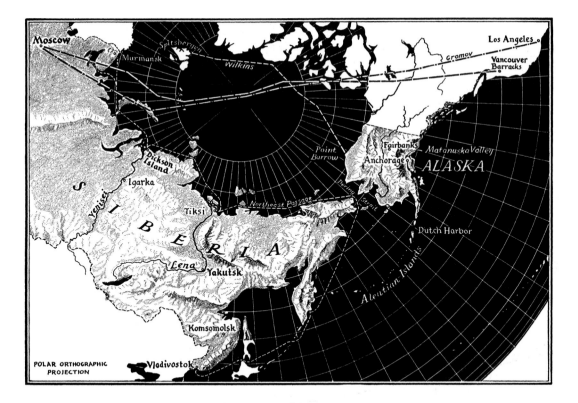

The top of the world. Three miles separate Alaska from the Soviet Arctic, the shortest distance between the two continents. When I joined the *SS Anadyr* in Igarka on its historic voyage, we sailed north along the coast of the Arctic Ocean for several weeks, until we reached Murmansk.

The book I had planned to write about women was sidelined when Simon & Schuster asked me if I had enough material to write a book about the Soviet Arctic. Max Schuster leafed through my photos and said, "We want this book."

I sent the *Trib* articles to Professor Schmidt with a note that I was writing a book. He answered, "Before you finish it, you must come and visit the Yakutia Republic to see how we are taking care of the Yakut people and the other native peoples of the North."

In the summer of 1936, I called to tell Max Schuster I was taking a few months away from the book to return to the Arctic for more material. Helen Reid again asked me to travel for the *Herald Tribune*.

In Moscow, I was told that I needed a visa to enter the Yakut Autonomous Soviet Socialist Republic. Each day I visited the visa office only to be told, "Not today. Come back tomorrow."

Time was my enemy. I spent the days in libraries reading up on Yakutsk and visiting with friends. At lunch one day in the restaurant of the Novo Moscovskaya Hotel, where I was staying, I asked Maurice Hindus, the well-known American novelist and Soviet expert, how to break through Russian and Yakut bureaucracy.

"You can't speed up bureaucrats," he said to console me. "Remember, they haven't allowed any of us into Yakutsk, though God knows I've tried. Just be patient. The Russians invited you back because you're willing to see with an open mind. You're willing to learn. Some of us old-timers are cynical or biased or weary. You haven't gotten to that stage yet."

I told myself, "He thinks I'm naive. I am naive. Naive and female in a tough man's world." Now twenty-five, I wanted to be a working stiff like the male correspondents who were traveling across the world with a typewriter and camera.

"Maurice," I asked him, "how would you sum up this year of 1936?"

"Darkness," he said. "Blackness. Spain ripped apart by civil war. Ethiopia crushed by Mussolini. Hitler arming troops, terrorizing Jews. Russia arresting Bolsheviks, some of them my old friends."

After three interminable weeks, the Yakutia visa office in Moscow finally stamped my passport. Wasting no time, I bought a train ticket and climbed aboard the Trans-Siberian Railway Express.

The days were hot, and the landscape was a canvas of unbroken forests with intermittent towns where the train stopped for passengers and mail and where we could run out to buy food. After five days, I reached Irkutsk. From here I was to fly north to the Arctic.

I spent a restless week at the Grand Hotel, waiting for the plane. War was in the air. In the parks, children and their parents practiced putting on gas masks. In the evenings, after work, they learned how to shoot.

Finally, at six one morning in a heavy rainstorm, I was driven to the waterfront, where I saw a Junkers monoplane. It looked like a slender bird with the markings in Cyrillic letters: CCCP-H5 (USSR-North 5). Victor Galishev, a tall, brawny pilot in a long brown leather jacket with a scarf around his neck and a

cigarette in his fingers, helped me aboard. There was one other passenger: Ilya Andreevich Adamovich, a political leader who was flying home to Yakutsk. I knew he was either important or rich: his mouth was filled with gold teeth interspersed with pearly white ones. He told me, "Everyone in Yakutsk is waiting for you. Professor Schmidt sent word for us to take good care of you."

We flew along the Angara River and then along the Lena River, which Adamovich pronounced lee-YAY-nah. The inside of the narrow plane was freezing and pitch black. Galishev insisted, despite my protests, that I wear his thick leather coat.

In the darkness, I made my way to a tiny window and looked down. Lake Baikal lay in the distance, separating Russia from Outer Mongolia. Adamovich joined me at the window and pointed out the sights. "We're flying over the Alexandrovsky Central, a terrible prison."

Below us was a large stone fortress. I shuddered as Adamovich went on. "Many of our leaders were imprisoned inside it or exiled close to it. Stalin, Molotov, others—they were all in this area. Many of the others were killed."

It was the gulag.

On the third day, we reached Yakutsk. An outdoor thermometer read eighty degrees Fahrenheit. The heat was welcome. We were greeted by a tall, heavy woman. Adamovich introduced her. "She is Tonya Kliukvina. She will be your guide. She can do anything you need, show you where to send your cables, be your secretary, take you all over Yakutsk."

She gripped my hand like a wrestler. I suspected her real job might be to spy on me. I decided to act casual and escape her whenever possible. We were both housed in Adamovich's modern home, while he stayed with friends. We each had our own bedroom. Adamovich left us his young live-in cook and housekeeper, whom I trusted and who soon became my friend.

Yakutsk was old and new. Like every Siberian town I had visited along the Trans-Siberian railroad, it was a city of wood. Modern prefab wooden houses often stood beside native yurts made of birch bark and reindeer hide. One or two of the wooden houses caught fire nearly every day from the candles and kerosene lamps that lit their rooms. To be sure, there was electricity, but it lit the homes

of the leaders; my bedroom was brightly lit with a lamp on my table where I typed my notes.

The population comprised a mixture of native peoples and political prisoners, who were allowed to bring their wives and children while they served out their prison terms. No one could escape. Yakutsk was surrounded on all sides by dense forests. The only way out was by airplane or ship, and no prisoner had access to either. Maxim Gorky, the Soviet novelist, had dubbed Yakutia "the Land of Death and Chains."

Soon after my arrival, I set up an interview with André Petrovich Carosin, the head of the NKVD, Russia's secret police. His head was shaved smooth as a bowling ball. He wore the khaki uniform of the secret police, with a burgundy red collar and a gold stripe and star on his arm.

"Everybody knows you have political prisoners in Yakutsk," I said, confronting him. "I've promised the *Herald Tribune* a story on them. But when I ask people where the Trotskyites are, they pretend they've never heard the word."

"Of course we have Trotskyites here," he said. "One of them runs the bookshop. We even have criminals and thieves. We rehabilitate them with work. Work, work, work. We don't have prisons here like they do in capitalist countries. We don't have guards or jailers, the way they did under the czars. We give our exiles freedom."

Freedom! A strange word in the gulag.

After I left his office, I went to the bookshop, where the man in charge stood motionless watching me leaf through books. After about half an hour, I saw him look around, making sure no one else was in the shop.

He then approached me. "I heard through the underground who you are. I must speak to you. My name is Medved. You are a journalist. I will tell you things the whole world must know. Can you come tonight?"

"I will come."

"Wait until it is dark on the streets. Then come to the bookstore. Make sure nobody follows you. I will take you upstairs, where I live with my wife and child."

That night, as soon as Tonya, my ubiquitous guard, left the house to visit her friends, I slipped out. Knowing that I might be followed and that a camera might tip off a spy, I left mine in my bedroom. But I hid a small notebook in my bra.

In the darkened bookstore, Medved led me up a ladder to a loft lit by a candle in a green bottle. I could make out his wife and his baby sitting against the far wall.

"I am a historian of India," Medved said. "If they let me do my own work, I'd be in a library doing research. Instead, all day I work in the store. I can only do my research at night, with no electricity. So I do nothing."

I decided to check up on Carosin's statements. "I was told by one of the political leaders here that political prisoners are not put into prison, that they're sent into exile as soon as they're sentenced."

"A lie," he said. "Political prisoners *are* put into prison and then exiled. I've been in different prisons almost every year since 1927. I was in prison for eight years. My wife and I, we've been here for over a year already."

"How many exiled prisoners would you say are now in Yakutsk?"

"They won't tell you the truth. There are at least 350 in this godforsaken city, but thousands, some of us think tens of thousands, are prisoners all over the Yakutia Republic."

"Why were you exiled here?"

"I was a soldier in the Great War. And I was in the Bolshevik party. In 1927, Stalin and Trotsky split. The way Stalin began to run the country was inhuman. It was murder. I decided to join the opposition. I took a job as an ordinary laborer in a factory, so that I could do underground work against Stalin, that murderer. I had a mimeograph machine in Leningrad."

"Tool of the revolution," I murmured.

"Correct. I printed leaflets telling the workers in the factory the truth. I worked up a real proletarian base. I committed sabotage."

"What kind of sabotage?"

"We entered factories and wrecked machines. We caused a death or two by doing it. It was the only way we could let the workers know that the opposition to Stalin was powerful."

He paused, waiting for me to jot his words in my notebook. "My wife," he said, "she was so afraid that the police would find all my books that she burned every one of them."

His wife began weeping. "I had to do it. They pulled up the floorboards when they came to our house looking for your books and your papers."

He went over to comfort her. "*Milenka maya* [my darling], I know you had to do it."

I left them, telling him as he led me down the ladder, "I promise you, one day I will tell your story."

My days were crowded with interviewing and photographing life in Yakutsk. In a small neighboring village, a 104-year-old Yakut woman, Marfa Mikhailovna, showed me a cradle in which she had rocked each one of her twenty children. It was an ingenious cradle made of birch bark, carved to fit a baby's body. Under the baby's bottom was a smooth trench of birch bark with a hole at the end. It emptied into a birch-bark potty.

"It has its own irrigation system," I laughed, thinking Yakut babies never needed diapers.

"You like it?" Marfa asked.

"It's a great piece of engineering."

"It's yours," she said. I would have liked to decline it, but I knew that in Yakut culture, if you rejected a present, you insulted the giver.

I carried Marfa's cradle back to New York and, fifteen years later, rocked my own children in it.

My book *I Went to the Soviet Arctic* was published by Simon & Schuster on September 1, 1939, the day that Hitler sent his tanks and troops in a Blitzkrieg into Poland. It was the start of World War II. All my relatives in Poland were murdered.

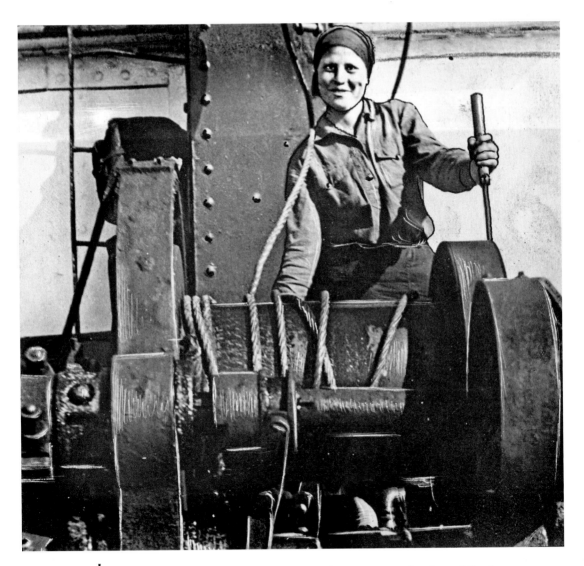

In America, our young people were inspired to go west and to live a life of adventure. When the Soviet Arctic was opened up, young people were urged to go north. Many came to Igarka, the boomtown north of the Arctic Circle, where I photographed them as they worked. I was especially excited to see young women in jobs long considered for men only.

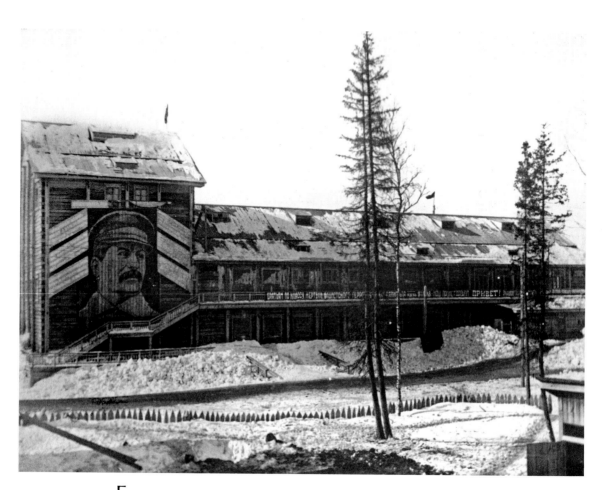

Evenings Igarkans spent in the clubhouse, with giant posters of Stalin's face staring down at them. They sang, danced, drank, and listened to lectures from political leaders who congratulated them on building this new town and told them how proud Stalin was of them.

Igarka was a lumber town with workers in the mills, others hauling lumber and still others hoisting lumber on ships bound for Europe. The town was built of wood, which meant at least one wooden house burned each day.

I was in Igarka for about a month and tried to send my articles by short wave radio to the Moscow office of the *New York Herald Tribune*. They would send them to Paris to appear in the *Paris Herald Tribune*. Paris would then send them to New York for the *New York Herald Tribune*.

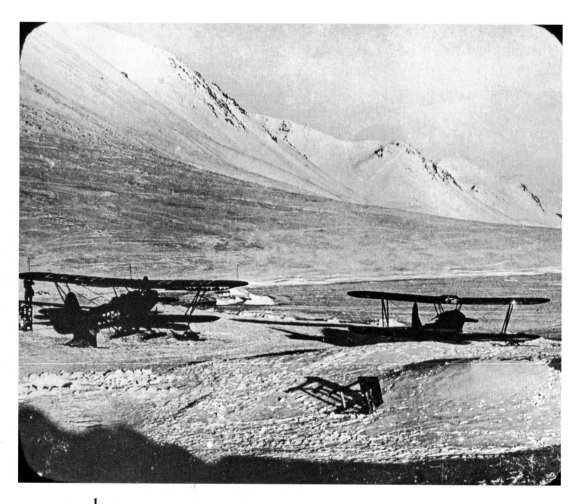

Ice floes in the Soviet Arctic became safe landing fields for polar seaplanes. I took this picture from the open-cockpit plane in which I flew around the Arctic in 1935 and 1936.

In Moscow, fellow reporters wanted to show me how excited they were that I had received this plum assignment. They brought presents, only a few of which I could really take. The most useful one was a hot-water bottle. The reporters tried to figure out how I got the assignment. Some decided it was good timing.

It was so cold flying in an open-cockpit plane that even before we took off people began bundling me in scarves and warm leather coats. The Russians were determined that the first *amerikanskaya jurnalistka* that they had ever seen in the Arctic had to be properly fortified against the cold.

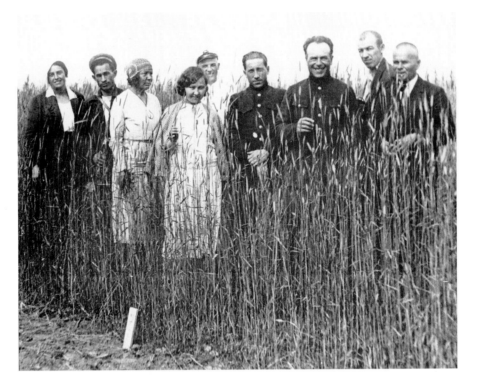

Igarka's agronomists and visiting officials, 1935.

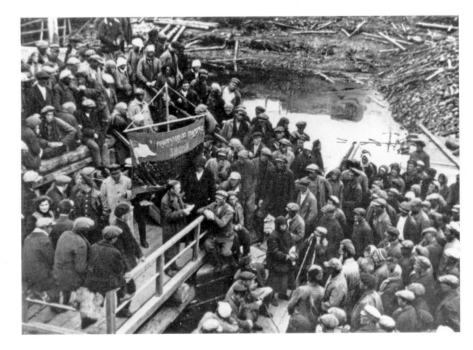

There were always rallies in Igarka to encourage the workers and to tell them they were meeting their quotas. These "Stakhanovites" were pioneers, who were rewarded with a few extra rubles.

A deckhand on the SS *Russianoff*, a Soviet ship that sailed across the Arctic Ocean carrying Siberian lumber from Igarka's mills to ports in Scandinavia, 1935. Siberian lumber was considered top quality. These workers carefully guarded their words when they talked with me. They wanted me to believe they were living in paradise. As the only foreign correspondent in Iganka, I was given free rein to photograph anything that interested me. But I suspected that if there were any prisons, military bases, or airports, they were hidden or disguised.

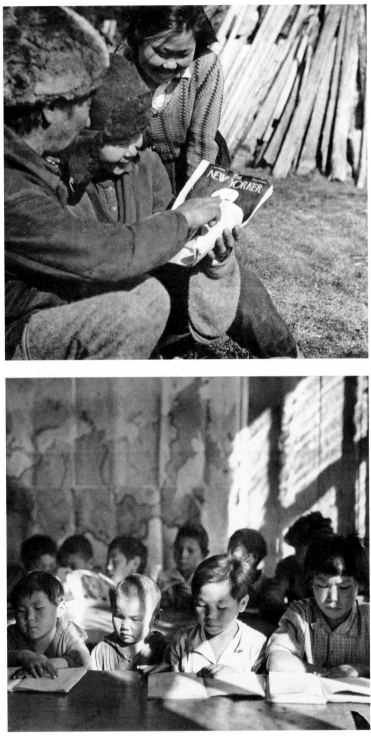

In 1936, I flew to Yakutsk in Northeastern Siberia, the largest town in the Yakutia Republic. I packed a duffel bag with copies of the *Herald Tribune* and *The New Yorker*, thinking: wouldn't it be fun to give these copies to the native people? The Yakuts were learning to read and write in their own language.

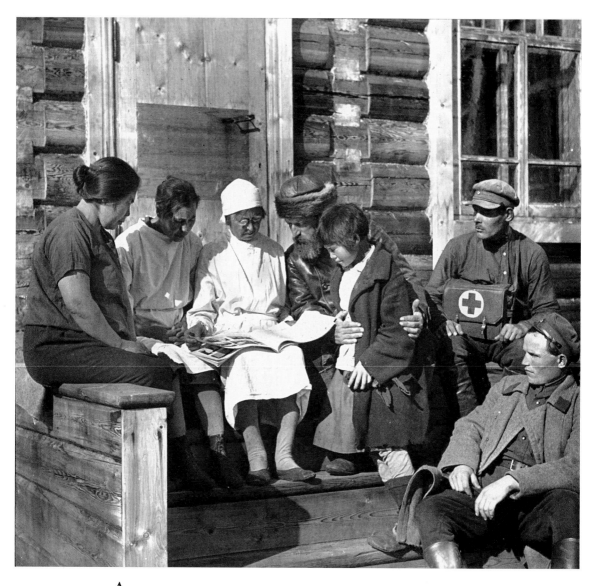

A public health nurse taught the Yakuts modern methods of sanitation. "Wash your hands, wash your bodies, and change your underwear once a month."

I lived in a modern house that had no bathroom. Like everyone else, I went to a bathhouse, where I was given a massage and where my back was beaten with leaves. There were special women's days, and I was happy to use every one of them. Sitting naked in a steam room, I soon became friends with many of the women.

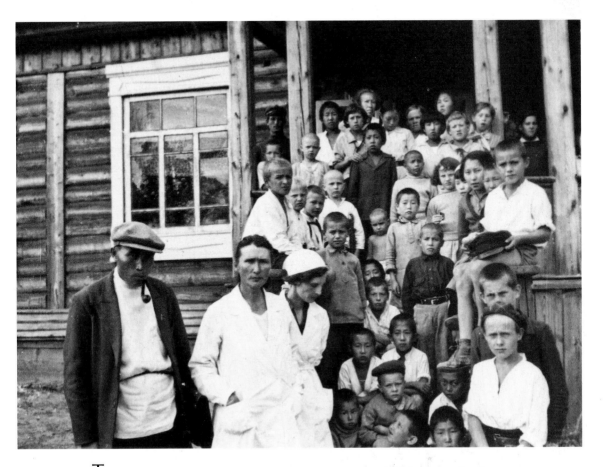

Tuberculosis was a dread disease in 1936. An entire building in Yakutsk was turned into a sanatorium for tuberculosis patients. To find a sanitarium in Siberia took me back home to Brooklyn. One of my older brothers, Harry, was a TB specialist at Kings County Hospital. His work alerted me to the havoc this disease caused families around the world. He became so involved with his patients that he turned the attic above our Brooklyn garage into a TB laboratory. He built his own pneumothorax machines, which were used to collapse the patients' lungs while they healed.

The children in this picture all had TB. The doctors and nurses I met told me how desperately they were trying to conquer this disease. I wondered, if I were to come back in a year or two, how many of their young patients would be alive.

The pasture lands of the Arctic tundra, 1936.

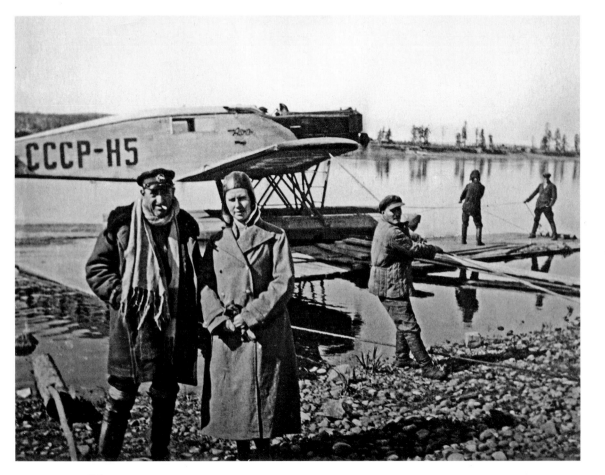

The pilot of this open-cockpit seaplane was Victor Galishev, one of the best pilots in the region. Standing beside him is Tonya Kliukvina, my interpreter and unwelcome guide, from whom I was forever seeking to escape; I was becoming more and more certain that her job was to report my activities to the secret police.

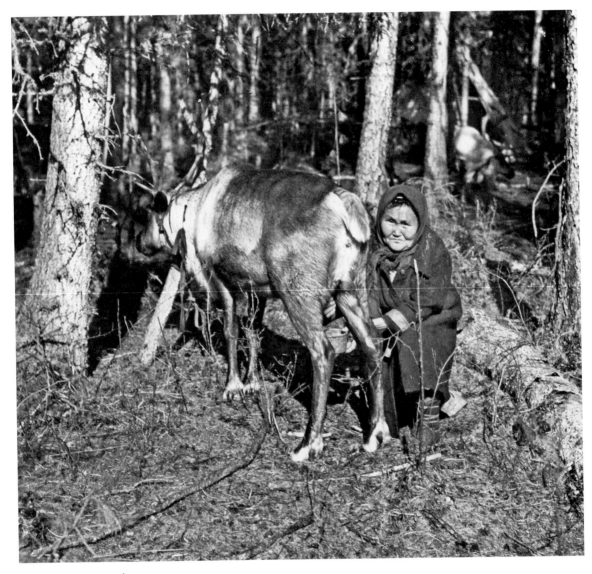

A Yakut woman milks her reindeer, 1936. Reindeer were an important part of Siberian life, providing leather, horns, skin, and milk for the native people.

Tixie Bay was a polar radio station on the rim of the Arctic Ocean, that guided planes and ships over the top of the world. The sun was shining brightly as I stood with one of the scientists. The rivers of Yakutia were like arteries pumping life into the station. Oceangoing ships brought goods from Europe and the Orient, and riverboats and barges ferried the goods up the Lena River to Yakutsk.

I think the fact that I was knowledgeable intrigued the scientists. I had worked for the explorer Vilhjalmur Stefansson, so I knew some of the Arctic problems and some of their solutions. Stefansson did a report for the War Department on the whole world's Arctic, and I had translated some German documents for the project.

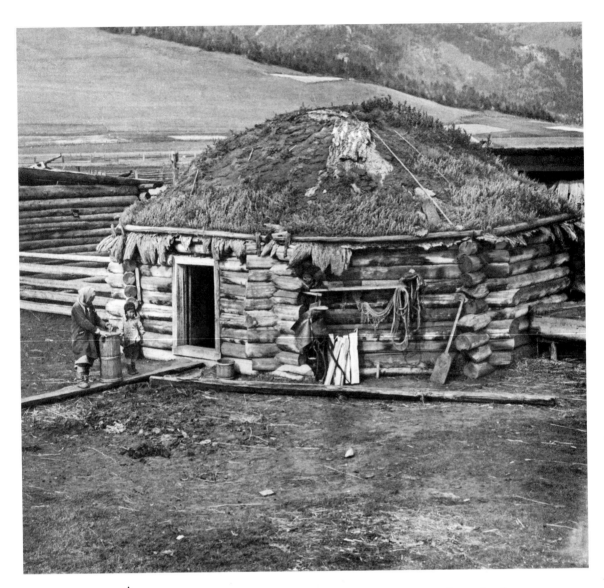

A yurt, made of wood and mud, was used largely as a winter house by the native people. It could have been a model for Bucky Fuller's geodesic dome.

Inside was a room with no furniture. The people slept on the floor in layers of clothing that kept them warm.

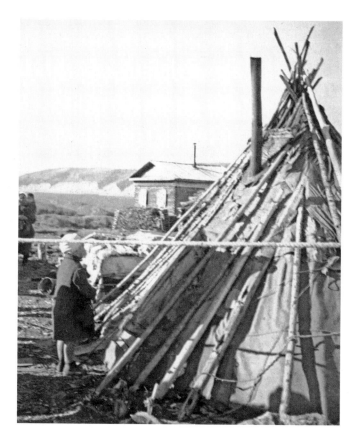

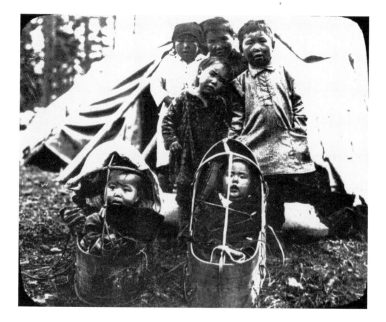

Some Yakut families lived in yurts, while others lived in tents made of reindeer hide. A Yakut family brought all their children out of their tent for me to photograph. Besides admiring their beautiful faces, I found their birch-bark cradles intriguing.

On their days off, many Yakuts dressed in Western holiday clothes and visited the Park of Culture and Rest. Inside were booths that sold food, newspapers, and magazines. Here, in faraway Yakutsk, some of the people told me they felt connected to the rest of the world.

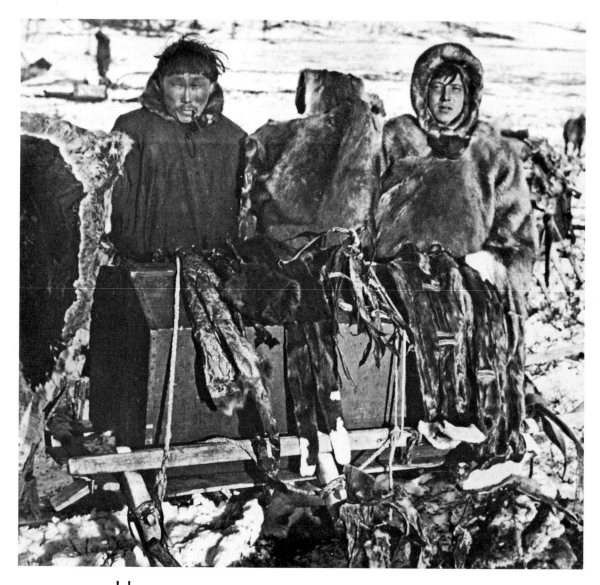

Hunters prepared furs to be sent to the international fur market in Leningrad.

Alaska

1941–1943

We'd like you to go to Alaska," Joe Barnes, foreign editor at the *New York Herald Tribune*, telephoned me in the spring of 1941. "We'd like you to do a series of articles on how we're preparing for war up there. Alaska's going to become very important once we enter."

Barnes suggested I take a train down to Washington to interview Harold L. Ickes, the secretary of the Interior. Alaska, not yet a state, was in Ickes's grab-bag department, together with Puerto Rico, the Virgin Islands, Hawaii, and the Philippines.

Ickes's office was a study in blue—a thick blue carpet and heavy blue drapes framed the long windows, with Ickes sitting hunched over his desk in a blue suit. By a lucky coincidence, I was wearing a blue suit with a blue hat and high-heeled blue shoes that I hoped would make me look taller than my five feet two inches.

"Sit down," Ickes said, pointing to a chair at the right side of his desk. Having read a good deal about him before coming to Washington, I expected to find a New Deal Democrat, a crusty curmudgeon, pugnacious and fiercely honest, who had cleaned up both the Teapot Dome oil scandal in the Interior Department and the corruption under President Warren G. Harding. Instead, I found a warm, approachable man who looked like the editor of a country newspaper, his eyes glinting behind gold-rimmed glasses.

After half an hour in his office discussing how important Alaska would

become as soon as we entered the war, I observed, "The shortest route between America and Europe is across the top of the globe."

Ickes nodded. Suddenly, looking straight at me, he said, "Don't go to Alaska for the *Herald Tribune*. Go for me. I read your book about the Soviet Arctic. I want you to do something similar. Make a social and economic study on how we can open Alaska to homesteaders, and at the same time save its environment. I want you to be my eyes and ears, and to send me constant reports. Travel wherever you want up there. Stay about a year. I suggest you take a couple of cameras and even a movie camera."

"Mr. Secretary, if you give me a camel and two strong men to carry all that equipment, I'll be happy to do it."

He laughed. "Carry as much as you can."

I had come for an interview as a freelance writer for the *Herald Tribune* and left with a full-time job as Ickes's field representative in Alaska. I was now a member of the Roosevelt administration.

For my reports to Ickes, I used a Leica for color photos, a Rolleicord for black-and-whites, and an 8-mm movie camera. The cameras were to play an important role in validating the reports and recommendations I sent to Ickes.

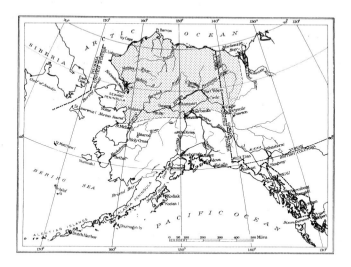

Alaska was an empty country. Though it was huge, a fifth the size of the United States, it had only 30,000 native people—Indians, Eskimos, and Aleuts—and 30,000 settlers.

In my notebook, I summed up my first few months in Alaska: "I went everywhere that first summer—everywhere. I wanted to see it all, live it, breathe it, experience it, swallow it, know it as I had known the Soviet Arctic." I recorded what I was seeing in countless notebooks and with three cameras.

I became enchanted with the Eskimos. I loved their way of life, their serenity, their acceptance of the climate, and especially the care they gave their children. An Eskimo mother was almost never without her child, either on her back or in her belly.

On November 4, 1941, sitting in my office in the penthouse of the Federal Building in Anchorage (it was the third floor), I sent Ickes a long report summing up the first six months of my study. I had already filled up forty-five notebooks, taken scores of pictures, and shot reels of film.

"All along the way," I wrote to him, "sailing down the Yukon, living among the Eskimos on the islands of the Bering Sea, photographing the government reindeer herd at Kotzebue, I've tried to get at the Truth of Alaska."

Truth had always been at the core of my writing. In the Soviet Arctic and now in Alaska, truth became the core of my pictures. To be sure, there are people who argue that photographs can distort the truth just as much as words can. But unmanipulated pictures do not deceive.

I discovered there was a mystique about the camera.

Photographs, just like articles and books, can help change the world. They can reveal the soul, the essence of people who are good and the essence of people who are evil. My goal was to capture the beauty of mothers and children and to bring to life workers, fishermen, pioneers, and so-called common people—though they were not common. They were, by and large, people who create and build, but do not destroy.

I did not want to romanticize Alaska, though I think the beauty of the country seen through the lens of my camera might have justified it. Nor did I want to trash it as did some of the soldiers. Many were teenagers who had never been told what their mission would be once we entered the war. They were homesick and confused. "Why were we sent up here?" they would ask me.

One morning, a teenage soldier from a farm in the Midwest knocked on my door. "Excuse me for bothering you. I'm so lonely. I only want to hear you laugh."

Often in Anchorage, I arranged to meet the soldiers in the Army clubhouse they had helped build. I encouraged them to show me snapshots and tell me stories of their mothers, their wives, or their girlfriends. Each day more and more soldiers came, pulled up chairs, sat in a circle around me, and shared their feelings about Alaska.

Army officers, seeing the soldiers absorbed, began asking me to give daily lectures in the clubhouse, illustrated with my photographs. I accepted, in the hope that, through these talks, I might help them understand Alaska's importance.

Citizens' groups, such as the Rotary, learning of the talks to the soldiers, began to ask me to speak to them, too.

On December 2, 1941—five days before we entered the war—I wrote Ickes about the lectures and the low morale among the soldiers and civilian newcomers:

> The question of morale, serious enough in the States, is really acute here. There have been a distressing number of suicides and insanities among the soldiers. Civilian morale, especially among the newcomers, is little higher. Evenings hang heavy; new saloons open almost overnight; the red light districts spread and flourish while men and women search desperately for time-killers.
>
> You hardly know there's a war going on [in Europe]. On the one hand, there's a listless apathy toward world events; on the other, a violent hatred for Alaska. Some of the boys look upon the territory as a prison, a place of exile. Their general attitude is: "If the Germans get Alaska, they deserve it."
>
> It seems to me that these soldiers and civilians need to know what they're defending and what they're fighting for. They need not only military education but political education. They ought to know the importance of Alaska, and of the whole Arctic, in times of peace and war; that Alaska is the springboard to Asia and Europe and that the Arctic is both the crossroads and the weather-kitchen of the world.

Knowing how secretive and careful I had to be not to divulge any military information, such as locations of airfields and numbers of troops, I ended the letter by making sure Ickes approved of my giving these talks. His answer came by air mail in less than three weeks:

THE SECRETARY OF THE INTERIOR

WASHINGTON

December 20, 1941

My dear Dr. Gruber:

I can see no reason why you should not speak to meetings of Alaska citizens as the newspaper clippings that you sent with your letter of December 2 indicate that you have been doing. I think that such talks are all to the good.

What you say in your letter about the morale situation indicates a very bad condition. We Americans seem to take the question of morale for granted. For over two years I fought a constantly losing battle in my effort to have the Administration set up a division to handle such matters. I am taking the liberty of sending a copy of your letter to the President.

Sincerely yours,
Harold L. Ickes
Secretary of the Interior

I soon discovered that if Ickes had faith in you, he gave you free rein. In another of my reports, I cabled him that the thousands of Aleuts, living on the Aleutian Islands and the seal-bearing Pribilof Islands, were the most vulnerable targets for the Japanese to attack. The Aleutians were pointed like a sword at Tokyo.

"The Aleuts are in harm's way," I wrote him. "They should be rescued."

He cabled back, "We'll do it."

The Coast Guard then loaded the people onto ships and brought them to Funter Bay, not far from Juneau, where I was able to photograph them settling in.

Of all the native peoples, I most enjoyed photographing the Eskimos. They fascinated me by their serenity, their acceptance of the harsh world in which they lived, and by their love for their children.

By December 7, 1941, the "date of infamy," tens of thousands of soldiers, sailors, airmen, and civilian construction workers had been flown into Army

bases. Alaska took on the beat and rhythm, the excitement and urgency of a boomtown. One of the teenage soldiers, caught up in the war spirit, stopped me on the street in Anchorage one day. "I'm not lonely anymore. I'm beginning to like this place. I might even come back when the war is over."

One of the most vulnerable targets for the Japanese to attack was Dutch Harbor, where I arranged to spend several weeks. The slim, fortyish commanding Army Air Corps officer met me at the airport. "We're putting you up at my house, and I'm moving over to bachelor quarters."

"Please don't do that," I protested. "I don't want to put you out of your house. I can stay wherever you put nurses or women soldiers."

"No, we want you to be very comfortable. I'm giving you my housekeeper and my two Hawaiian cooks."

I still protested, but he waved me off.

"We do some drinking," he said, "but nobody is allowed to drink until 5 p.m. Here, look at this." He showed me the wristwatch on his left hand. Every number was five.

"We have only one request of you," he continued. "Give a dinner party every night for the top brass and for the visiting VIPs. We get a lot of them here."

Now, in Dutch Harbor, as well as in Anchorage, my base town, with the war raging, I wore out more evening gowns than I did in a lifetime at home. I was constantly writing to my mother to air-express more of my gowns and evening shoes.

Though my evenings were social events, with dinner parties and dances held at the officers' club, my days were hectic, taking photos and notes, interviewing people, and sending constant reports to Ickes. The movies I shot around the country were made into a film by the Coast Guard to train cadets for war service.

One day, I arranged with one of Alaska's best bush pilots to fly me from Anchorage to Nome. I was sitting in my office waiting for the pilot with my bags packed when my phone rang.

"This is the Army Signal Corps," a male voice said. "We have a message for you from Secretary Ickes. We have to decode it."

All of Ickes's messages to me were in code.

The pilot arrived breathless. "Ready? We have to take off right away!"

I shook my head, "I'm waiting for a message from the Signal Corps."

"Sorry," he said, "I've got other passengers rarin' to go."

He dashed out. The next day the *Anchorage Times* carried the news. The pilot had flown through an Arctic storm and crashed into a mountain. All aboard were killed. I cabled Ickes, "You saved my life."

With no hotels in the Eskimo villages, I generally found living space with the schoolteachers or the nurses. But on Kodiak Island the only space available was in the jail. I had a fairly comfortable room and was even given my own cook. The warden was awarded a dollar a day for every prisoner he rounded up. Most of them were arrested for being drunk. Early each morning the warden gave them fishing rods and released them to spend the day fishing. Nobody ever ran away. As in the gulag in Siberia, there was no place to run or hide.

In the evening, the prisoners returned with their catches and cooked their own dinner. The warden and his wife invited me to dine with them for many of my meals.

One of the most important lessons I learned in Alaska was not to fight time but to live inside of time.

Before Alaska, I was always restless. If the train from Kosciusko Street in Brooklyn was late taking me to New York University, I would pace the platform, cussing under my breath like a longshoreman. But in Alaska, what good did it do to cuss, get angry, or send my blood pressure spiking? The only way I could get in and out of a place like Kodiak Island was by ship. Instead of bashing my head against the wall of the jail, I learned to calm my restless brain and surround myself in a kind of golden bubble. It liberated me. Especially in the Eskimo villages, I had more time to live among my Eskimo friends. More time to take photos, especially of happy children wrapped around their mothers' necks and backs. More time to send reports to Ickes and letters home, and more time to read books outdoors in the twenty-hour-long days of dazzling, clear, unobstructed sunlight.

· · ·

I left Kodiak for Point Hope and from there decided to move on to Point Bar-row, the northernmost village in Alaska. I cabled a small airline in Anchorage to send a pilot to fly me. Weeks passed as messages dribbled in: Bad weather. Engine broken. Planes all booked. Pilot indisposed (meaning drunk).

Finally, more specific answers arrived: "See you Tuesday, weapers." "Weapers" meant "weather permitting." Tuesday came. No pilot. The next Tuesday came. No pilot. The third Tuesday came. Still no pilot.

Then, unannounced, a pilot appeared in a small black plane. Point Hope had a fairly good dirt airfield, but Herb Hager, a disheveled, dust-covered pilot, made a dramatic landing on the beach. The entire village came to drag his plane up to the airfield and to say good-bye to me. Ida Susak, who cooked for me, handed me a box of emergency rations. Hager pushed the box aside.

"What kind of pilot do you think I am, traveling without rations?" he demanded.

Concerned lest I should hurt his feelings, I handed the box of food back to Ida. I looked at it longingly. It was overflowing with sandwiches. But I managed to sneak a Hershey's chocolate bar out of the box and hide it in my purse.

Next, I tried to slip the winterized sleeping bag a colonel had loaned me through the plane's door.

"Leave that junk here," Herb said. "What kind of pilot do you think I am, traveling without a sleeping bag? I've got one right here."

Maybe he's afraid of overloading the plane, I thought, asking Ida to return the sleeping bag to the colonel.

Finally we took off, waving good-bye. A small thermometer in his plane read eighty degrees Fahrenheit. I was happy to be wearing a light blouse and thin Army trousers. The plane was so tiny that I was forced to sit close to the pilot. We were in the air a short time when he asked me if I had a map.

"You mean you've flown this route so often you don't need a map?"

"I've never flown this route before."

After a while, he said, "We're getting close."

The plane began to shake. "Hold on," he said, "we're coming down."

The thermometer showed that the temperature had fallen to twenty degrees. He carefully landed the plane on a beach covered with snow.

"What happened?" I asked him.

"I don't know," he said, "and I don't know where we are, but we can't be too far from Point Barrow."

"Should we walk there?" I suggested.

"We can't. I'm wearing bedroom slippers."

I tried to move far away from him, though there was little space. The night was interminable. I shared my bar of chocolate with him. In the morning, I decided to take a walk. I came upon a monument dedicated to Wiley Post and Will Rogers. Their plane had crashed in a fog right on this lagoon. A shiver ran down my spine.

Herb decided to try to take off again. He lightened our plane by unloading a few gadgets, took off, and made a safe landing in Point Barrow.

"The Lord sure had His arms around us," he sang.

In Point Barrow, a group of hunters took me on a small white whaleboat to hunt walruses. The thought of killing a walrus sickened me. But I realized that these beautiful creatures provided the Eskimos with food, and oil, and with protective covering for their bodies and their tents. They were hunting not for profit but for survival. I began photographing them with my movie camera.

We were maneuvering around the ice floes when the first walrus's head emerged out of the ocean. Abraham Kippy, the leader of the group, fired a bullet, then shook his head and smiled benignly at his failure. "Missed him."

A few minutes later, still smiling, he called out, "Another one!" He had spotted a walrus sleeping on an ice floe. One of the hunters on the boat whispered, "No noise." They stopped the outboard engine and quickly donned white parkas to blend in with the ice. I was filming the scene while the men paddled softly. The walrus woke.

"Shoot!" Abraham ordered in a soft voice. Two hunters raised their guns. The ice floe turned red with blood. The walrus dove into the sea. One of the men called out, "He's hit!"

Another one started the motor while we chased the creature.

"Shoot again," Abraham commanded, "but don't hit him in the head or he'll sink immediately."

Slowly, the wounded walrus rose out of the sea. "Don't shoot," Abraham whispered. He flung his harpoon into the walrus's body, and with a rope pulled

the dying creature toward us. I was so caught up in the excitement that I continued filming long after my movie camera ran out of film. I kept reminding myself this was not killing for profit. The hunters were shouting with joy.

We towed the body to a large ice floe, stopped the boat, and climbed out. Two men with sharp knives cut through the skin and removed the blubber, then handed pieces of it to each of us. I took a few bites. It was like sinking my teeth into a chunk of fat. I worked desperately to keep it down.

After a year and a half of traveling and sending reports to Ickes, I decided it was time to go home. Back in Washington in 1942, I went to say good-bye to the secretary, thinking my assignment as a government official was over.

"Oh no," Ickes said. "You're staying right here as my special assistant."

He then began to drop different assignments into my lap. I grew to know his style of writing better as he asked me to draft letters for him to send and speeches for him to give concerning Alaska. Hundreds of letters flooded the department each day, most of them now from soldiers who had begun to love and understand Alaska and who wanted to homestead when the war was over. Married soldiers often wrote saying they wanted to give their children the excitement of growing up on our last frontier.

Soldiers, as well as civilians, wrote Eleanor Roosevelt, asking her the same questions about homesteading. Her office forwarded some of those letters to me, to draft her responses. That was when I learned of her passion to help everyone who wrote to her.

So many requests came to Ickes and Mrs. Roosevelt that I suggested to the secretary that I write a paperback book on Alaska to be published by the Department of the Interior and to be sent free to would-be pioneers and homesteaders.

"Do it," he said.

Ickes wrote the introduction:

> The war has rekindled the fires of curiosity about our last big land frontier. . . . This booklet is designed to clear away the misconceptions, to debunk the ballyhoo, and to answer some of the questions. It attempts to give a true picture of Alaska, its opportunities and its limitations. Life on

the frontier is not easy, and those who go there must be ready to trade hard work for the right to build on wide horizons.

In the midst of the war, Ickes asked me to return to Alaska and the Canadian Northwest to investigate the Canadian oil project (Canol) and to report on the Alcan Highway, linking Alaska and Canada. These were newly coined words in the lexicon of oil and highways. The name of the Alcan would soon be changed to the Alaska Highway.

"I want you to go," Ickes explained, "because you know Alaska and you know the Arctic. Nobody has given me a report yet on how the oil project and the Alcan Highway are progressing. Can you be ready to leave in twenty-four hours?"

I laughed, "What will I do with the extra twenty?"

He pressed a button for his operator. "Get me General James A. O'Connor in Edmonton, Alberta."

"General," he said, "I want to send my special assistant along the highway."

I gathered that the general said something like, "Send him right up, Mr. Secretary."

Ickes shouted, "It's not a him, it's a her."

The general must have said what I heard so often: "We've got no bathroom facilities to take care of women. We're not letting any women drive on the highway, least of all civilian women."

Ickes's jowls shook with laughter, "You don't know the plumbing this gal has lived with. She was in Siberia, where the outhouses were so high you needed a ladder to get up to them."

A day later I was on a plane flying to the Canadian Northwest. General O'Connor, a jovial Army officer with a chest full of ribbons, met me at the airport in Edmonton. He shook my hand. "The politicians up here are so excited about your coming that they asked me if you will speak in the Parliament."

The next morning, the general picked me up at my hotel and drove me to the huge Parliament building. A Canadian guard escorted me to the podium. I looked out at the audience. They were all men, some in civilian clothes, the others in Canadian Army uniforms. I decided to talk to them the way I had talked to the soldiers in the Anchorage clubhouse, telling them the stories of Alaska

that had become so much a part of me. It seemed to work. They stood up and applauded. The general's comment made me chuckle. "To think I tried to stop you from coming."

The next three weeks were spent with geologists, architects, Army engineers, and workers sent by three American construction companies, Bechtel, Price, and Callahan, who were already starting to build the Canol pipeline. Some of them were enthusiastic about the prospect of finding oil, but others were convinced that too much money and time had been spent without finding sufficient quantities. In the Senate, Harry Truman, then a senator chairing the Truman Investigating Committee, later denounced the Canol project as an "inexcusable boondoggle." When I learned that Ickes agreed with Senator Truman, I asked him, "Then why did you send me to cover it?"

"I didn't want to influence you with my bias. I knew I would get your honest opinion."

Unlike Canol, the Alaska Highway was an instrument of war and later peace, stretching 1,500 miles from Dawson Creek in British Columbia to Fairbanks, Alaska. It was a swiftly built road across which food, ammunition, and medical supplies could be trucked from our factories in the States through Canada to Alaska. It augmented the work that both our pilots and Soviet pilots were doing, flying butter and guns to the Soviet Arctic and on to our Allies in Europe. For me, it reaffirmed what Stefansson had been arguing for years, that the shortest transport routes of the world lie over the top of the globe, not around its belly.

I traveled the highway in an Army jeep driven by an affable African-American soldier named Tom. With Southern courtesy, he opened the door of his Jeep, helped me up, put my camera bag on my lap, and made space behind me for my Army knapsack, loaded with film, fresh notebooks, pens, and a small DDT bomb to protect me from diseases and hopefully from the curse of mosquitoes.

The highway began in the heart of golden prairies and then broke a path through mountains that, in the sunlight, turned soft lavender. It ambled naked and broad through birch forests that cast long, lean shadows on it. It was a road of moods, bright and inviting in the morning, a little sleepy in the hot sun of the early afternoon, and mysterious at night when you rode beneath the Northern Lights, whose curtain of colors lit up the subarctic sky.

Intrigued by my driver's courteous behavior, I asked him where he was from.

"Louisiana," he said. "We're mostly all from the South. We're a black unit building the Alcan. Funny, huh?"

It was not funny. An Army officer told me one day, "Somebody ought to be court-martialed for the way those Negroes are treated. They suffer from rank negligence and stupidity. In December, they were wearing the same clothing they had worn in building an airfield in Florida."

To take the sting out of his remarks, I told him, "Ickes was one of the first cabinet members to desegregate his department's cafeteria."

"That's good," the officer agreed. "Washington, you know, is still the segregation capital of the United States."

It was not until the end of the war that President Truman finally desegregated the military.

After sending more reports to Ickes, I again told him in one of my cables that I was planning to fly home.

Ickes answered, "Would like you to stay on and go to Juneau to cover the territorial legislature?"

In Juneau, Dorothy Gruening, the wife of Governor Ernest Gruening, invited me to stay at the Governor's Mansion. She ran the Governor's Mansion with the ease and skill of a well-trained first lady. Each dinner party was a venue for discussing politics and especially for dwelling on the governor's dream that Alaska should become our forty-ninth state.

The long days at the legislature were filled with the venom that some of the legislators felt toward the governor. Often, when a bill was running its course, someone would ask, "Is Gruening in favor of this one?" If the answer came back "yes," the bill was defeated.

But Gruening's popularity skyrocketed when Alaska became the forty-ninth state in 1959. He was elected, almost unanimously, to be Alaska's first U.S. senator. One day on the floor of the Senate in Washington, he greeted me and said, out of the blue, "Ruth, I predict you're going to find more ways to help people. You'll never know what turn your life will take." I wondered how he knew.

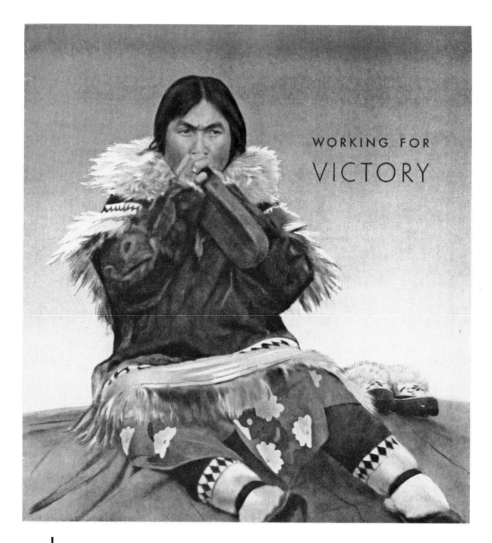

WORKING FOR
VICTORY

I was visiting an Eskimo hut when I came upon a woman making mukluks (boots) like the ones she was wearing. She especially wanted me to see how she softened the reindeer leather soles with her teeth. In this so-called primitive village—with no sewing machines—Eskimo women learned from their mothers how to design and create their own fur boots and fur parkas. My parka was made of groundhog with a collar of wolverine, which doesn't freeze. Before I left for Alaska, the editor of *Natural History* magazine asked me to send him some photographs. He selected this Kodachrome slide for the magazine's 1941 holiday cover.

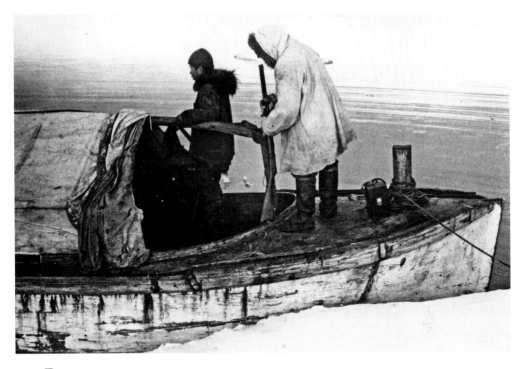

Point Barrow, Alaska's north-ernmost Eskimo village, became one of my favorite villages. One day, the Eskimos invited me to participate in a walrus hunt. I found comfort in knowing that the Eskimos did not waste any part of the animal they hunted.

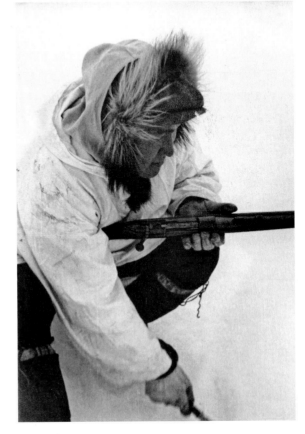

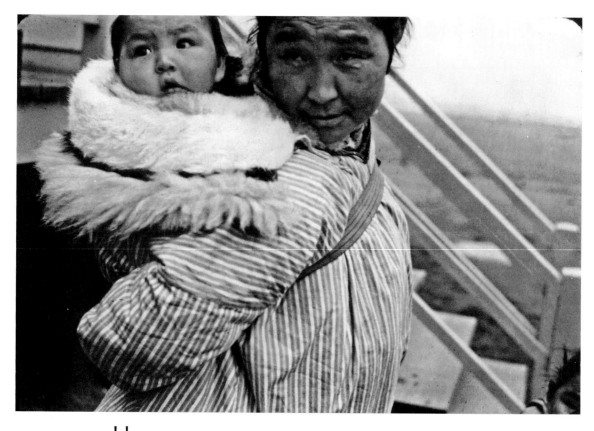

Hooper Bay, Alaska, 1941. Hooper Bay, a typical Eskimo village on the
Bering Sea where I spent many days. The babies bonded with their moth-
ers from morning to night, content and protected. They snuggled against
their mothers in parkas and wolverine fur collars.

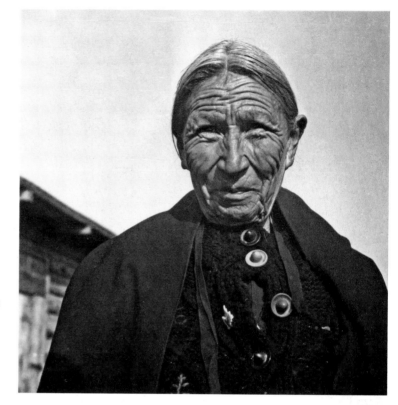

The Hooper Bay schoolteacher was about to leave for a hospital. She and her husband sent me an SOS: "Could you come and run the school for us till we get back?" "I'll come," I answered. I taught the students English and math. It was a curriculum designed for indigenous people. That's when I took the picture of an Eskimo woman reading *Life* magazine. At one schoolhouse I gave each child a copy of *Life* and asked them each to write about what they had read. Every single one in that school wrote about the ads. So much for us journalists.

One child wrote, "This is a story of a little girl. She is waiting at the church. The groom has left her. She has bad breath." The ad was for Listerine.

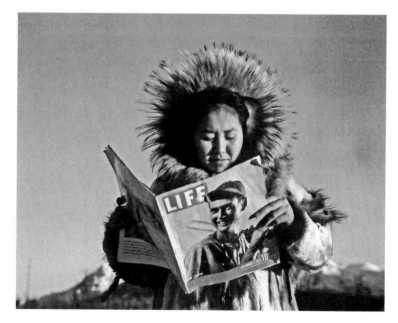

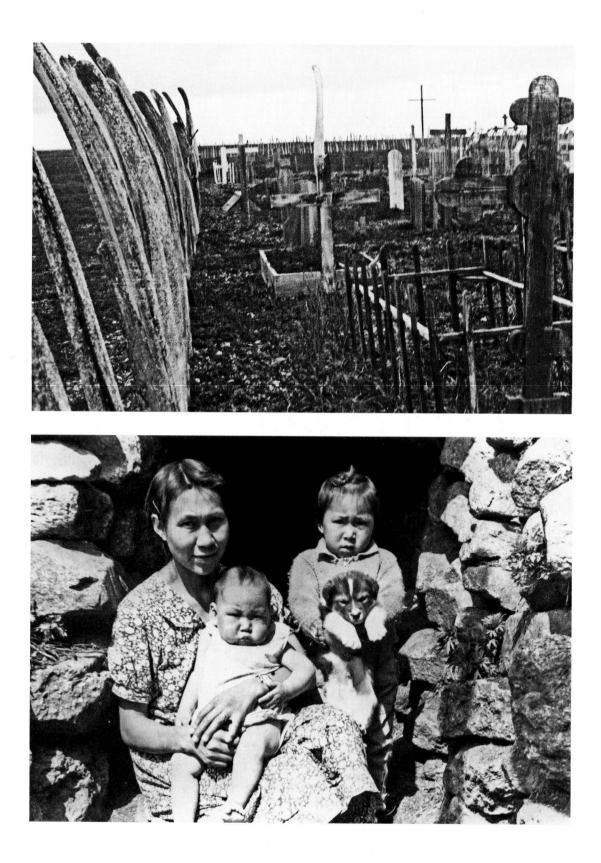

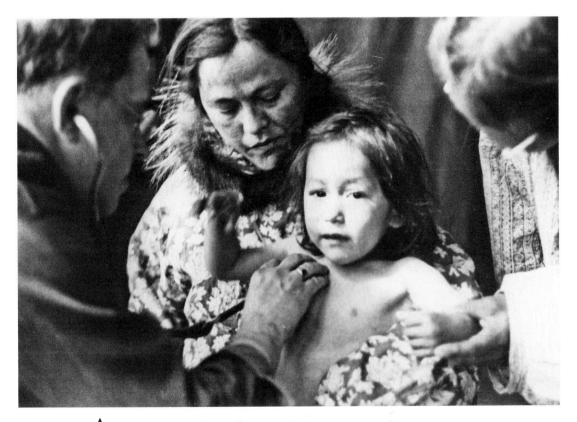

An Eskimo cemetery, Point Hope, Alaska, 1941. Missionaries came every year to convert the Eskimos to Christianity; they didn't want them to use shamans. But the Eskimos believed that shamans could help them. The new missionaries came with alcohol, which ruined the health of the Eskimos and their ability to cope with life there. (*lower left*)

Dr. Levine, a pediatrician sent by the Bureau of Indian Affairs, was furious that every Eskimo village was without a doctor and nurse. Often it was difficult to get the people to a hospital—they had to wait for bush pilots. Tuberculosis was prevalent, though it had been even worse in Siberia. Many Eskimos lived crowded in one hut, and parents, unknowingly, would pass the disease on to their children. (*above*)

The Army and Coast Guard always think in terms of camps, so they moved the Aleuts who were in danger of a Japanese attack to a camp near Juneau in Funter Bay. The people had to start a whole new life in a whole new climate.

Many of the Aleuts were unhappy in living in southeast Alaska. The government was working hand in hand with the Fowke Fur Company in St. Louis, Missouri so women could wear sealskin coats. In the midst of the war, they took men from Funter Bay and sent them back to the Pribilof Islands so they could hunt seals and send the skins to St. Louis.

The main street of Fairbanks, Alaska, 1941. I interviewed people about why they had come to Alaska, if they were planning to settle there. They came from all over the United States and many from Sweden and Norway. Some came for the fish, an important industry. Others came to hunt game and still others to attend the university in Fairbanks.

In 1941, there were few roads to Alaska. You entered the territory either on a plane or a ship. The U.S. Army realized that in the event of war, a road from Edmonton, Alberta, to Fairbanks would make it possible to truck ammunition and supplies to the Fairbanks airport.

By the time war broke out on December 7, 1941, there were more than 100,000 soldiers and a score of civilians living along the route of the Alaska Highway.

The Alaska Highway, 1943, cut its way through magnificent mountains, crossed Arctic rivers and lakes, and filled the air with dirt and, according to the soldiers, with "mosquitoes as big as bombs." I reported to Ickes how African American soldiers had built the highway in less than one year. It was an incredible engineering success.

A rest stop at mile 20 along the Alaska Highway.

The Alaska Highway was not yet a tourist's road. It was a pioneer's and dreamer's route that we hoped one day would link Alaska to the Strait of Magellan on the border of Chile and Argentina.

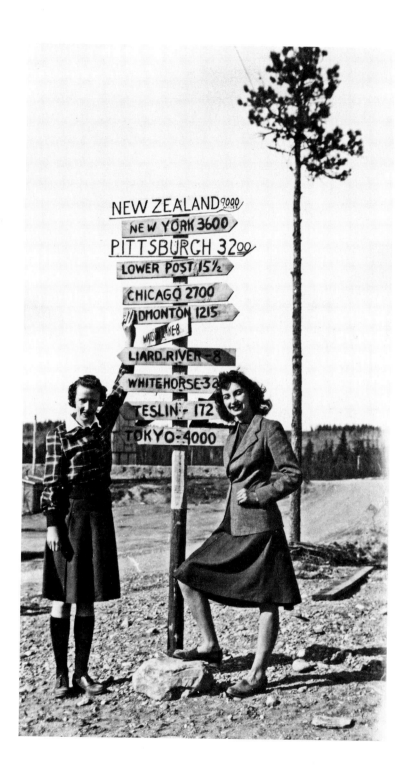

I thought Muncho Lake, along the highway, provided one of the most serene and peaceful areas in British Columbia.

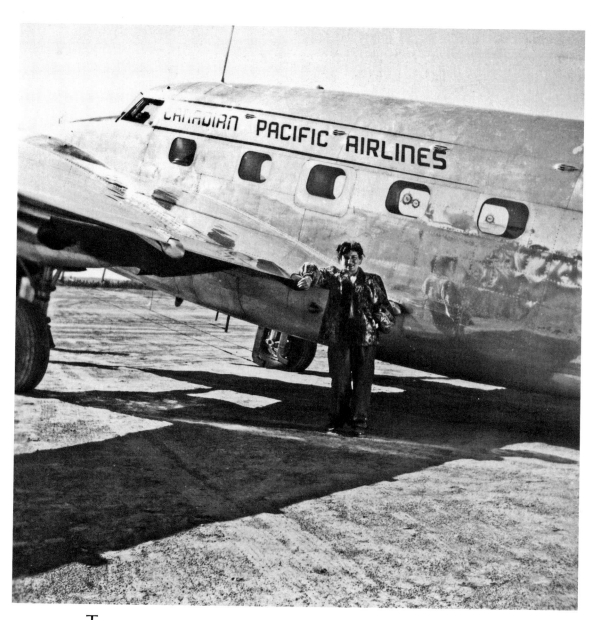

The Royal Canadian Air Force pilots flew me from Edmonton to Norman
Wells in the Canadian Arctic.

The native fishermen were fascinated with the road builders. When had they ever seen so many black soldiers? When had they ever seen Army engineers determined to finish a 1,500-mile-long highway in one year?

U.s. Army engineers worked tirelessly against the hardships of the North. Loneliness was one of their worst enemies. My driver ruefully said, "You're probably the first woman they've seen in weeks." I was happy to smile and wave to them as we drove on.

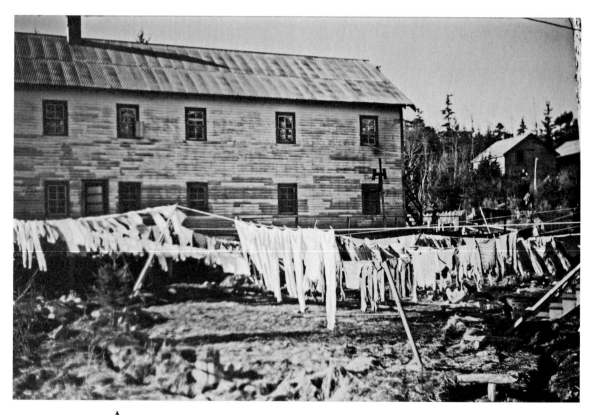

As we drove along the highway my camera caught scenes of Alaskan life.

Progress along the highway came in the form of stores like Sears, Roebuck *(top right)*, which sold necessities—even luxuries.

The native people often took time off to watch the way the highway promised to change their lives by solving one of the biggest problems—transportation.

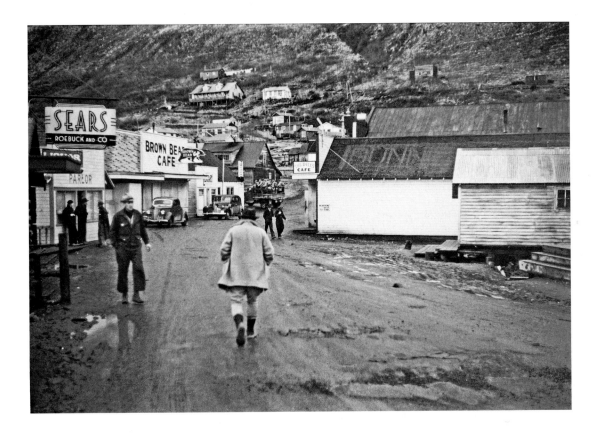

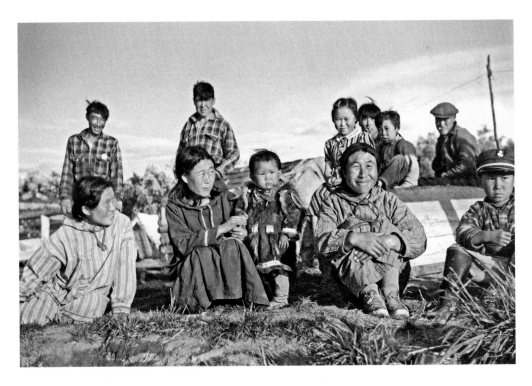

World War II and the
Oswego Refugees

1944–1946

In January 1944, President Franklin Delano Roosevelt made a startling announcement: "I have decided that approximately one thousand refugees should be immediately brought from Italy to this country."

What was the reason for this almost incredible turnabout in the government policy of strict quotas, based on the racial bias that kept our doors effectively sealed against Eastern European Jews? I soon learned that one of the major reasons was a report written in the Treasury Department called "Acquiescence of the United States Government in the Murder of the Jews." Though the report was written by Joe DuBois, a young lawyer in the Treasury Department, it was signed R.E.P. (Randolph E. Paul) of the War Refugee Board.

On January 16, 1944, a rainy Sunday morning, Secretary of the Treasury Henry Morgenthau, Jr., brought the report to his friend President Roosevelt. It was an honest, passionately written document, telling how our State Department had not only barred Eastern European Jews from entering our country but used the machinery of government to bar them.

Breckenridge Long, assistant secretary of state in charge of the visa division, was, in effect, the arbiter of life and death, since no one could enter the United States without a visa. Mr. Long, an admirer of Mussolini, was sending coded messages to our consulates abroad that if Jews came for visas, delay, delay, delay. Meanwhile, cables sent from Switzerland were kept top secret in the files of the

State Department. These cables warned of Hitler's determination to annihilate all Jews.

The key word was *Vernichtung!* Annihilation.

In the months since my return from Alaska, I had been feeling helpless, angry, and frustrated. Working for Secretary Ickes, I knew that Jews were fleeing bombs, terror, anti-Semitism. What were we doing to help them? Almost nothing. We saved famous people, like Albert Einstein, Marc Chagall, and the German novelist Lion Feuchtwanger, whose defining novel, *The Oppermanns*, told the story of Hitler's rise to power. (I wrote a preface for a new edition in 2001.) But except for saving such people, we were doing shamefully little to stop the annihilation of six million Jews.

Roosevelt, who was magnificent domestically, kept arguing, "First we must win the war. Then we can worry about refugees." Yet it was clear to many of us that if we waited until we won the war, there might not be any refugees to save.

Now I discovered with gratitude and joy that Roosevelt had pulled the rug from under Breckenridge Long and had created a brand-new government agency, the War Refugee Board. Their assignment was to rescue Jews.

Then, as he did so often, FDR dropped the whole project in Harold Ickes's lap. I hurried to Ickes's office. "Mr. Secretary," I said urgently, "these refugees are going to be terrified, traumatized. Somebody has to hold their hands."

Ickes had been looking weary. Suddenly he was energized. "Of course. I'm going to send you. You're a young woman. You're Jewish. There will be a lot of women and children. I'm sure this will mean as much to you as it does to me."

"Mr. Secretary, this is the most important assignment of my life."

He nodded. "You know this project is the president's idea. You'll be going as his emissary. It's top secret. We'll have to make you a general."

"Me? A general?"

"You'll be flying in a military plane. If you're shot down and the Nazis capture you as a civilian, they can kill you as a spy. But as a general, according to the Geneva Convention, you must be given shelter and food, and kept alive."

With my camera bag hanging over my shoulder, my portable typewriter in my hand, and a suitcase with winter and summer clothes, I boarded an Army Air Force plane filled with officers wearing the uniforms of many of our Allies.

It took five days changing planes in half a dozen airports across Europe. In each airport, soldiers sprayed me from head to toe with DDT. We didn't know then that DDT could be fatal.

In Naples, Bob Neville, an old friend and editor-in-chief of the GIs' newspaper *Stars and Stripes*, met me at the airport, helped me climb up into his Army truck, and showed me Naples's lunar landscape. Buildings hung like rags. Houses were sliced down the front. Staircases led nowhere, and curtains were flying insanely in the wind.

"The Neapolitans," Bob told me, "are living without water, without plumbing, without food. The Germans blew up the water supply. They put a twenty-one-day bomb in the post office, so innocent people would get killed weeks after the Germans were gone. To add to the madness, they even emptied the prisons and the insane asylums."

After dinner with his newspaper staff, he showed me a map of the war they were covering with passion and integrity. I returned to my hotel and immediately switched on the radio for news. A German voice was screaming: ". . . this criminal attack against the Führer."

Dear God, was it possible? Had someone attacked Adolf Hitler? Was he dead?

The next voice was Hitler's, high-pitched and hysterical, barking into the room. I pulled out my notebook to jot down his disjointed words: "We will catch these traitors. Their stupidity is enormous. They plot for the slavery of our people. They planned a terrible fate which our people will live through."

His screams felt like a snake crawling on my skin.

If only that assassination attempt had succeeded, I thought, we would be saving not one thousand but tens of thousands of refugees.

The next morning, an Army soldier drove me to various government officials to whom Ickes had given me letters of introduction. Dressed for these diplomatic calls, I wore a white suit, the obligatory white gloves, and a large-brimmed red straw hat to protect me from the Neapolitan sun.

In midafternoon, my GI driver drove me to the waterfront. The port was completely fenced in by barbed wire to keep out potential spies. A huge sign hung over the entrance gate: KILL HITLER, KILL MUSSOLINI. The sense of the battles being waged north of us in Italy was everywhere—in the water, in

the air, and on the docks. Soldiers, carrying their guns and heavy gear, marched down the gangplanks of destroyers and troop ships, jumped on camouflaged trucks and personnel carriers, and headed straight to the battlefields.

The driver helped me board the motor launch that would take me to the ship. A Navy lieutenant greeted me politely as I settled on the deck, surrounded on all sides by a seawall of ships.

"There she is! Your ship!" He pointed to a khaki-colored vessel with steel cables, lifeboats, huge tubs with gun emplacements, and a single black smoke-stack. "It's an Army troop transport, the *Henry Gibbins*," the lieutenant said. "It's loaded down. Your thousand refugees are up front, and in the rear—can you see it?—a thousand wounded soldiers going home to hospitals in the States. You're gonna be part of a big convoy."

He suddenly looked at me. "You can't climb a rope ladder in *that* outfit!" he said. He motioned to one of his sailors: "Go below, take off your pants, and get somebody to bring them up here fast."

I pulled the pants over the white skirt and awkwardly stepped onto the bottom rung of a rope ladder, clinging to it as it swung wildly. The ropes dug into my hands. The water below looked menacing. As I neared the top, a sailor leaned over, caught me under my arms, and hauled me up the ladder. A crowd of refugees rushed toward me. I heard a man shout, "It's Eleanor Roosevelt!"

Many of the men were in concentration camp pajamas; others were in threadbare shorts, naked to the waist. Some wore beach sandals. Several had wrapped their feet in cloth or newspapers. Many of the women were in ragged skirts and blouses; most of the children were barefoot. I could not stop looking at the children's eyes, sad and haunted.

The thirteen days and nights on the ship were filled with efforts to prepare the refugees for life in America. Knowing that I would have to report to Ickes, and through him to Roosevelt, I began interviewing and photographing the people. A middle-aged man, still wearing his camp pajamas, said, "We can't tell you what they did to us. It was too obscene, and you're a young woman."

"Forget, if you can, that I'm a woman," I told him. "You are the first witnesses coming to America. Through you, America will learn the truth of Hitler's crimes."

So, day after day, pacing the deck, they told me stories of courage, of terror,

of hiding in forests, caves, and sewers, of risking their lives to save others, of defying death. Often I had to stop writing and photographing, thinking, "I can't listen anymore." But I listened.

From them I learned that no person believes in his or her own death.

John Shea, the captain of the *Henry Gibbins,* told me that the commander of the entire convoy had received a message from Roosevelt: "If you are attacked, you must protect the ship of refugees."

Thirty Nazi planes flew over us and did not attack us. Nazi submarines detected our engines, but we escaped.

On a cold night at sea, standing alone on the blacked-out deck, I replayed their stories of horror in my head. There was Manya Hartmayer, a tall, graceful singer who had been in five concentration camps, running, starving, until she ended up in the French camp in Gurs. There was Doris (I Dorrit) Blumenkrantz-Schecter, who was five years old when, holding her father's hand and trailing her frightened mother and newborn baby sister, she ran barefoot across minefields to escape the Nazis, who had just entered the small town in Italy where her family was hiding. There was Abe Furmanski of Warsaw, with the look of a prizefighter, who described the torture he escaped in German-occupied France. "In closed trucks that were meant to hold twenty people, the Germans pushed a hundred or more. Quicklime was placed on the floor ten inches high. The doors were sealed tight so no air could escape. The people had to urinate. That started the lime cooking. The gas and fumes came up and choked them to death. The bodies were thrown into special ovens and burned."

With the stories rumbling through my head, I realized that from this moment on, my life would be inextricably bound with rescue and survival.

We reached New York Harbor on August 3, 1944. It was the very day that Anne Frank and her family were betrayed. And while we were bringing one thousand refugees to freedom in America, Adolf Eichmann was busy day and night sending 750,000 Jews from Hungary to Auschwitz in cattle cars. The Nazis knew they had lost the war in Europe, but they continued their war against the Jews.

From New York City, we traveled by train to Fort Ontario, a former Army camp located in Oswego, New York, closed in by a chain-link fence topped with barbed wire. The sight of the fence terrified some of the refugees. One of them

turned on me. "Mother Ruth, how could you do this to us? We escaped from such camps in Europe, and you bring us into the great America and put us in another camp?"

My efforts to explain that all Army camps in America are surrounded by a fence were failing when a woman said, "Don't let some of these people upset you. We're glad there's a fence. We feel safer inside."

The people lived inside the camp, with permission to go into town for six hours at a time, but they had no legal status. They were not prisoners of war. They were not enemy aliens. They were not immigrants with proper visas. They were "guests of the President," which gave them no rights at all. But the schools of Oswego opened their arms to the children, and these children brought America and the Bill of Rights into the camp.

Two days after Yom Kippur, Eleanor Roosevelt drove down from Lake Placid with her good friend Elinor Morgenthau, the wife of Henry Morgenthau, Jr.

The refugees welcomed her into their barracks. Several of us joined her for lunch and then escorted her to the auditorium, where our singers and performers entertained her. She was especially moved by Leo Mirkovíc, who had been the leading baritone singer of the Zagreb National Opera, and who sang *"Fee-gar-o, Fee-gar-o, Fee-gar-o"* with such gusto that she stood up to applaud. In her syndicated daily column, "My Day," Mrs. Roosevelt described Leo's singing: "An opera singer from Yugoslavia sang for us, and I have rarely enjoyed anything more."

After the performance, she climbed onto the stage. Even before she spoke, the people applauded enthusiastically. I saw her smile with gratitude. She spoke in English, and though most of the people could not understand a single word, they felt her compassion and caring. She ended her column that night: "Somehow you feel that if there is any compensation for suffering, it must someday bring them something beautiful in return for all the horrors they have lived through."

On April 12, 1945, word ran through the camp: the president is dead. The refugees went into mourning. They walked to the grounds of the old fort where two men raised the flag of the country they had grown to love. Their musicians played "The Star-Spangled Banner," and Leo Mirkovíc sang Sibelius's "Prayer

of Peace." The people wept and I wept with them. They were in America because of this American president. Their father, their protector, was dead.

As the Allied victory neared, a dark shadow fell over the refugees. They had signed a paper before boarding the ship in Naples promising that they would return to their countries of origin as soon as the war was over. They would have signed anything to escape the terror and the bombings in Europe. But to what would they be returning?

With help from people like Ickes and Eleanor Roosevelt, we fought the State Department, Justice Department, and Treasury Department, who were determined to send the refugees out of the country. Ickes told me, "We have to fight the bureaucrats." He sent me to New York several times to ask my friends on the *Times* and the *Herald Tribune* to write editorials explaining why these one thousand refugees should be allowed to stay. The editorials were strong, but the climate was still unchanged.

By November, with the war over, the people were beginning to panic. "Go back to the camp," Ickes told me, "and see what you can do to calm them." I left immediately.

As always, many greeted me with their theme song, "Don't Fence Me In." Artur Hirt, a former Polish judge, accosted me: "The paper we signed in Italy, that we would go back at the end of the war, doesn't hold. The Poland I would have to go back to is no longer Poland. My part of it is Russia. I don't want to go to Russia. I hate the Communists. I hate Stalin. Where should I go? I warn you, we can't hold out much longer."

Others told me, "We can't go back. Our wives are dead. Our husbands are dead. Our parents and our children are dead. The blood of our families is on the streets." The camp came together in the auditorium to hear my report on the stage:

> Some of you tell me you think you are forgotten. That is not true! Every day conferences are taking place, government officials are meeting, letters are being written from one branch of government to another. Your cause is being defended with all the eloquence and passion our friends can command.
>
> You have an important mission. You are the first DPs [Displaced

Persons] who were brought to this country. You are the vanguard. What the government decides should be done for you may influence what the world will do for hundreds of thousands of other DPs. Your struggle is their struggle, your agony their agony. Like you, they want the right to live in a land they dream of, with decency and dignity, without hunger and without fear.

We must not give up hope. My philosophy is that wherever there is a door, it can be opened. There are still a few doors. Let me assure you that every one of us who loves you and has faith in you is working tirelessly, day and night, to do two things: to shut the camp down so you can work, move around, and live as free human beings again; and to get you into the country legally under the quotas.

That day, at the Statue of Liberty, you told me the air of America smells like free air. Believe me, we want you to breathe it.

On December 23, as a Hanukkah and Christmas present, President Harry Truman announced on the radio that the refugees could stay. They were ecstatic.

Whether it was because of their culture or their love for education or their passion for America, the refugees gave back to America everything America gave them and more.

Dr. Alex Margulis, from Yugoslavia, who became chief of radiology at the University of California in San Francisco, helped create the CAT scan and saved thousands of lives. "Oswego," he told me, "was one of my most wonderful experiences. We young people were happy. It was an island of plenty."

Rolf Manfred, from Berlin, who was one of the creators of the nuclear-armed Minuteman missile carried by America's Polaris submarines, turned his back on these instruments of death, and was sent by our government to teach third-world countries the uses of energy for peace.

Leon Levitch, the pianist who organized the choir and accompanied the singers who performed in the camp, became a composer of orchestral and chamber music.

Leo Mirkovíc, the baritone from the Zagreb National Opera, became the cantor of the Brotherhood Synagogue on Manhattan's Gramercy Park.

Irene Danon, who came, like most of the others, penniless, is now a real estate tycoon in Los Angeles, a painter, and a poet.

Zdenka Ruchwarger Levy, who trained as a nurse in Yugoslavia, worked full-time on the ship coming to America, then served in a physician's office and is now married to David Levy, a salesman, whom she met on the *Henry Gibbins.* He was one of those who persuaded Eleanor Roosevelt to help open the college in Oswego to the camp's teenagers.

Margaret Spitzer Fisse became a teacher in the San Francisco schools.

Gloria Bass Fredkove, whose mother, Eva Bass, had an unforgettable voice, worked for years in legal offices as a legal secretary and sang in a synagogue choir.

Paul Arnstein worked in the U.S. Public Health Service as a veterinarian. "I feel," he reminisced, "that the Oswego experience should never be forgotten. We are one small group of people who were supposed to be exterminated in Europe, survived, and who came to America."

Paul Bokros worked as an electronics engineer in secret projects in the Department of Defense and in the conquest of space.

Eva Kaufman Dye, the daughter of the camp's official photographer, Branko Kaufman, became a schoolteacher in California.

Dr. David Hendell became a dentist and teacher at Columbia University and one of the pioneers in bonding teeth.

Edna Tusak Loehman taught environmental economics at Purdue University and traveled to Israel to develop water-sharing projects between Israelis and Palestinians.

Manya Breuer, who had been saved by nuns and who starred in every camp production, settled in Los Angeles, where she sang in operettas and became a consultant to art galleries. Manya often bursts into tears.

"But when I sing," she assured me, "I stop crying."

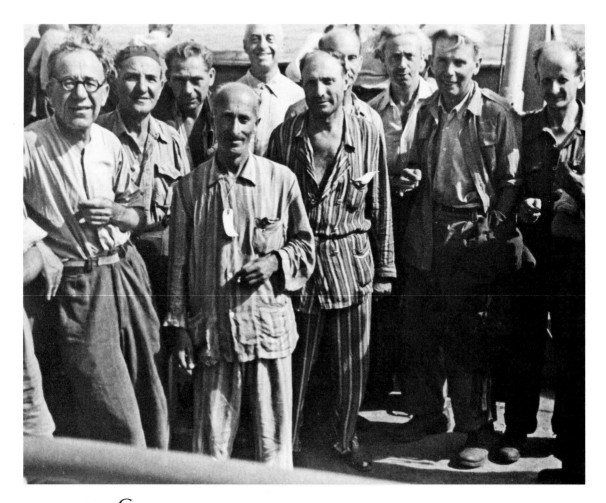

Climbing aboard the *Henry Gibbins*, I was greeted by a group of Holocaust survivors still in their concentration camp clothing. They had each been allowed to take only one small piece of baggage on board.

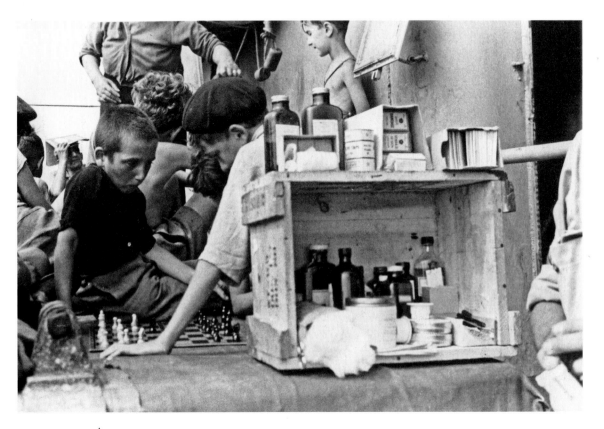

A kindly young medic improvised a pharmacy on the refugees' deck of the *Henry Gibbins*. He had pills and other medications for bellyaches, headaches, sunburn, scratches, and anxiety. We had a hospital on the ship with refugee doctors and nurses, but many of the passengers preferred the medic's sympathetic hands-on treatment. Even little boys found him so caring that they set up the chessboards we gave them alongside his outdoor pharmacy. Many of his pills were merely placebos, which many times worked better than the brand-name drugs. I often congratulated him on his steady stream of miraculous cures.

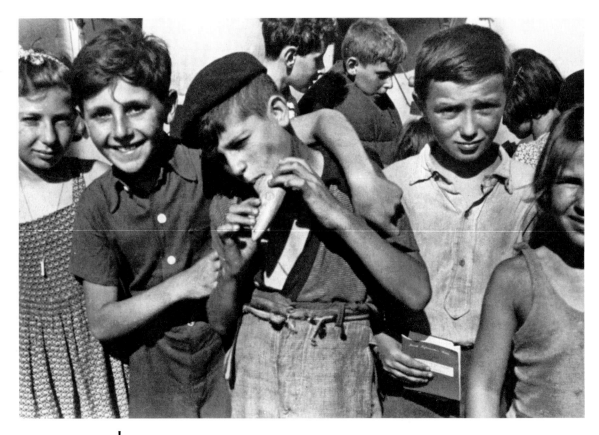

I couldn't help but take pictures of the children. Many were happy to have their photographs taken. They looked upon this voyage as a great adventure, but others were sad and brokenhearted. You could always tell who came with a family and who was an orphan. You read it in their eyes.

Mathilda Nitsch saved countless Jews from Yugoslavia. She was a Roman Catholic who ran a boardinghouse in Croatia, where she hid Jews, stole passports, and sent the Jews to her friends in Italy. She was caught and imprisoned in an ice cellar, where water dripped for ten days on her head, but she refused to betray the Jews she was hiding.

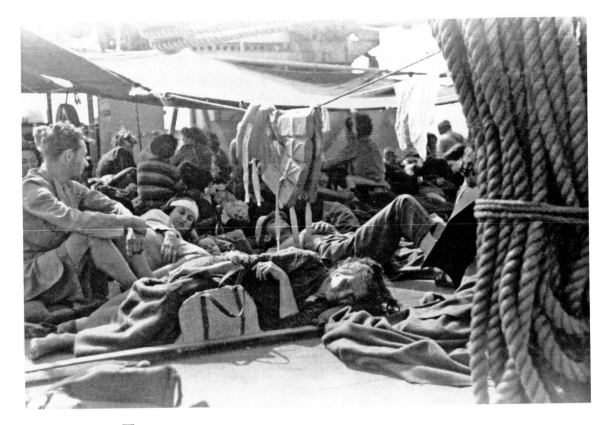

The Mediterranean sun was so oppressive that I asked the bosun to hang a
few tarpaulins to provide at least one shady spot on the deck.

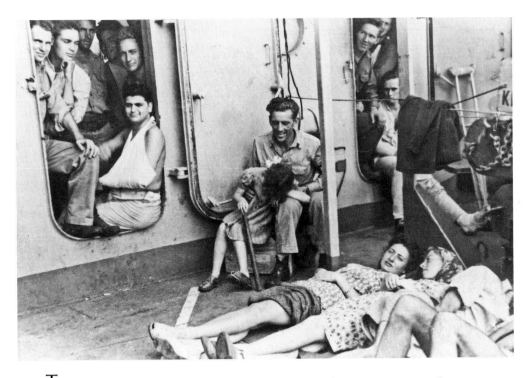

Two ships sailed on each side of us carrying Nazi and Fascist prisoners of war. The officer in command of the whole convoy was told that he must protect those ships as well as ours. Thirty Nazi planes flew over us, but did not attack us. Miracles were happening.

I stood on deck and asked one of the officers, "Why didn't they drop bombs on us? Why didn't they sink us?" He said, "Obviously, they had another mission."

When hysteria was mounting among the wounded soldiers who were blaming the refugees for the Nazi planes flying over us, one soldier called out, "Quiet everybody," and they were quiet for a little while. He later said to me, "I'm a Jew, and I want to tell you I'm proud of what you're doing."

I decided to show the soldiers who these refugees were. Once we were out of the Mediterranean and in the Atlantic, we put on a show for them. We had several gifted singers, some of whom had sung in Paris nightclubs. The soldiers saw those girls and began to yell, "Hubba hubba. Look at that tomato. Bring them back."

At the beginning of the voyage, the refugees and the American wounded were segregated on the ship. The captain of the *Henry Gibbins* warned me to prevent the crew and refugees from fraternizing. But after the show, the captain gave up. You couldn't keep the soldiers off our deck. They came every day, bringing cookies and chocolate for the children and Army jokes for our young women.

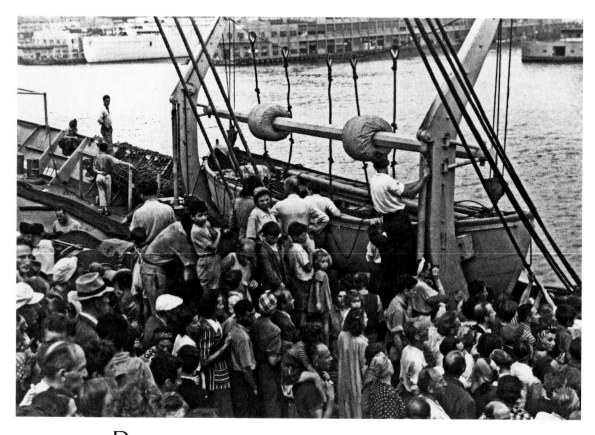

Day and night the refugees told me their stories. Some were reluctant to speak at first, but soon they began to pull me aside, determined to bear witness to the horrors that had been done to them. Listening to their stories of survival, I had an epiphany. I realized that for the rest of my life I would use my tools—my words and images—to fight injustice.

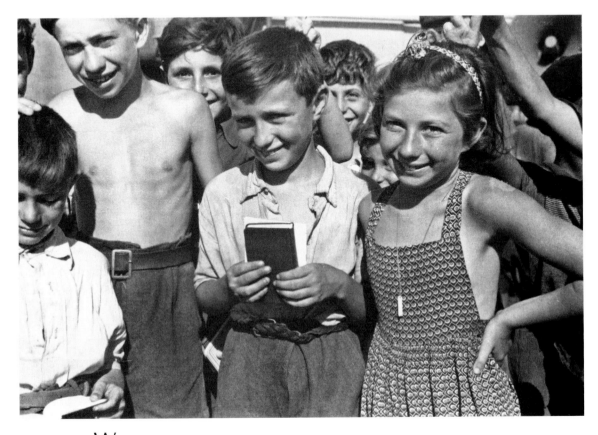

We gave children books in rudimentary English to prepare them for their new life in America. I felt the way to help the people was to teach them a little English, so the bosun hung up a big blackboard and I began writing on it. "How do you feel?" "I feel fine," they replied. I heard those words in eighteen accents even when they were leaning over the railings, seasick.

During one of my classes, an Army major in charge of the refugees warned me, "Tell the people that the name of the ship is top secret and they must never tell anyone where our ship came from." I followed orders and added my own interpretation. I instructed the refugees, "When you get to America you must tell everybody the name of the ship you sailed on is a secret. And when they ask, 'Where did you come from?' tell them you came from the North Pole." Months later I learned that when their teachers in America asked them what ship they came on, they all answered, "The name of the ship is *Secret*." And when asked, "Where do you come from?" they replied, "From the North Pole."

When the *Henry Gibbins* arrived in New York Harbor on August 3, 1944, one of our rabbis asked me if he could say a prayer. I said, "Of course."

He knelt down on the deck and kissed it. He prayed and we prayed with him. Then he said, "Now that we have reached the land of freedom, we must never believe the lies the Nazis tell about us, that wherever we go we bring evil. It's not true. We bring truth and we bring the blessings of the Torah. And now that we are here in this land of freedom, we must be filled not with hatred, but with love."

At home in Brooklyn, I called Ickes right away and said, "We've landed. Now I'd like to leave tomorrow morning for my office." "No, you better wait there," he said. "You know the refugees. I have another job for you. The Army insisted this mission was top secret, but the *Times* and the *Trib* and the *Washington Post* made such a fuss that the Army had to back down. They're going to hold a press conference, and you've got to run it."

The next morning, I taxied to the Empire State Building. Two men from the War Relocation Authority (WRA) were waiting for me.

"Pick out the refugees who should be interviewed," they told me.

"Get me a typewriter." I typed up the case histories from my notebook and had them mimeographed.

The refugees spent the night aboard the *Henry Gibbins*, sleepless with anticipation. The next morning, they were transferred to a boat to Hoboken, where the press was waiting. One by one I presented the refugees; they were terrified. They had never been interviewed in their lives.

Mathilda Nitsch said, "I don't know what to say."

I said, "Don't worry, Mathilda. Whatever you say, they'll love."

When we arrived at the Emergency Refugee Shelter at Fort Ontario in Oswego, each family was given a one-room renovated barrack and then told to come to a long table where they were given their first towel and bar of soap. One toilet and shower were at the end of every hall. I arranged for volunteers from the National Council of Jewish Women to sew shower curtains to give the people some privacy, something many had not known for over a decade. Their meals were cooked in large kitchens. Because it was a government project, it had to be ecumenical. The refugees spent their first month in quarantine while the Army interrogated them. They remained at Fort Ontario for eighteen months.

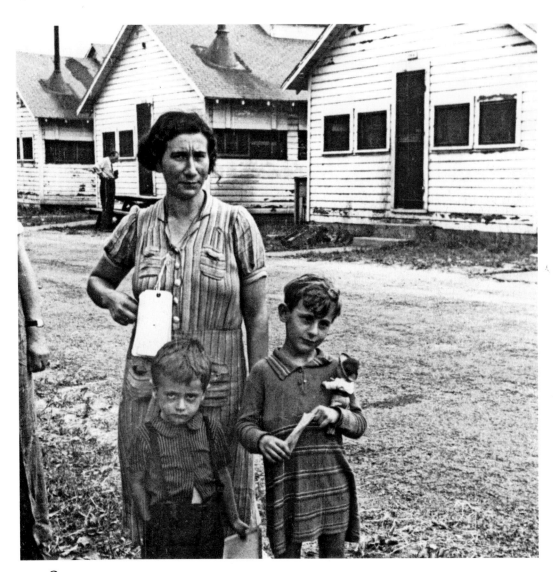

Sarah Frajerman stood with her son and daughter outside their barracks, wearing the ID label the Army had given each adult aboard the *Henry Gibbins*. The labels were marked "casual baggage."

Sarah told me, "Bedsheets! Imagine having bedsheets for the first time in years!" She later gave birth in the camp to her fourth child, Harry. The life juices that for many of the women had dried up in the concentration camps returned at Oswego.

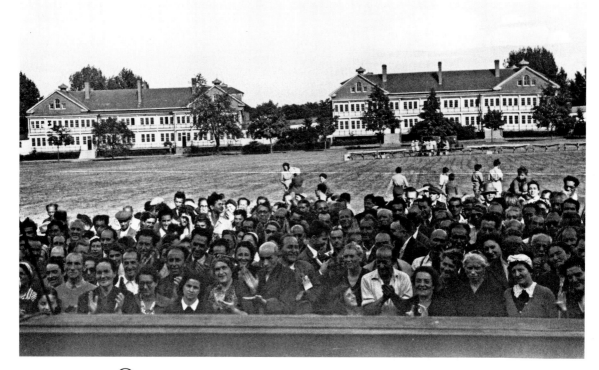

Only the press and government officials were allowed in the camp during a monthlong quarantine. Once the quarantine was over, Dillon Myer, the head of the WRA, came with other Washington officials to deliver welcoming speeches. Myer asked me to be one of the speakers.

Many of the refugees smiled at me as I took their pictures from the platform.

The Anglo-American
Committee of Inquiry on Palestine
and the Nuremberg Trials

1946

With the war over in Europe, the newspapers began printing photographs of skeletal survivors, their faces ravaged with hunger and fright, their sunken eyes reflecting the evil they had witnessed. Why didn't we know during the war that six million Jews were being murdered? Why was the story hidden by *The New York Times* and all the periodicals that followed its lead? Why could they print on their front page a story of a child falling down a well, while on a back page in one or two obscure paragraphs, the note that 90,000 Jews were murdered within one day in Poland?

To ease the pain and guilt of having done little or nothing, some found comfort in believing that as soon as the camps were liberated, the survivors rushed out and tore down the cynical sign *Arbeit macht frei* (Work Makes You Free).

That is not what happened at all. Those survivors who were able to walk either hitchhiked or caught a train to return to their former homes. But the ghosts of their families hovered over the streets. Too often, when they knocked on their own doors, they were greeted by a neighbor who had moved in and was carrying a shotgun. "What? Are you still alive? Why didn't they burn you or turn you into soap?"

In Kielce, Poland, forty-two survivors returned home and all of them were murdered.

So the Jews of the Holocaust learned that they could no longer live in

the homes and the lands they had once loved. Thousands made their way back to their former enemy, Germany, to find refuge in the DP (Displaced Persons) camps run by UNRRA (United Nations Relief and Rehabilitation Administration).

They had a new dream. They knew American soldiers and social workers were running those camps, and they believed that Americans would help them get to Palestine.* But the way to the Holy Land was blocked by Britain, which refused to give visas to most of the Holocaust survivors.

It was one of the ironies of history. In 1922, after the Great War, the League of Nations gave Britain the mandate to govern Palestine and to help establish it as a national home for the Jewish people. After Hitler came to power in 1933, Britain allowed thousands of German Jews to take refuge in the Holy Land.

Then, when Arabs attacked not only Jews but the British soldiers serving in Palestine as well, Britain sent one of its best Army officers, Gen. Charles Orde Wingate, to suppress the Arab riots. But as Britain's need for Arab oil grew, the policy of the Foreign Office changed. In 1939, just as Hitler shut all escape routes from Germany, the British government issued a White Paper. Its purpose was to limit Jewish immigration into Palestine during the next five years, then end it.

The Foreign Office's pro-Arab policy continued even after the war ended. Holocaust survivors, hoping to reach Palestine, dreaming of "going home," found the way blocked by British warships. Defying the British from 1945 to 1948, nearly half a million made their way to the DP camps in Germany and Austria. In the rush to set up camps for them, the U.S. military commandeered former Nazi concentration camps, death camps, slave labor camps, and even SS stables. President Harry Truman, learning of the sordid, overcrowded conditions, sent Earl G. Harrison, dean of law at the University of Pennsylvania and an expert on refugees, to investigate.

In Germany, Harrison was shocked to see twenty or thirty Jewish DPs sleeping in one room on bunks of straw on which thousands of Jews had slept before they were burned in the ovens. Harrison told Truman that some American soldiers were treating the Holocaust survivors much the way the Germans had

* The holy land now called Israel, was then called Palestine.

treated the Jews. The only difference, he said, was that we weren't murdering them.

Harrison's report was so devastating that Truman asked Ernest Bevin, Britain's foreign minister, to allow 100,000 Holocaust survivors to enter Palestine. Bevin could not afford to turn the president down. The British needed American help. Britain's economy had been devastated by the war. So Bevin did what government officials often do: he said, "Let's form a committee." Truman agreed.

The Anglo-American Committee of Inquiry on Palestine was formed, consisting of six Americans chosen by Truman and six British chosen by Bevin. Truman exacted a promise from Bevin: if the committee voted unanimously to allow 100,000 Jews to enter Palestine, Bevin would agree.

Ted Thackrey, the editor in chief of the *New York Post* and the husband of Dorothy Schiff, owner of the paper, telephoned me. "Ruth, I would like you to accompany the committee as our foreign correspondent. Will you do it?"

I said I would be delighted, but I had to check with my boss, Secretary Ickes. When I asked Ickes, he shook his head: "No, I need you here."

"As long as you need me, Mr. Secretary, I'll stay."

But Thackrey was adamant. "I'm not giving up. You know Washington. The American members of the committee will need all the help you can give them. You know the problems of refugees. You are the one to do this job. I'm going to work on Ickes."

On January 21, 1946, Ickes called me to his office. "I was wrong," he said. "You must go. You owe it to your people."

I called Helen Reid at the *Herald Tribune:* "The *New York Post* has asked me to cover the Anglo-American committee for them. I want to know if my going for them will affect my relationship with the *Trib.*" I had been thinking of returning to the *Herald Tribune* after I left the government.

"It won't affect our relationship at all," Helen said. "This is the story that the *Post* has made its own. I'm glad you're doing it for them, but you are definitely still in our family."

For the next four months I traveled with the committee through Europe, the Holy Land, and the Arab world, taking photographs, cabling articles, and spending sleepless nights after listening to the survivors' stories of torture and

murder. In one DP camp a distraught woman took my arm and said, "You are the only woman traveling with these men. I feel I can talk to you. I saw my husband burned. I don't want to be burned. I want to live—in the Holy Land."

"That's why we're here," I said. "But if, Heaven forbid, we fail to get the doors of Palestine open for you, where would you want to go?"

"To the crematorium."

In each camp, there was always one question the committee asked: "Why do you want to go to Palestine? It's a poor country. There's so much fighting going on."

A teenage orphan gave us the most poignant answer. "Everyone has a home. The British have a home. The Americans have a home. The Russians have a home. Only we don't have a home. Don't ask us. Ask the world."

In February 1946, while we were in Frankfurt, with the help of the Army I found my younger brother, Irving, a dentist, serving as a captain in charge of a medical unit under Gen. George Patton. He had been sleeping in a tent one night when a Nazi plane dropped a bomb on the bed of the officer sleeping next to him and killed him.

The Army apparently found Irving's services so useful that they prolonged his tour of duty, though most of our troops were already on their way home. He was heartsick. Before leaving for the war, he had married the woman he loved, Fannie Davis, and he was counting the days until they could be reunited.

Bartley Crum, the crusading San Francisco lawyer on the committee, invited Irving to join us on our way to the Nuremberg War Crimes Trial, the "trial of the century."

Inside the Palace of Justice, I pulled my Army coat tightly around me, shivering, as I sat between Bartley and Irving in the front row of the VIP gallery. The brightly lit courtroom was packed with dozens of men and a handful of women, while the judges, representing Britain, France, the Soviet Union, and the United States, sat at the judges' table with the flags of their countries behind them. There was an air of apprehension in the room. We waited impatiently for the prisoners to enter the dock.

Finally, Hermann Goering, the former head of the Luftwaffe, Hitler's air force, goose-stepped in. He was wearing his blue uniform, stripped of all his medals, as pompous as if he had won the war. Twenty others, following him,

took seats in two rows in the wooden dock cordoned off from us with a red rope. Behind each defendant in the second row, stood an American soldier wearing a white helmet, on guard for potential action.

The sight of Julius Streicher, chewing gum, smirking, and looking bored, sickened me. He was the editor of the Nazi rag *Der Stürmer,* which had disseminated lurid anti-Semitic propaganda for years.

It seemed fitting, I thought, that this international military tribunal was convening in Nuremberg. As an exchange graduate student in Germany in 1932, I had been enchanted by this ancient town, especially by its Glockenspiel, the famous town clock with its lovely chimes and figures that danced around on a platform.

It was here that Hitler had promulgated the 1935 Nuremberg Laws, which deprived Jews of their citizenship, their professions, their businesses, and their jobs. Jewish children could no longer attend school. The Nuremberg Laws were the beginning of the end of Jewish life in Germany. Now Nuremberg lay in rubble, as if our pilots had been making a statement by destroying the city Hitler had made the center of his evil kingdom.

During a pause in the trial, we were taken to a screening room in the palace. Here, we sat in silence watching the films of naked bodies piled on top of each other, of huge ovens in which bodies had been burned, of the nooses in which Jews had been hanged. Supreme Court Justice Robert Jackson, the chief U.S. prosecutor, had described the horror of these films in his opening statement on November 21, 1945:

> We will show you these concentration camps in motion pictures, just as the Allied armies found them when they arrived, and the measures General Eisenhower had to take to clean them up. Our proof will be disgusting, and you will say I have robbed you of your sleep. But these are the things which have turned the stomach of the world and set every civilized hand against Nazi Germany.

I was still shaking when we returned to the trial to watch the defendants picking their noses and ears and scratching their chests. Goering kept yawning, like one of his pet lions. I clutched my brother's hand and whispered, "I wish we were closer and I had a gun."

My anger rose in my throat when we were taken on a tour of the jail. The cells filled two sides of a long gallery. A helmeted soldier, with no apparent weapon, stood at the door of each cell, even while the defendants ate a lunch provided under the laws of the Geneva Convention. The doors themselves were not iron-barred but looked like solid metal, with a square window set in each one. We were told the guards were ordered not to turn their gaze away from the windows for even a few seconds lest a prisoner try to commit suicide.

Looking through one of the windows, I could see an Army cot covered with an Army blanket and a toilet in a small alcove. Their laundry was done for them, and their uniforms were carefully pressed, every day. To while away the time, they were given a choice of eight hundred books.

"Compare these accommodations," Bartley muttered bitterly, "with the conditions we've been seeing in the DP camps."

Nearly every one of these defendants was condemned to death by hanging. Goering avoided the noose by swallowing a cyanide pill. Heinrich Himmler—head of the Gestapo and the architect of the extermination camps—had averted even standing trial in Nuremberg, also by swallowing a cyanide pill.

We left Germany and began traveling through the Middle East. Here I encountered two of my worst frustrations as a journalist. A reporter's mission is to get the story, and twice I failed.

In Jerusalem, traveling with the committee, I learned that a subcommittee was going to Baghdad and planning to fly from there to Saudi Arabia. It was an important subcommittee made up of two British and one American—Sir John Singleton, the British chairman of the committee, Harold Beeley, the British secretary, and Frank Buxton, the American editor of the *Boston Herald*.

Determined to cover their work and learn how the monarch of Iraq and the king of Saudi Arabia looked upon the Arab-Jewish problems in Palestine, I left Jerusalem by bus for Baghdad, and registered in the hotel where the men were staying.

An hour later, walking through the lobby, I was stopped by a blond-haired, blue-eyed man. "I am a Kurd," the man said. "I can see from your camera and notebook that you are a journalist. May I talk to you?"

"Of course," I said. We found seats in the dining room and ordered coffee. He spoke in English and watched me record his words in my notebook as he talked with urgency.

> Every promise this Iraqi government has made to the Kurds has been broken. We are a proud people, and since the beginning of history, we have always been fearless and independent. Now in many ways, we are a minority without a state, treated like second-class citizens. Our children cannot learn our language in schools; our literature is not taught. We live in other countries, too. In Iran alone, there are about 750,000 Kurds, and all together we are about four million.
>
> We live in the richest area—it's Iraq's oil—yet we get nothing from the land we inhabit, from the wealth of our own country. We just pay taxes. We are victims of the "oil curse." Everyone, even in foreign countries, benefits from our wealth except us.

Still troubled by his bleak words, I said good-bye and left to interview the Saudi Arabian consul in Baghdad. I told him I was traveling with the Anglo-American committee and wanted to be with them in Saudi Arabia.

"We'll be happy to have you," he said.

I handed him my passport, pleased that it had been so easy to get a visa. I could feel joy and anticipation rise through my body as I watched him stamp the picturesque Arabic visa in my passport.

"What about accommodations?" I asked.

"You would stay with the women in the sultan's harem," he said as if it were obvious. I nodded, but did not permit myself to respond. He went on, "I suggest you buy an *aba*—that's a long robe—and a *yashmak,* to cover your face."

Clutching my purse containing the precious visa, I shook his hand, thanked him, and made my way by foot to Baghdad's Jewish quarter to interview Rabbi Sassoon Khadouri, Iraq's chief rabbi. His office was inside a large courtyard. I climbed a flight of rickety stairs and knocked on his door.

The rabbi himself opened it and greeted me. He was robed like a monarch in a medieval drama. Vastly overweight, he wore a long gray dressing gown with a wide paisley sash and a matching turban. His stomach pushed through the dressing gown.

He motioned for me to enter and sit facing him as he walked to his desk

and introduced his son, Dr. Meir Sassoon, a slim twenty-four-year-old who spoke fluent British-accented English and who sat beside him, acting as our interpreter.

Rabbi Sassoon opened the meeting with a benign, fatherly smile. "Tell me all your questions at once."

I had a long list in my notebook, but I sensed I should ask only a few. What did he think of the Jews of Iraq trying to get to Palestine? How were Jews treated here? What did he think of Holocaust survivors breaking their way through the British blockade of warships to enter the Holy Land?

He stroked his chin. "I have met many foreigners, but no one has asked me better questions than you."

He did not answer a single one. Instead he said, "The meeting is over. My son will show you around Baghdad."

He blessed me as we left. It was the first of my two failures to get a story.

On the street, Dr. Sassoon whispered, "We'll soon be followed. Watch what you say very carefully. Don't say anything provocative. The Jews are not safe here. My sister is already in Jerusalem, and I hope to get there very soon. My father is opposed to Jews entering Palestine. He will stay here—this is his job—but the rest of us are making plans."

Dr. Sassoon was an excellent guide. He showed me the villas of the wealthy and the hovels of the poor. There were Jews in Iraq in 1946 who had power and wealth. One of them was even the finance minister. But in the Jewish ghetto, beggars held their hands out for money. Many, blind, crippled, in clothes made of tattered burlap, looked as if they had not eaten for days. *This land*, I thought, *was once the cradle of civilization.*

I told Dr. Sassoon I needed to buy clothes for Saudi Arabia. "No problem," he said, leading me to the Baghdad marketplace. In a crowded booth with gowns of all sizes hanging on a rack, I found a long black silk *aba* and a *yashmak*. Together, they cost a little over eighty dollars.

Back at the hotel I said good-bye to Dr. Sassoon.

"I hope to see you again," he said, quoting the line we sing at Passover. "Next year in Jerusalem."

The words had never had so much meaning to me.

Using the phone in the lobby, I called Harold Beeley, the secretary of the committee, and asked him to meet me. He came down. "So you followed us here?" Amazement distorted his face.

"I want to tell you I have a visa to Saudi Arabia. I would like to fly there with the three members of the committee and with you."

Beeley, who was Foreign Minister Ernest Bevin's chief Arabist, blinked his eyes and stuttered whenever he grew excited. "W-w-what? Y-y-you have a visa to S-Saudi Arabia? How in the world did you get it?"

"It was no problem. The Saudi Arabian consul here gave it to me."

"S-s-stay here," he said. "I-I-I must speak to Sir John."

While waiting in the lobby, I thought that in all the months of traveling with the committee, I had never been able to get an interview with Sir John Singleton. I knew that he and Judge Joseph Hutcheson, the American chairman, were constantly battling. In one of my interviews with Hutcheson, he told me that Sir John was so cruel that when he had served in Ireland he was known as the "Hanging Judge."

About half an hour later, Sir John stood over me, looking, I swear, as if he wished he had a knife in his hand. "Don't you know," he shouted, "that no women are allowed to enter Saudi Arabia?"

His voice was so strident that nearly everyone in the lobby stared at him.

I opened my purse, pulled out my passport, and showed him my visa. He pushed it aside. "I am in charge here, and I say you will not go! I simply will not allow you aboard our plane."

I hardly recognized my own voice, filled with anger and disbelief. "By whose authority?"

"By mine!" He turned on his heel and stomped toward the elevator.

In my room, fully clothed, I fell on my bed. It was my second failure in Baghdad. I remembered the cold, pompous, almost sadistic way Sir John had interrogated the Holocaust survivors while we were in the DP camps in Germany. I realized now I was everything he despised—an American, a Jew, and a woman. All that night I berated myself for not having been able to win him over. Why hadn't I gone to the plane and tried to force myself onto it? What would I have done if he had called a security guard to pull me off or perhaps throw me into

jail? Why hadn't I at least tried? It was useless, I knew, to cry over spilt milk, but it was a lesson I would carry for the rest of my life. If you feel passionate about something, let no obstacle stop you.

Months later, Frank Buxton wrote me an apology from Boston: "I will never forgive myself for not having fought Sir John and gotten you on our plane, a twenty-passenger plane with fifteen empty seats. I was especially furious when I learned that we were paying for it; it was an American plane."

The four months of travel were winding down. After amassing stacks of testimony, the twelve-member committee wound up in Lausanne, Switzerland, to write their report. I stayed in daily contact with them, while they argued, fought, and tried to influence one another. Judge Hutcheson told me he was so irritated by Sir John's obstinacy that he demanded, "Is you is, or is you ain't, with us!" Sir John finally agreed, and in the end, the committee voted unanimously to open the doors of Palestine to 100,000 DPs.

Truman was elated. In Palestine, thousands of Jews rushed into the streets, dancing with joy. The DP survivors were coming home to the promised land.

Their celebration lasted barely three days. Bevin had read the committee's report and denounced it, saying, in effect, "Over my dead body."

David Ben-Gurion refused to take defeat. He continued his fight to open the Holy Land not only to survivors of the Holocaust but also to any Jew who wanted to enter. My first meeting with Ben-Gurion was in 1946 at the YMCA in Jerusalem when he testified before the committee, but our friendship began when I interviewed him in New York City in the summer of 1947. He was staying at Hotel 14, the building that housed the Copacabana nightclub. The day was one of the hottest that summer, so I wore a black cotton shift. Ben-Gurion greeted me sharply. "Why are you wearing black? Are you mourning somebody?"

"Mr. Ben-Gurion, this is the coolest dress I have." It amused me that this strong labor leader, who was focused on opening Palestine, should even notice what I was wearing.

"Well, don't wear black anymore, unless somebody has died," he warned me.

A few days later I went to see him again, not in black, and brought the printed interview. Before even looking at it he said, "Some of my friends have

read it and they like it, but they didn't like your putting in that stuff about your black dress. Why did you do it?"

"Because I thought it was a funny story."

He brushed me aside. I watched as he read the opening paragraph: " 'There is a man in our town today who is to the Jews of Palestine what Abraham Lincoln was to our people in the midst of the Civil War.' "

He had a high voice, but now, as he jumped up from the sofa, he shrieked, "How can you say I am like Abraham Lincoln? When I think of a great leader, I think of Lincoln. Who am I? 'A little Jew.' "

"Not to your people," I said softly.

He continued reading the article. Then he turned to me and said, "I want you to do me a favor. Take me to some bookstores, and help me find books in Greek—I'm studying Greek now."

"Why Greek?" I asked him. It seemed pretty daunting for a man preoccupied with establishing a nation to be studying Greek.

"I want to read the Greek classics in the original," he answered. "There's a saying, 'To read a book in translation is like kissing a woman through a veil.' "

"My second request," he said, "is I want you to buy every available book on Abraham Lincoln." We spent the next hours running from bookstore to bookstore and purchasing everything on Lincoln we could find. We did not find many books in Greek in New York. But the books on Lincoln filled one of his suitcases.

Several times a year I returned to Palestine and became one of the few journalists to whom he always granted an interview. I was prepared to sit at his feet, but every time I spoke with him, he would turn the tables and interview me about the political picture in America.

Of all the world's leaders, I found Ben-Gurion to be the most prophetic. In the months that followed, I witnessed his passionate struggle to keep the doors of the Holy Land open to scores of hunted and displaced people. His words frequently sent me back to the Bible to find the truth and beauty of my Jewish heritage. Because of his courage in facing down his enemies, he inspired me to record, in words and pictures, as clearly and simply as I could, the truth of whatever I was witnessing, no matter how controversial it might be.

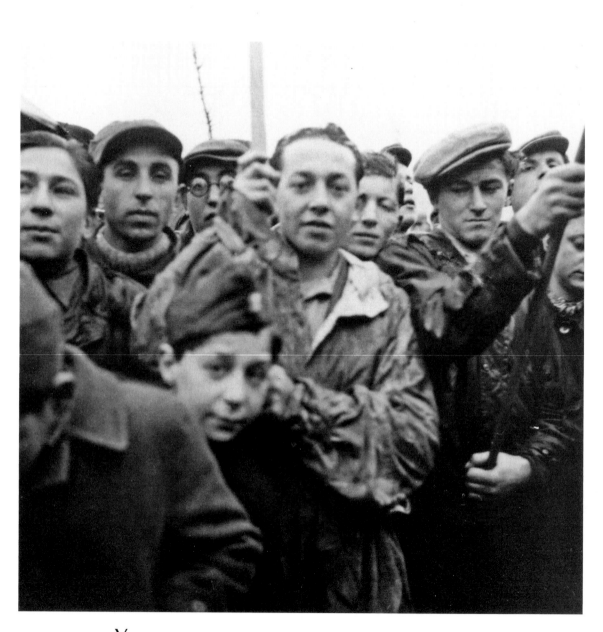

Young people in a DP camp in Germany, 1946, most of them orphans, greet the Anglo-American Committee with hope that the committee will help them make their way to the Holy Land. My camera was like a magnet for the orphaned children. As soon as I focused on a small group, others rushed to join us. Each image contained some faces of hope, but far more displayed eyes shadowed with sadness.

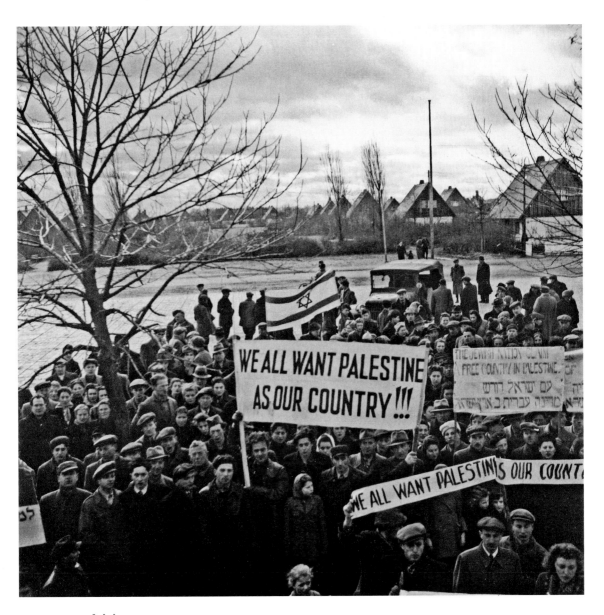

Wherever we went the people greeted us with passionate signs. In January 1946, the refugees in each DP camp that we visited raised banners, telling us of their determination to find a home in Palestine.

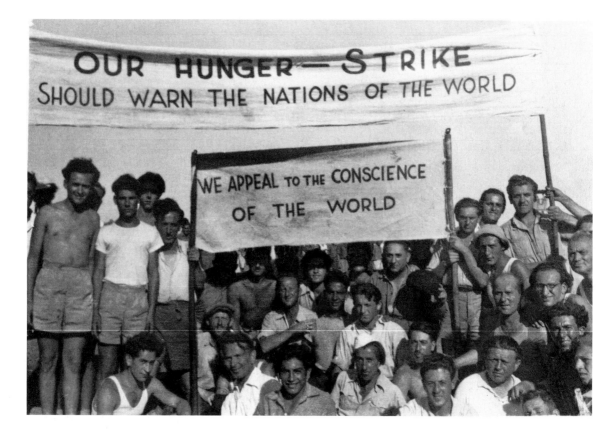

In the DP camps, refugees would often tell me they were planning a hunger strike so I would tell the world about them. They told me stories of horror, explaining why they had to have a home.

When I got back to New York, the first person who wanted me to tell those stories at her dinner parties was Helen Rogers Reid. I was shocked when Richard Kluger, in his book *The Paper,* called Helen an anti-Semite.

I was asked to counter Kluger, who was discussing his book at the Overseas Press Club. "No anti-Semite," I said, "would have made a secret trip to Paris to meet with Britain's foreign minister Ernest Bevin. 'You must let the people out of your camps,' she told him. 'After what they have been through, to keep them in your prisons!' "

Bevin's answer was "I'm deeply honored by your visit, but these people are all illegals. They're acting against the laws."

Helen said, "They're only illegals according to your White Paper, and the only country that accepted your White Paper was Pakistan."

Bevin refused to help her.

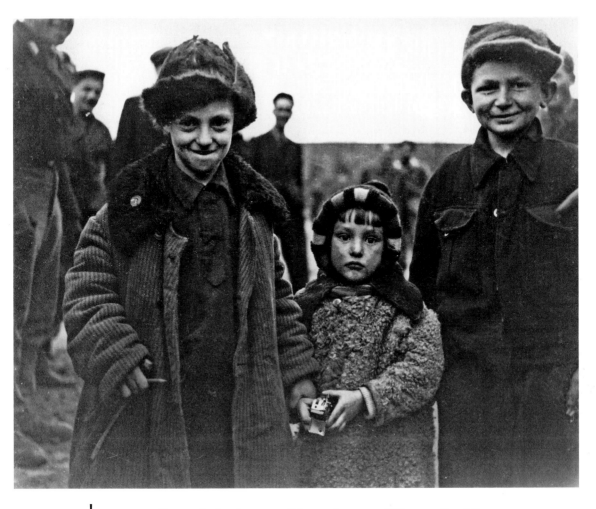

I was especially caught by the eyes of the orphans at a DP camp for children in Leipheim, near Munich, in 1946. It was in a former SS barracks. The word "orphanage" was verboten. The orphans were put in "children's homes." Children of nine or eleven became the parents and guardians of the six- and seven-year-olds. Some of the children looked brave and confident, while others seemed terrified. This little girl's eyes carried the images of the horrors they had witnessed. A few of the children held out their arms to me; I embraced them, holding them close to me. I didn't know who needed to be hugged more, they or I.

Munich, 1946. I first went to Munich on Christmas day 1931. The American exchange students in Germany were all invited by the State Department to a ski lodge in Hitler's favorite vacation spot, Berchtesgaden. I was working on my doctoral dissertation on Virginia Woolf and took it with me on the train from Cologne, together with a copy of Hitler's autobiography, *Mein Kampf*. Hitler was not yet in power, but his book was in the window of every bookstore. A State Department official invited the American exchange students to dinner with local townsfolk. I found myself seated next to a Bavarian in his late thirties whose beer stein was never empty. After several drinks, he put his arm around my waist. I promptly removed it. He then declaimed in a loud voice, "I hate Americans and I hate Jews." I stood up furious. "I will not allow you to insult my country and my faith." I picked up my purse and stormed out.

I was followed, not by the drunken racist, but by the State Department official. Livid with anger, he grabbed my elbow in the hall and said, "You go right back into that restaurant and apologize to that man!"

"What?" I freed myself. "You want me to apologize to a rude, drunken man who insults my country and my religion? He should apologize to me!"

"We are their guests," he sputtered. "And you represent America."

I did not wait for the rest of his diatribe. He was scolding me as if I were a child. I ran upstairs to my bedroom. It was freezing. I called downstairs to the concierge to send something to warm my feet. He sent up a hot brick, wrapped in a towel. Unable to sleep, I wrapped myself in my coat and left the next morning.

Fifteen years later, in January 1946, I returned to Munich with the Anglo-American Committee.

Munich had once been a beautiful city. Lovely shops and thriving businesses had filled the streets. Now it lay in ruins from the war Germany had started. I could only think of the babies and the other children who had been murdered in the nearby concentration camp, Dachau.

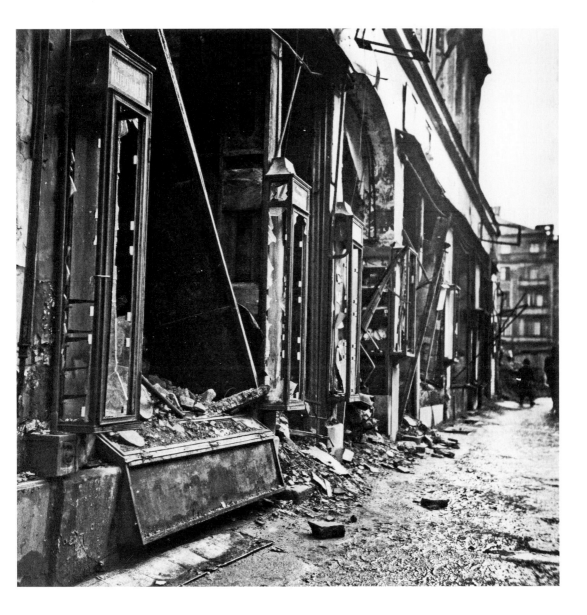

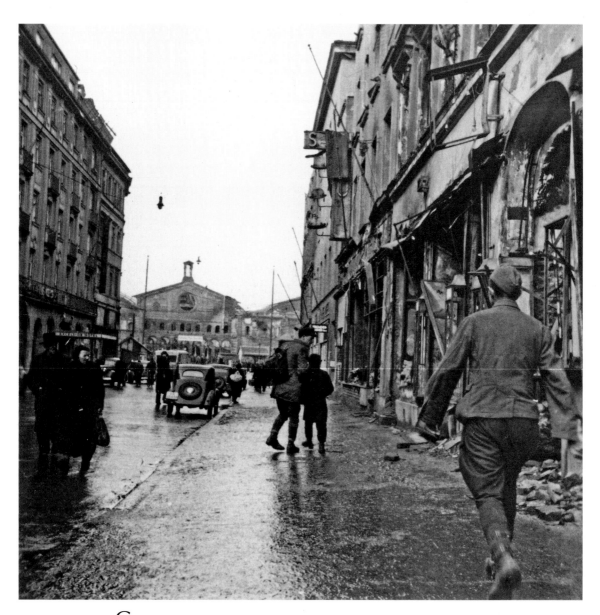

Germans struggled to reconstruct their lives after Allied bombs ripped Munich apart.

Traveling with the Anglo-American Committee, I went from Munich to Dachau, one of the Nazis' first concentration camps and killing centers. When we first got to Germany and I saw the devastation our pilots had done, I thought, "Why did we do so much damage?" But after a few days in Munich, and listening to the testimony of surviving victims, I looked at the devastation differently. If there was one building standing on this German street, I wondered why the pilots hadn't destroyed that one too.

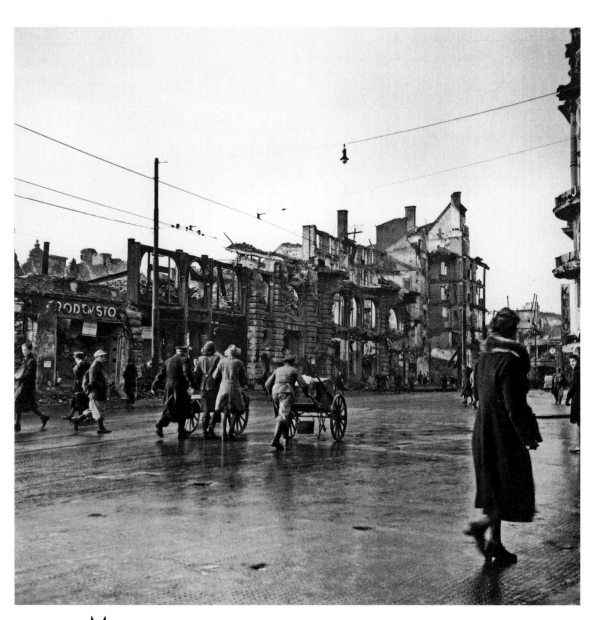

Munich, 1946. Germany was divided into four Allied-occupied zones at the time, and we were interested primarily in visiting the American and British ones. Survivors of the Holocaust began filling up the DP camps while the people of Munich scrounged for food and shelter amid the rubble. Seeing women walking around in their expensive winter coats, I couldn't help wondering if those coats had been pulled off the backs of dead Jews.

At Tyre, in Lebanon, the committee members enjoyed the sights of young Arab boys watching us. We interviewed Arab leaders who were determined to keep Jews out of Palestine. The pashas welcomed us with sumptuous banquets. The tables were piled high with lamb, sheep's eyes, and other food I didn't recognize. When no one watched I slipped the food into my tote bag.

After dinner, they played music, jazz, and even a Viennese waltz. Several young Arab men drew me onto the dance floor. One of them said, "You see how easily we get along. We're cousins, Arabs and Jews."

Sir John Singleton, the British chairman of the Anglo-American Committee of Inquiry, kept saying, "We don't want to open those doors in Palestine; we don't want Jews in there."

Haifa, 1946. We spent days interviewing Arabs and Jews. The town's citizens were famous for the harmonious way they lived together, shopped together, and even voted together.

Haifa was the industrial center of the country. I always thought of it, with its big oil tanks and industries, as the morning city. Tel Aviv was the noonday city: crowded, busy, people running back and forth. Jerusalem was the sunset city. The sun seemed to set from inside those beautiful stone walls.

I brought Helen Rogers Reid to Haifa, and its mayor, Abba Hushy, came to take us around. Helen wanted to know how they voted—it was election time. So he showed us what he was doing in that city.

Most people thought that the Arabs would stay in the city during the War of Independence, but their leaders said, "Leave Haifa. We'll bring you back with a victorious Arab Army, and you'll control the city."

And they left. They believed their leaders.

Gerold Frank, the prolific writer and biographer, was one of the journalists who covered the Anglo-American Committee's travels for the Overseas News Agency.

Although I was one of the few women in the press corps, I rarely encountered gender discrimination. Not only did we read one another's stories, we also often worked together and shared information.

There were a few resentments held against me as a woman journalist, however. Some of the male journalists were jealous that I was able to make friendships easily with the leaders. One day in the Government Press Office in Jerusalem I was approached by Moshe Sharett, who would become Israel's first foreign minister, and asked if I would join him and his family for dinner that night. After he left, one of the French correspondents confronted me: "What scoop did he give you?"

"He invited me to meet his wife and children at dinner," I replied. "That's what you say; I don't believe it." I simply shrugged my shoulders. Fortunately, these incidents rarely happened.

Arabs and Jews walked and worked peacefully together in Jerusalem in
1946. I hoped that the two peoples that inhabited this tiny land could help
each other build it.

With members of the Anglo-American Committee and a few of their staff, I visited Cairo in 1946. The meetings were held at the elegant Mena House, where President Franklin D. Roosevelt, Winston Churchill, and Chiang Kai-shek had held a summit during the war. Only Arab leaders came to testify.

Bartley Crum, the most charismatic American of the committee, learned later that King Farouk had summoned the Jewish leaders, including the chief rabbi, and had warned them that it would be wiser for them not to testify. All the Arabs' speeches had the same theme: Palestine should *not* be opened for 100,000 Jewish DPs.

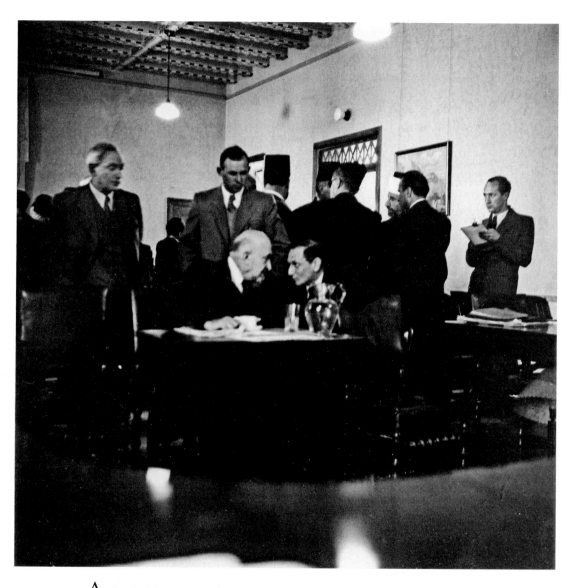

At the YMCA in Jerusalem, Dr. Chaim Weizmann *(seated; left)*, who later became Israel's first president, held a head-to-head conversation with David Horowitz, later Israel's chief economist. Dr. Weizmann was the first leader to appear before the committee.

"We warned you, gentlemen," Dr. Weizmann said passionately. "We told you that the first flames that licked at the synagogues of Berlin would set fire, in time, to all the world."

Each day in Jerusalem, foreign correspondents had to appear at the government press office for a new press card. When we complained of this time-wasting order, we were told that if we lost the press card and a terrorist found it, he could enter the YMCA and kill us. We doubted their excuse,

convinced that it was another way for the British to learn what we were cabling to our papers.

Chaim Weizmann was the official head of the Jewish community in Palestine, the one the world recognized as the leader. He was old and frail and nearly blind, but he was eloquent, and he had a brain like a ballerina's toes. He was witty. He was always correcting me because I drank weak tea. "She takes a rag, she runs it through a glass of hot water, and she calls it tea. What she needs is *krepke chai*"—in Russian, strong tea.

He said to the committee, "Europe is burning. If you let it burn, it will burn all over." He was predicting what would happen if war were to occur. He was so brilliantly eloquent that the reporters stopped taking notes and just listened.

He persuaded Truman to include the Negev when the UN debated partitioning Palestine—the Negev was Israel's future.

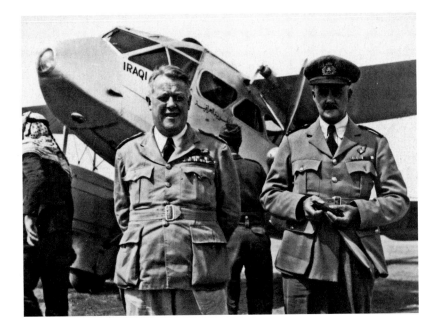

Iraq, 1946. A British pilot and copilot flew some members of the Anglo-American Committee from Jerusalem to Baghdad. I followed them to Baghdad, but was barred from boarding the plane that took them to Saudi Arabia.

David Ben-Gurion, then head of the Jewish Agency (the shadow government in Palestine that the Jews had created under the British), testified before the Anglo-American Committee. He tried to make the committee members understand why the survivors of the Holocaust, living in DP camps, were desperate for their own homeland.

"Here," he said, "they can have security and freedom." My friendship with Ben-Gurion and his American-born wife, Paula, began during the hearings and continued until their deaths. He saw the Jewish state as a place of refuge, a true democracy, a land where Arabs and Jews could live together in peace.

UNSCOP, the *Exodus,* and Prison Camps in Cyprus

1947

Having sabotaged the work of the Anglo-American Committee of Inquiry on Palestine, Foreign Minister Ernest Bevin announced that Britain no longer wanted to rule the Holy Land. It meant the end of Britain's mandate to turn Palestine into a Jewish homeland.

There were pundits who predicted that the United Nations would say, "Please, Mr. Bevin. Don't do that. You are the only one who knows how to handle those ornery Jews."

Instead, the UN decided to create its own committee, UNSCOP (the United Nations Special Committee on Palestine). It was the twentieth committee to study Palestine, but the first without a single Englishman. Its eleven members were from countries that had little or no oil. ("We would have no problems in the Middle East," President Truman told me one day in his office, "if not for that dirty three-letter word: OIL.")

Helen Rogers Reid asked me to accompany UNSCOP as the *Trib*'s special foreign correspondent. I was in a quandary. To assuage my disappointment over Bevin's rejection of the Anglo-American Committee's unanimous report, I had begun to write a novel based on my work with the committee.

Should I drop the novel or travel with UNSCOP?

By chance, Lion Feuchtwanger, the famous German novelist, was in New York on a book tour. Having met and interviewed Feuchtwanger several times, I asked his advice.

"You can always write a novel later," he said. "To cover this UN committee is an opportunity any journalist would give his eyeteeth for. I think this will turn out to be the most important committee yet in opening the doors of Palestine. This committee may lead to the birth of a Jewish state. And you will be part of it."

I took his advice and traveled with UNSCOP through Europe, Palestine, and the Arab lands. I discovered that the novel I had been writing was like a pianist's finger exercises. It sensitized me for the real work to come; it prepared me to understand the refugees we were meeting and the problems they faced.

In the DP camps in Germany, we were greeted once again with huge new signs: WE WANT TO GO. WE MUST GO. WE WILL GO TO PALESTINE. Once again, we were taking testimony from Holocaust survivors; once again, I was not sleeping nights, but when I fell asleep, I relived in dreams some of the horrors they told us.

In the Arab countries, especially in Egypt, Lebanon, and Syria, we were entertained by belly dancers, fed Arab delicacies, and listened to Arab leaders who wanted to prevent any more Jews from entering Palestine.

Friday, July 18, 1947, we were in Jerusalem's YMCA taking testimony when I learned that an American ship named *Exodus 1947*, built to hold four hundred people and now carrying 4,500 Holocaust survivors, was trying to enter the Holy Land. Four British warships and the cruiser *Ajax* were attacking it outside territorial waters.

I cabled the *Trib* that I was leaving UNSCOP temporarily to cover the *Exodus*. The cable came back: "Good luck." Within an hour I was driving north to Haifa.

The dock was bustling with British tanks, personnel carriers, paratroopers wearing red berets, and soldiers preparing for battle. Savage-looking Sten guns lay on top of hospital stretchers. Haifa looked and smelled more like a war zone than Naples had in 1944, when I picked up the Oswego refugees.

Three ships lay in the harbor. "What are those ships doing here?" I asked Colonel Cardozo, the British officer in charge of the whole operation. He was a short marionette who never walked but danced as if on invisible strings. I had to dance after him to get his attention.

"They're hospital ships. We're going to divide up those 4,500 people and put 1,500 in each one of the three ships."

"I'd like to go aboard one of them."

"Impossible. But I can tell you they're a heck of a lot better than that tub they sailed in. We're giving the people sheets, blankets, clean beds."

"Where are you taking them?"

"To Cyprus."

Parts of Cyprus, then a British crown colony, had been cordoned off into two prison camps, which the British had set up to intern refugees caught trying to break through the British blockade and enter the Holy Land.

"Cyprus is a prison!" I said. "You're going to lock them up!"

He danced away as the battered *Exodus* limped into the harbor.

I gasped. The ship had the biggest hole I'd ever seen. An entire deck had been destroyed. I could see torn pipes, people running, mothers searching for children, lifeboats hanging at crazy angles.

The first ones off were some of the 150 wounded, carried on stretchers: their heads, their arms, their legs bandaged. British Military Police unwound the bandages to make sure these were genuine wounds. Only the most badly wounded were put on ambulances and taken to local hospitals.

The rest of the passengers began descending the gangway looking tired, bewildered, hopeless. Those who refused to come down were dragged down by soldiers. A few British soldiers tried to help by lifting babies from their exhausted mothers' arms.

The soldiers then herded the people into separate Army tents, one for men and one for women. They were ordered to take off most of their clothing and then sprayed from head to toe with DDT. Families were separated indiscriminately and forced onto the "hospital" ships bound for the prison camps in Cyprus.

On the dock, camera in hand, I was shooting the scene more with my heart than with my fingers, often stopping to help some of the overburdened women and hug some of the frightened children. For some of the teenagers, this was a great adventure; but for most of the adults, it was one more day of anguish.

That night, meeting some of the crew members who had escaped, I learned

what had happened during the battle at sea. The British warships had attacked the *Exodus* from two sides. The British marines were armed with pistols and clubs, with firecrackers and tear gas; the passengers and crew were armed with potatoes and cans of kosher beef.

The firecrackers, tossed at the *Exodus*, frightened the crew for a moment, and in that moment eighteen British soldiers rushed down the drawbridge of one of the warships and jumped onto the deck of the *Exodus*.

Bill Bernstein, from California, who had been a U.S. naval officer in World War II, was guarding the wheelhouse when a marine clubbed him on the left temple. I watched the British soldiers carry him down the gangway on a stretcher, one knee up like an innocent child. I did not know how soon he would be dead.

His body was followed by the bodies of two sixteen-year-old orphans. Hirsch Yakubovich, from the DP camp at Kloster-Indersdorf, had been watching the action from a porthole. He tossed an orange at a marine entering the ship. The marine shot him in the face and killed him. The other orphan, Mordecai Baumstein, from the DP camp at Bad Reichenhall, was trying to beat off the marines with a can of beef when a marine shot him in the stomach.

Some of the crew, Americans in their early twenties, disguised themselves as refugees and threw in their lot with the passengers. Others managed to escape and returned to Europe to sail more ships filled with DPs hoping to enter Palestine.

Hiding in a secret shelter he had made in the bowels of the ship was the captain, Ike Aronowitz, a twenty-two-year-old Palestinian Jewish seaman who looked like a street-smart kid. His identity was kept secret lest the British arrest him for sailing this "illegal" ship. In the dark of night, when the last British soldier had left the dock, he escaped with a few other members of the crew.

The next day, I flew two hundred miles north to Cyprus to meet the three "hospital" ships. I was greeted at the Cyprus airport by the heads of the American Jewish Joint Distribution Committee (JDC), who convinced the British soldiers guarding the gate of the largest of the camps that I was a new JDC employee. The JDC man told me the distressing news that the three ships seemed to have vanished.

For nearly a week, while waiting for some word, I met with refugees, heard

their stories of terror and survival, and photographed their life in the camps. If I had thought the DP camps in Germany and Austria were horrors, Cyprus was worse. It was a hot hellhole of desert sand and wind, of tents and Quonset huts with a long road hemmed in by two walls of barbed-wire fences and a wooden watchtower guarding the whole camp. The architecture had come straight out of Auschwitz.

The Mediterranean Sea creamed the shore, but there was no water in the camp. No privacy. To sleep together, couples hung a blanket from the top of the tent or the hot roof of the tin hut. There were no sewers. You had to smell Cyprus to believe it.

The camp was guarded by young British soldiers who resented their role as policemen and babysitters for Holocaust survivors. But the camp was run, not by the soldiers, but by social workers, teachers, and doctors sent by American Jewish organizations and by the Jewish Agency. These workers helped the refugees set up their own self-governing bodies and schools. I was shocked sitting in a makeshift outdoor school under the summer heat, watching fifteen-year-olds learn that $1 + 1 = 2$.

The life juices that had dried up for men and women in the death camps returned. Seven hundred and fifty babies were born the first year in the Cyprus hospital.

"Until I came here, I believed in science," Dr. Walter Falk, the tall, kindly pediatrician who had come from the Hadassah Hospital in Jerusalem, told me. "Today," he said, "I believe only in miracles."

Each month, another 750 men, women, and children were allowed to leave the camp for Palestine. The order was "first in, first out." When it was their turn to leave, the people had to line up at the exit gate, show their exit certificates, and return their British-issued aluminum bowl, cup, and Army blanket. Some tried to escape by hobbling with a stick and looking like old men, hoping a guard would have compassion and let them leave without a certificate. A former makeup artist asked me to help paint black lines on young men's faces and fit them with false teeth. I relished my job, hoping my artwork to age them would get them through. Sometimes it succeeded; more often the guard would feel their muscular arms and tell them, "Who you kidding? Get back!"

While I waited for news of the three missing "hospital ships," I learned how

Golda Meir, then head of the political department of the Jewish Agency, had come to Cyprus with a special mission.

Standing on a platform of crates, she talked urgently to the refugees. "There is typhus here in the camps. We cannot allow Jewish babies to die. We owe them life. I am asking you to make a sacrifice, that some of you, who are slated to leave this month, give up your right and wait for next month."

A man interrupted, shouting, "Hitler did enough to me in Europe. Now I've been in this hell for six months. I want to get out!"

"Friends, hear me," Golda answered. "If we delay getting the little children right out, they may die. We want them to live. We want all of you to live. We want all of you to come home."

A woman called out, "She's right! I've waited so long, so many years. I can wait another month. Golda, take my certificate. I have no babies anymore to be saved. My babies are dead."

Golda succeeded. The "baby transport" was filled with babies under age one and their parents, taking them to freedom.

In the short span of three years, from the end of the war in 1945 to the birth of Israel in 1948, some 52,000 Holocaust survivors were incarcerated behind the barbed-wire fences in Cyprus.

At the end of my stay in Cyprus, I learned that the reason the three "hospital ships" carrying the *Exodus* refugees had disappeared was that the British Parliament could not decide what to do with them. Finally, after a raging debate, they decided that the *Exodus* refugees should be taken back to Port-de-Bouc, the port near Marseilles from which they had set sail on their tragic journey.

I flew to Port-de-Bouc and soon made contact with local French officials, who told me that they had orders from their foreign minister, Georges Bidault, in Paris to comply with the British demand that they force the refugees off the ships.

"We make our own laws here," one of the Frenchmen confided. "We know who the enemy is. Those refugees are not the enemy. We will welcome anyone who wants to disembark voluntarily—maybe someone is sick or ready to have a

baby. Of course, we will give them food and shelter. But we will not force anyone off."

The officials arranged for their longshoreman to put me in a motor launch and send me around the three ships, the *Runnymede Park*, the *Ocean Vigour*, and the *Empire Rival*. I waved to some of the people on the decks—the same people I had seen getting off the *Exodus* in Haifa. While I watched, they raised signs printed in gentian violet, blue ink, and red lipstick on bed sheets and white underwear:

À NOUS LA PALESTINE
LIBERTÉ, ÉGALITÉ, FRATERNITÉ

WE THANK FRANCE BUT TELL ENGLAND
TO GET US OUT OF HERE

WE WILL GO ASHORE IN EUROPE
ONLY AS DEAD MEN

One day, a French worker, who had delivered the food supplied by both the JDC and the French Aid Society to the *Empire Rival*, approached me on the dock at Port-de-Bouc.

"We're not supposed to talk to the people when we bring up the food," he said, "but one of them whispered to me, 'We're hungry. We're hungry for books.' "

We made sure the next shipment was loaded with books, newspapers, and several Bibles.

The captain of the *Empire Rival* decided all books in Hebrew and Yiddish were propaganda and ordered them burned. These refugees were the people of the book and the people of the land. And on this fateful voyage, both the book and the land were taken from them.

Life on the ships became more intolerable every day. The temperature was boiling. The British hoped that the heat, often reaching 105 degrees, would drive the people down. But the people refused to go. Then four days of rain fell through the holes in the deck, and the refugees, sleeping on the floor of the dark hold or standing against the walls, were soaking wet. But the people stayed.

They went on a hunger strike, and when I wrote it up for the *Herald Tribune,* the British denied the hunger strike in their press. The survivors began to feel that the world had forgotten them.

Avi, a representative of the Jewish secret service who had come from Jerusalem, sent a letter to the refugees to assure them they were not forgotten. He reminded them that they had astonished the world by their hunger strike.

> It must be said that now, for the first time, the American press began taking a systematic interest in your fate. The *New York Herald Tribune* sent one of its top journalists, Ruth Gruber. . . . She understands us well and her articles have special importance. Last night, she tried to obtain permission to board the ships from the [British consul] and he refused. She did manage to get to the vicinity of the ships and take photographs. Meanwhile this action has succeeded, that is, people are again taking an interest in your fate.

After eighteen days of suffocating heat, Bevin announced that the *Exodus* Jews were to be taken to Germany, the death land. It was hoped that such a drastic solution would discourage more Holocaust survivors from trying to enter the Holy Land.

The world was outraged. Reporters flew in, clamoring to board the three ships. Edward Ashcroft, the British consul general in Marseilles, called us together on the wharf. A scrawny man with a dark mustache riding over his lips, the trademark of the CID (Criminal Investigation Department), Ashcroft was dressed, British-fashion, in khaki shorts separated from his knee-high socks by a stretch of hairy thighs. It was hard to think of him as a diplomat.

"I can't let you all go aboard the ships," he proclaimed, "so I will select three." He ticked three fingers off: "One for the British press. One the French press. And one the American press." His forefinger pointed to me to act as the American pool correspondent. He then invited me to sit next to him in one of the launches. The water was rough. My camera, hanging from my shoulder, kept hitting his bare thigh.

The launch took us out to the *Runnymede Park.* It was ironic to me that it was named for the site on which the Magna Carta was signed in 1215. That document guaranteed that no king is above the law.

I climbed aboard the *Runnymede Park* and was greeted on the bridge by Lt.

Col. Martin Gregson, the commandant in charge of the soldiers guarding the three ships. He stood with one foot on the deck and the other inside his cabin, grinning as if this were a vacation cruise.

Gregson stopped grinning for a moment. "Ashcroft tells me you're from the *New York Herald Tribune.* Go on, ask me some important questions."

I was quite sure I would get casual and airy answers to any serious questions, so I decided to ask some statistical ones. "Colonel, you're in charge of these three ships. How many babies have been delivered on them while the ships were anchored here in Port-de-Bouc?"

"I don't know," he waved his hand. "Put down any number you want, maybe six, maybe a dozen, maybe twenty. They're always having babies."

I left the grinning colonel, who invited Ashcroft for a last drink before he was ready to turn his three-ship armada toward Germany.

A young, serene-looking captain from the Sixth Airbourne Division came toward me. "I've been assigned as your escort."

He led me to the fore section of the bridge. Below me on a crowded deck, hundreds of half-naked people were jammed into a steel cage, as if they had been thrown into a dog pound. They began shouting at me in English, Yiddish, Hebrew, French, Spanish, Ladino, their words tumbling over one another.

Several called up to me, "It's good down here. Air. There's air down here."

Some air, I thought. Inside the steel cage was a wooden outhouse with two six-holers for 1,500 people. The smell, the agony, the contempt for life, the human tragedy made me want to shake the world by its lapels: how can you let this happen?

This was no hospital ship, I realized; this was a prison. It was a former Lend-Lease ship that President Roosevelt had loaned to Britain to save her from Nazi submarines at the beginning of the war.

Strong-armed young men, naked to their shorts, raised a huge black banner held upright between tall poles. They had painted a purple swastika on the British Union Jack. My hand trembled as I shot several rolls of film to capture the flag from every angle.

The people in the cage, watching me with my camera, applauded and cheered so loudly they brought Colonel Gregson out of his cabin. I was shooting a new roll when he walked to my side. He was still grinning.

"They'll be pleased that you're taking pictures of that flag. They've been working on it for weeks now."

These were Jews the world had never seen, Jews who had refused to be killed in the gas chambers, Jews who had refused to wait in DP camps while governments and committees like ours had argued over them, Jews who were defying not only the British Empire, they were defying the whole world.

"Go below," a man shouted. "Go see our floating Auschwitz."

I descended the stairs to the hold. It was a scene out of Dante's Inferno. Heads here. Feet there. Some of the people, learning that I was an American and a Jew, began handing me little slips of paper with telephone numbers.

"Call my uncle. He's in Chicago."

"My mother's in New York. Call her."

"Take pictures!" they shouted. "Show the world how they treat us!"

I took more pictures, but I was blind. The only light came through prison bars shielding the one tiny prison window. And I was blind with their agony.

I doubted any of the pictures would come out, but when Eric Hawkins, the British-born editor of the *Paris Herald Tribune,* had them developed, he told me, "I never cry over pictures, but they made me weep."

"I shook taking them."

"Ruth, these pictures belong to the world. I gave them to the AP, and they traveled around the world in eight minutes."

On the *Runnymede Park,* my escort from the Sixth Airbourne Division told me it was time for me to go. I stood on the wharf with a young Haganah girl, weeping as we watched the three prison ships sail for Germany. "Now," she said, "you will see the birth of a Jewish state."

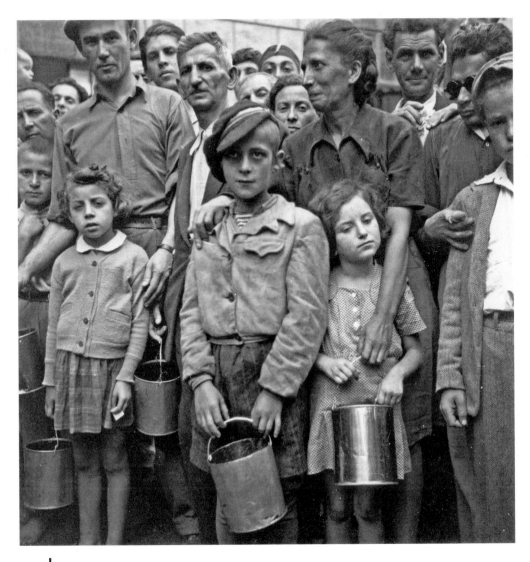

In 1947, Helen Reid asked me to cover UNSCOP. I accompanied the eleven-member committee through Europe, Palestine, and the Arab lands. We were in Vienna when Dr. Enrique Fabregat, ambassador to the UN from Uruguay and a member of UNSCOP, asked me if I would take him to visit the Rothschild Hospital as his guide and interpreter. The Rothschild Hospital had been turned into a DP camp. On this day one hundred refugees arrived from Romania. Some of the children told me how they had escaped from soldiers and police and had traveled across mountains and through forests to get to Vienna. The little girl leaning into her mother's arm tried to comfort her. Soon they were to get their first hot meal in weeks in their new pails.

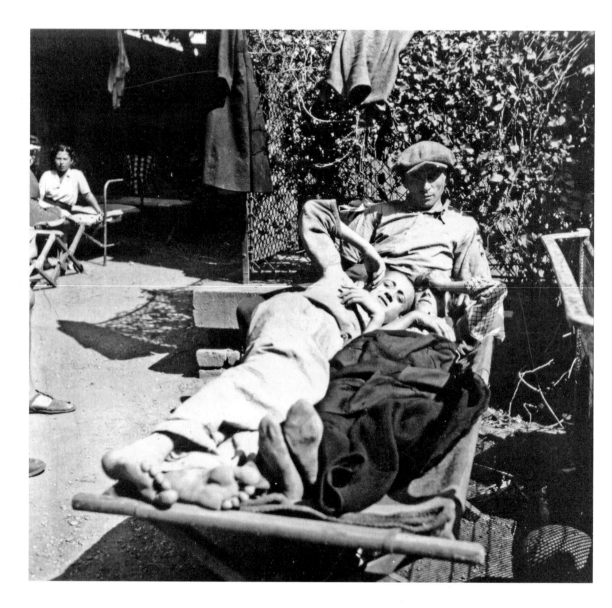

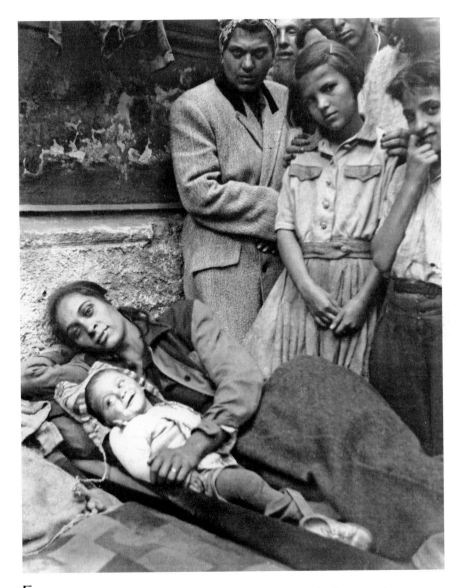

Each day, dozens of newcomers arrived at the Rothschild Hospital DP camp. The hospital was so overcrowded that people slept on the street and in the bushes.

The camp served as a stopover for thousands of Jews crossing Europe to secret ports in the Mediterranean. Their goal was to circumvent British war ships that were attempting to blockade them and, at last, to reach the Holy Land.

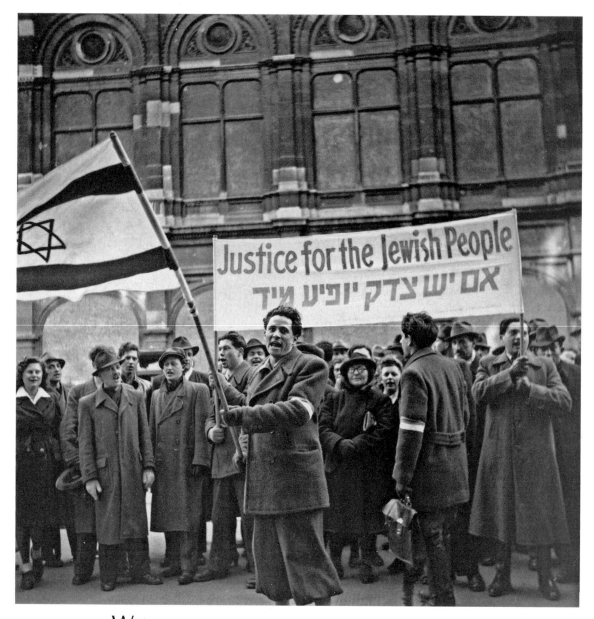

Wherever we traveled the members of UNSCOP questioned people about the horrors they had survived. As we prepared to leave the Rothschild Hospital, three thousand men, women, and children joined us in singing "Hatikvah"—the song of hope. It is now Israel's national anthem.

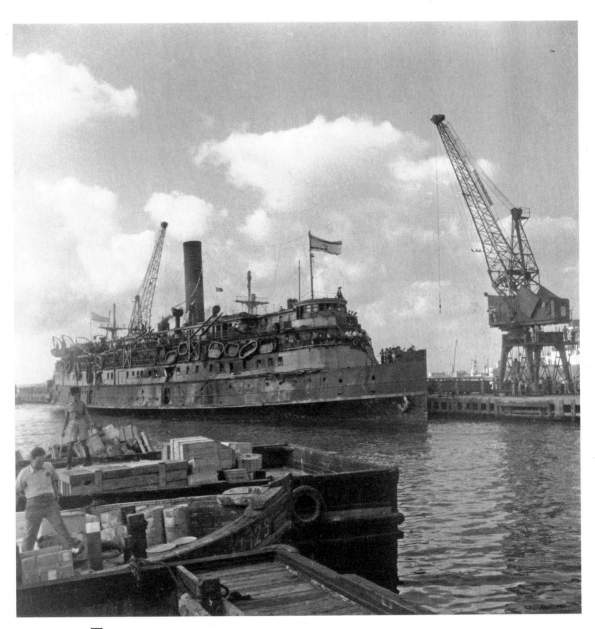

The battered ship *Exodus 1947* as it limped into Haifa Harbor.

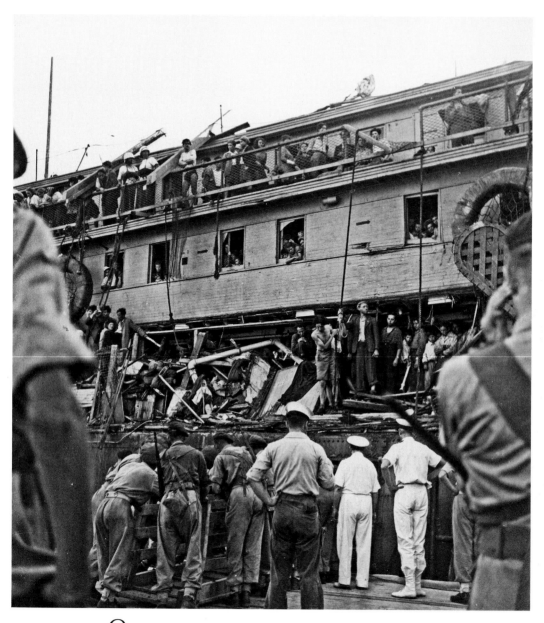

One whole deck was shattered by British warships before it reached Haifa in 1947. I found it hard to believe that the ship did not break apart.

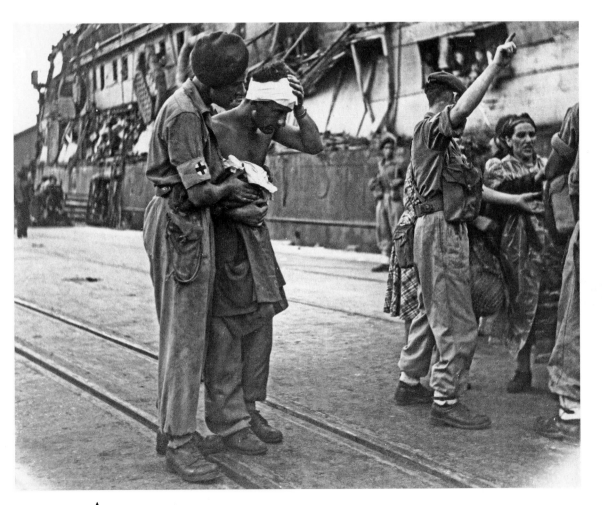

A wounded refugee from *Exodus 1947*. My camera shook as I tried to capture images of refugees who had been beaten over the head or who were being carried out on stretchers. Bill Bernstein, the first mate and a former U.S. Naval officer from San Francisco, lay unconscious on a gurney with one knee up like an innocent child falling asleep. He died soon after he was brought down.

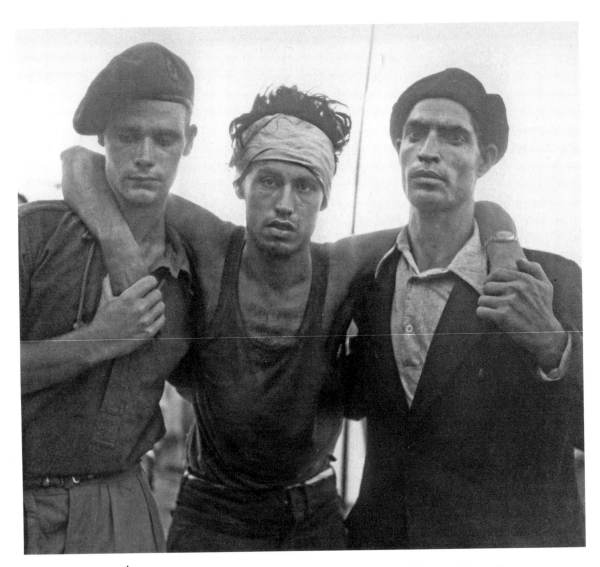

A severely wounded refugee from the *Exodus,* helped by a soldier and a friend. British soldiers, kind to some of the refugees, were ordered to unbandage head wounds to make sure the refugees were not faking injuries. The severely wounded were transported to Haifa's hospitals and allowed to stay. The people trickled down the gangways looking weary and shattered. Surrounded everywhere by troops, they made their first steps on the dreamed-of soil. They were exhausted and breathed the air.

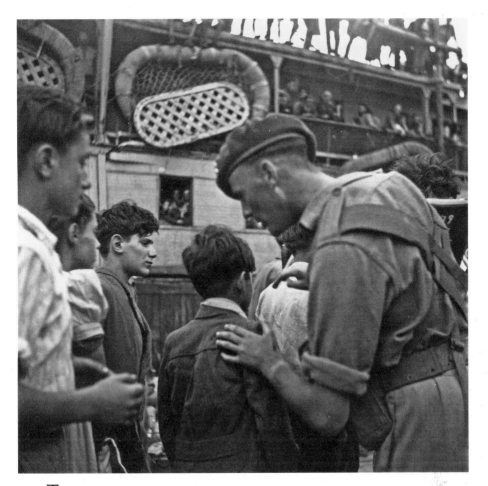

The *Exodus 1947* carried some six hundred orphans whose parents had perished in the Holocaust. Some of the British soldiers and medics tried to comfort the bewildered children. This soldier was abashed when I thanked him for his compassion. Nearly everyone carried a green bottle of water to sustain them on the journey from southern France to Haifa. It was the first thing the British took away from them, as though they feared it was a secret weapon. On the dock, the refugees were separated from one another to be searched: the men to be searched by soldiers, the women by hostile Arab women. Some of the refugees fought the soldiers who were trying to pull them down from the ship. The most severely wounded were taken to a Haifa hospital; the dead were taken to martyr's road in Haifa cemetery. I joined 15,000 mourners at their funeral. Most of the refugees were eventually settled in Israel.

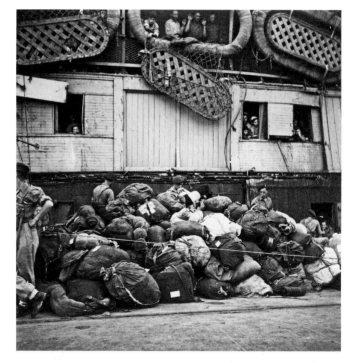

The 4,500 refugees from the *Exodus* were forced onto three prison ships. Families were torn apart, their baggage carelessly thrown off the side of the ship and never retrieved. Soldiers distributed a mimeographed statement in several languages that told the refugees they were going to Cyprus, where they would get their belongings back. Film was removed from their cameras and the cameras were then confiscated. Scissors, knives, razors, and even fountain pens were confiscated and never returned. I had the feeling that they were being robbed of any objects that might have given them some independence.

Refugees waited in line to be sprayed with DDT powder.

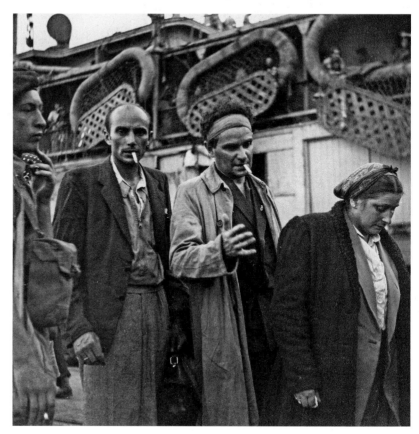

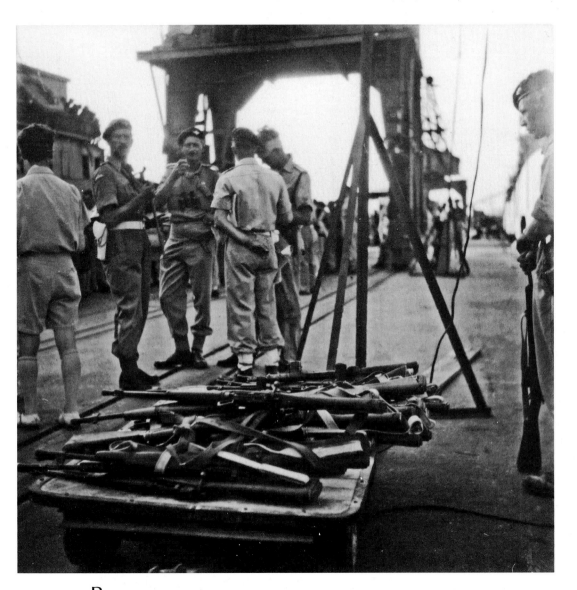

British soldiers created their own Arc d'Triomphe on the dock and rested their guns on Army gurneys, as though cause and effect had been confused. The refugees were forced to walk a long journey from the battered river boat to the prison boat, passing inside tracks filled with soldiers under the hastily built archway.

The three "hospital ships" sat patiently in Haifa harbor, each one prepared to take 1,500 refugees. President Roosevelt had assured Congress that all Lend-Lease ships would be returned to the United States when they were no longer needed. We never expected that these same ships would be turned into prison ships. Their sole purpose now was to carry refugees captured in Haifa to the British prison camps in Cyprus. I flew to Cyprus and waited for days to meet the *Exodus* refugees on the three prison ships. Where were they? No one knew.

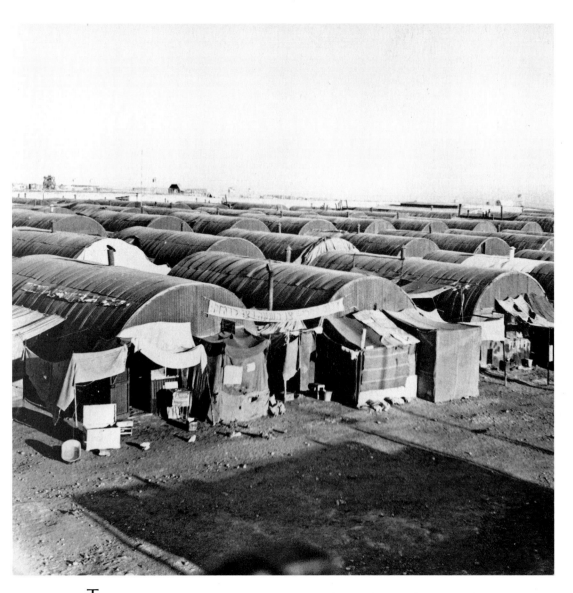

The Cyprus prison camps, 1947. Colonel Cardozo had assured me in Haifa that soldiers had filled each of the three so-called hospital ships with 1,500 refugees from the *Exodus*.

"Where are you taking them?" I asked him.

"Cyprus."

A short flight from Palestine, the Cyprus prison camps were filled from 1946 to the birth of Israel in 1948 with over 52,000 Holocaust survivors. When I flew to Cyprus, it looked to me like a hellhole of desert sand, wind, and aluminum Quonset huts. I spent a week photographing the life the prisoners made for themselves. There was no protection from the broiling sun in the summer or the freezing wind in winter. While Cyprus was a hated prison for Jews, most of it was a favorite recreation spot for the

British military and elite. But the three ships carrying the *Exodus* refugees never reached Cyprus. It was considered too good for them. They were taken to prison camps in Germany, escaped, and were in Israel when it became a nation.

No reporter had ever been allowed into these camps before. It was a British secret that they were interning all these DPs, Holocaust survivors. They had come to Cyprus in all kinds of ships, little fishing boats—they sailed in anything to be able to get to the Promised Land. The British brought them to the two prison camps on this crown colony, Cyprus. But even Cyprus was considered too good for the Jews of the *Exodus*. They were taken to Port de Bouc, the village near Marseilles from which they had embarked for Haifa.

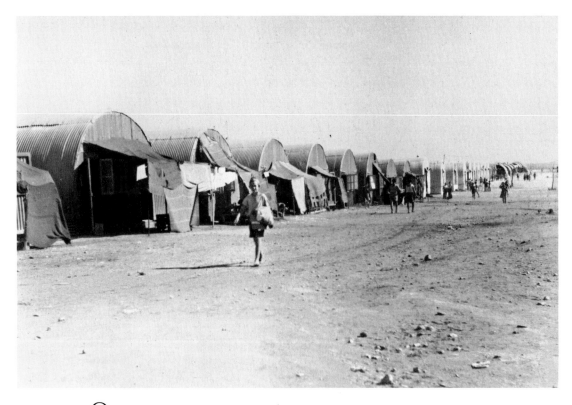

On orders from London, British guards prevented reporters from entering the camps. I was smuggled in as a new member of the American Jewish Joint Distribution Committee (JDC), which helped administer the camp. They brought in food and clothing, set up schools, and with the help of the Jewish Agency even trained young men in self-defense.

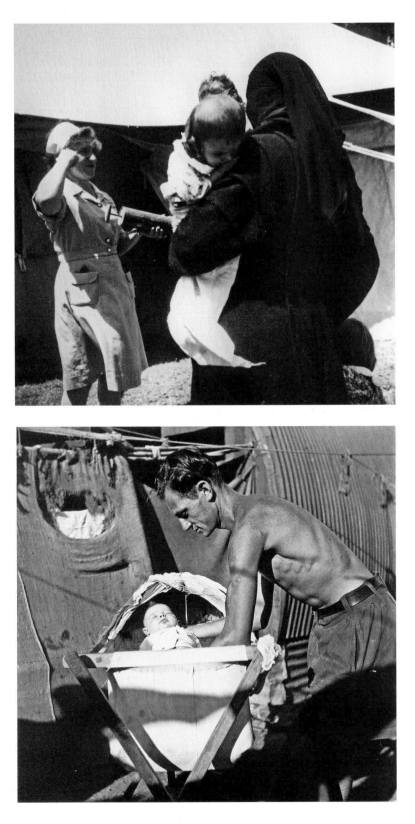

DDT filled the air with its poison. Most of us did not know then the damage DDT did to our crops, our birds, and our bodies. We were all victims: refugees, staff, even the soldiers.

An ingenious father gathered up rags and pieces of wood to make a bassinet for his baby in Cyprus. Everywhere I went in the camp there were babies. It made me realize that life juices were returning. Every man and every woman wanted a child to help make up for the millions of babies the Nazis had burned. The joy in having a baby changed the climate in the dismal camp. I felt my own anger at the misery—no water, no privacy, the improvised schools with fifteen-year-olds learning to read and write— tempered by the new births in Cyprus's military hospitals every day.

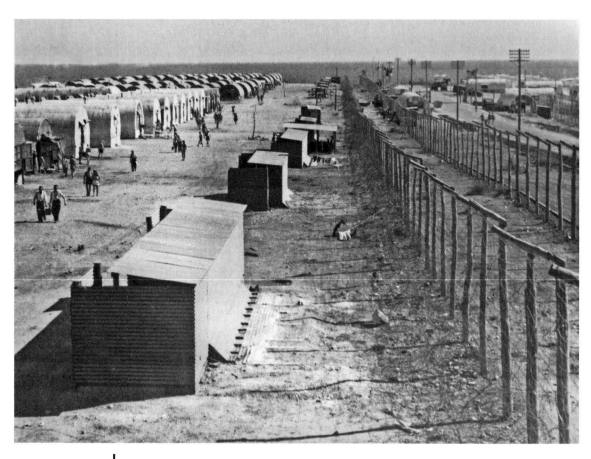

I hated the architecture of the prison camp, with its bare tin huts stacked against one another to the horizon and the long dirt road walled in on both sides by chain fences. It was the grim architecture of Auschwitz. You had to smell the latrines for 20,000 people in each of two camps to believe it—and you didn't believe it. You had to smell the garbage that piled up waiting for the trucks that didn't come. Each evening, I left the prison camps and went back to the fashionable Savoy Hotel with its guests dressed in evening clothes. I showered but I felt I could never wash away the smell.

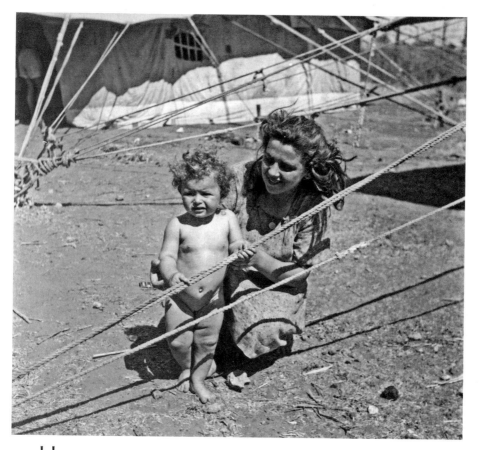

How can you have a baby in this prison camp?" I asked the young mother. "Don't you know," she answered gently, "that under Hitler, as soon as a Jewish woman was pregnant, she was burned. Women were the propagators of the race, and they were the ones who had to be eliminated first. This is our answer to Hitler. You can have a child and live."

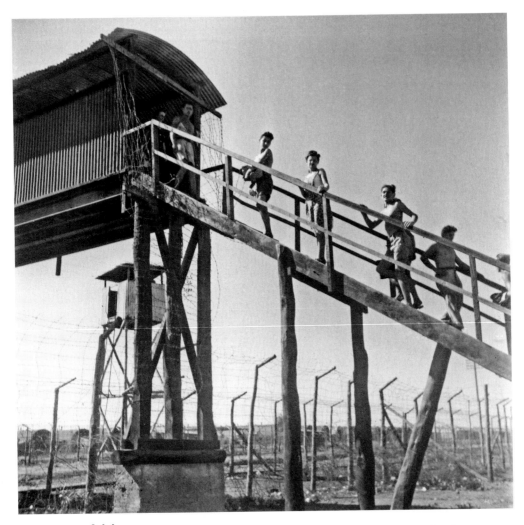

With the irony and humor that has kept Jews sane for thousands of years, they renamed the bridge that the British soldiers built "the Warsaw Ghetto Bridge." In Warsaw a footbridge was built by Poles to keep Jews off the streets leading to the ghetto. In Cyprus the bridge was built when rumors flew that water was to be delivered on a little truck. The refugees hoped that when water ran out on one side of the bridge they could find water on the other side.

In an exhibit of my photographs in Philadelphia some fifty years later, a woman studying this picture screamed, "That third woman on the stairs is my mother, the man in the doorway is my father." She thanked me for giving back her parents, even if it was only in a picture.

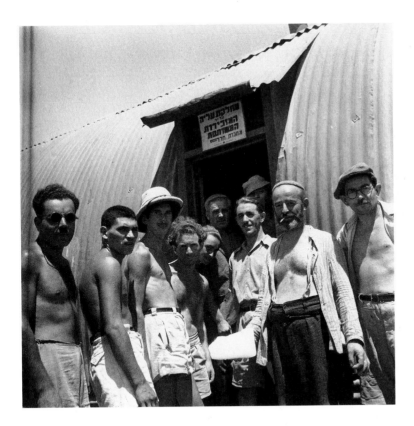

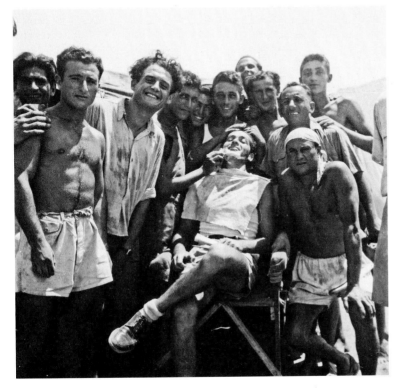

The refugees were allowed to leave—first in; first out.

Artists among the refugees wanted me to help them make the young men look older so they could leave out of turn. I painted dark lines and shadows on their faces and gave them ugly false teeth. I did my work carefully, hoping to fool a British guard. We hoped they looked old enough to pass muster, but when the British soldiers tested the muscles on their arms, the men were pulled out of the departing line. We never gave up, and to our delight we often succeeded.

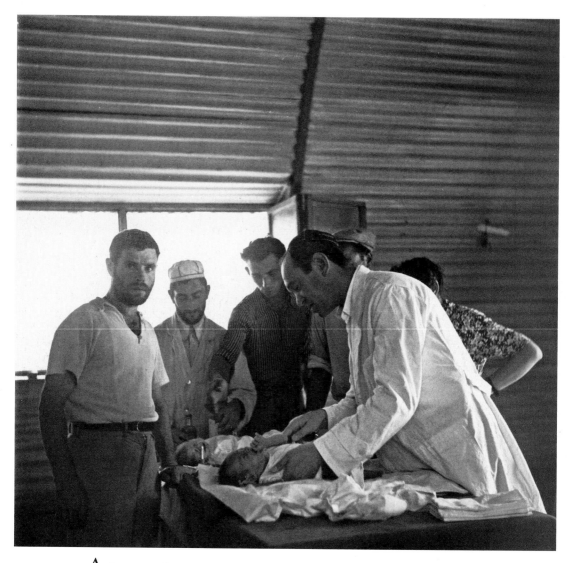

A doctor performs the ritual circumcision on two baby boys in a Cyprus camp. Exultantly their fathers sing *"Am Israel Chai"*—"The people of Israel live!" More than eight hundred weddings took place and 750 babies were born in 1947.

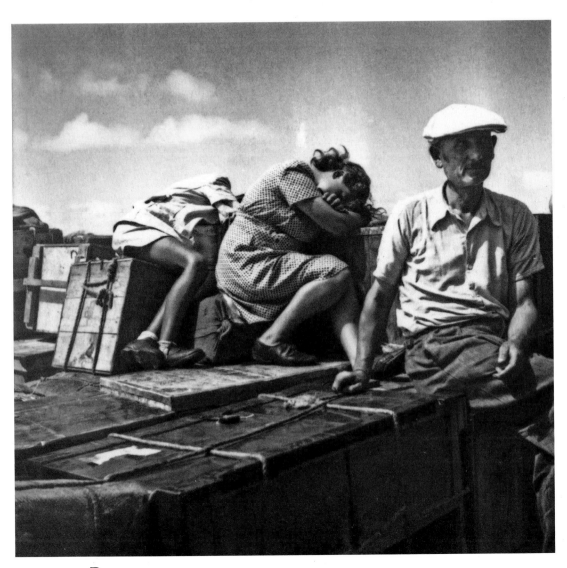

Refugees rest during the interminable wait to get certificates to leave the island.

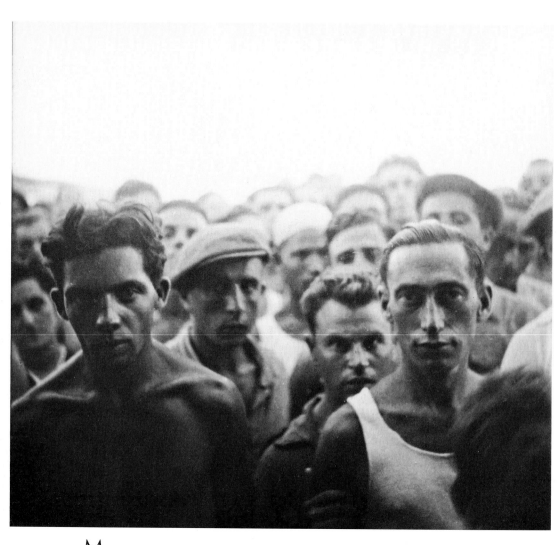

My camera recorded the frustration, bewilderment, and discouragement as more refugees captured by British warships descended from prison ships into Cyprus's Famagusta Harbor. They did not know how long they would be confined behind barbed wire. They only knew that Cyprus was a suburb of sorrow.

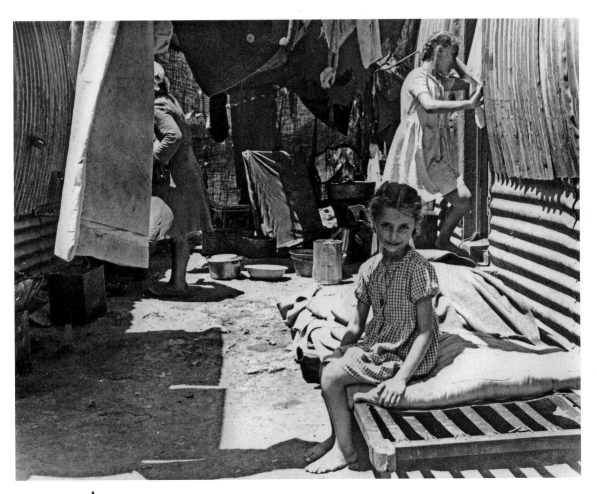

In each segment of the camp I found a lonely child waiting while her mother, exhausted, used her meager ration of water to keep her children clean. It is the innocence of this little girl that captivated me. I took this picture as a promise to myself that I would come back to spend more time with her. I returned and she was still sitting there. Children of the *Exodus* had enormous patience. They knew that one day their dream would be fulfilled.

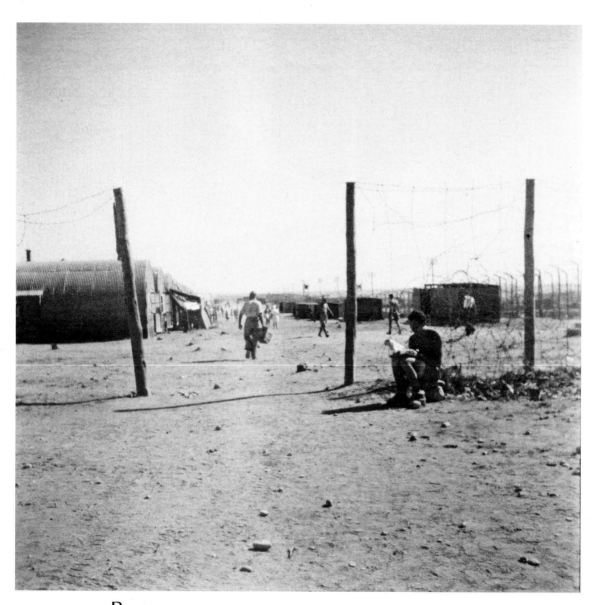

Beneath this desolate landscape men were secretly digging a tunnel that would get them out of the camp. It ended at the harbor of Famagusta, where if they were lucky they were hidden aboard fishing boats that took them to Haifa. They often asked me to sit with them in a circle near the entrance to the tunnel to hide it.

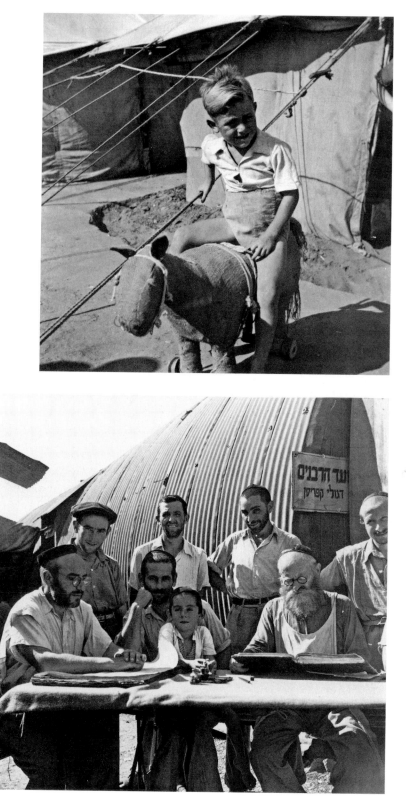

In the Cyprus prison camps, parents spent their time making toys for their children. I could not get my fill of the beautiful children growing up in a prison background. Did they know the sacrifices their parents had made to try to enter Palestine, only to land in Cyprus? Resilience, I thought, was the key to their survival. Resilience and hope.

Even on this prison island older men began teaching the Torah to younger men and children.

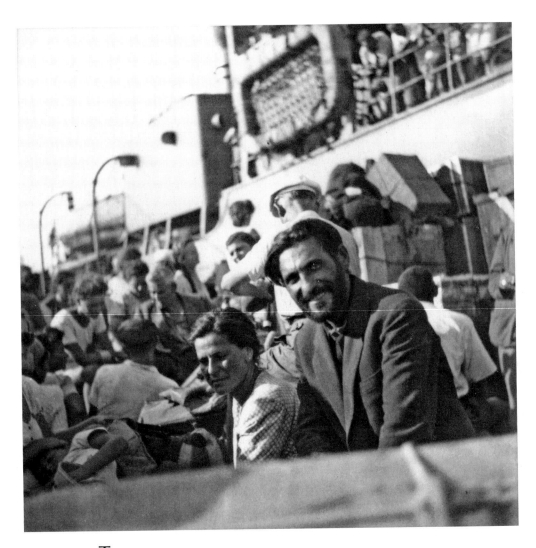

These fortunate refugees were preparing to leave Cyprus. It was a rare experience to photograph smiling people on the prison island.

"I haven't seen my mother since the war began," the smiling man told me. "After all these years of running, hiding from bombs, seeing people murdered, then these last two years on this prison island—Cyprus—who can believe it? Who can believe I'm going home? I'm going home at last. *Eretz Israel.*" He uttered the words "the land of Israel" as if they were a song.

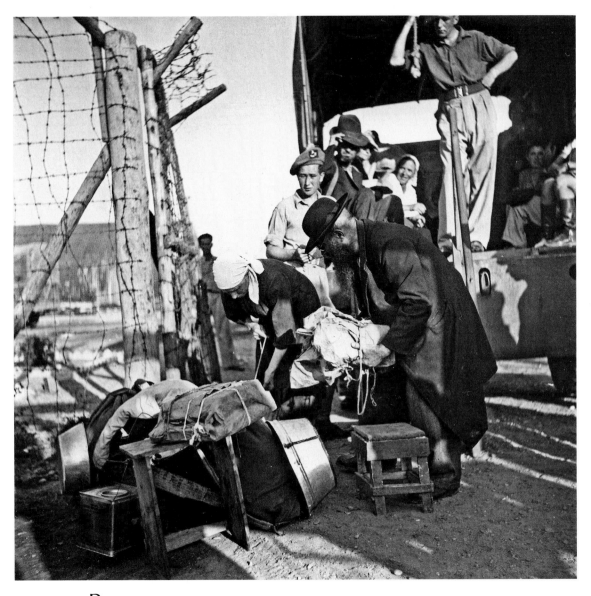

Refugees departing from Cyprus for Israel.

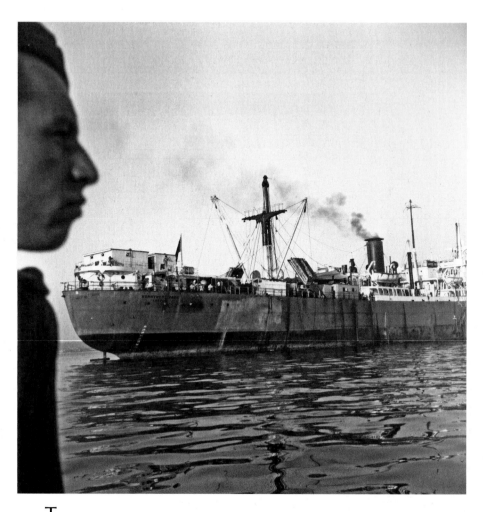

The *Runnymede Park* was one of the three ships on which refugees were taken from Haifa to Port-de-Bouc in southern France.

On the ship, the prisoners were allowed on deck to use the outhouses. "It's good here," they said, "there's air." Two wooden outhouses provided just six holes for 1,500 people.

Below, half-naked people lay next to one another. The space that they filled on that slimy floor was their kitchen, their dining room, their bedroom—everything. That's where they lived. And there were both younger people in their twenties and babies, because every man and every woman wanted a child. There were a lot of babies, no elderly people. They had all been burned.

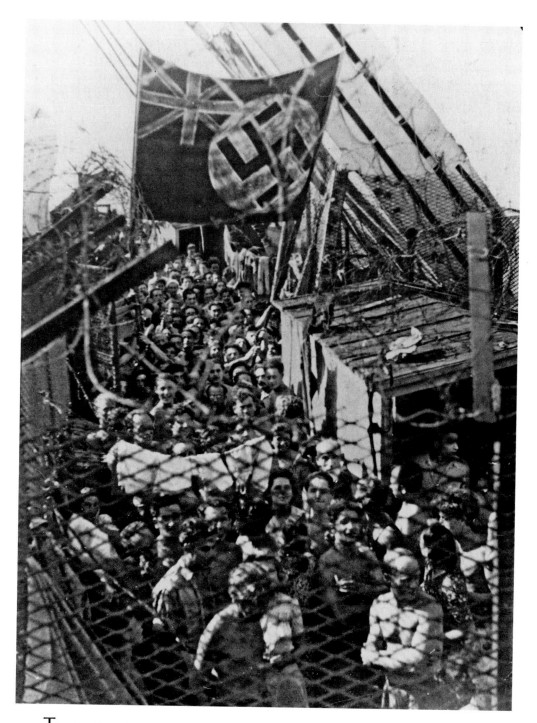

The *Exodus* refugees on the *Runnymede Park* painted the swastika on top of the British Union Jack. They were defying not only the British empire but also the whole world. This became *Life* magazine's Photo of the Week.

Inside the hold of the *Runnymede Park,* one of the British ships that the *Exodus* refugees were transferred to, a mother who gave me her child to hold. She was beautiful—beautiful. The mother said, "My life is over." I asked, "How old are you?" She said, "Twenty-three." I said, "Don't talk that way. They can't do anything worse to you than what they're doing here. They'll let you go. They'll have to." She was much wiser than I. She said, "No, I'm going to live. I'm going to live so my child will live. I'm going to live so that no Jewish child is ever torn from its mother's arms again. So that no child is ever burned in a gas chamber."

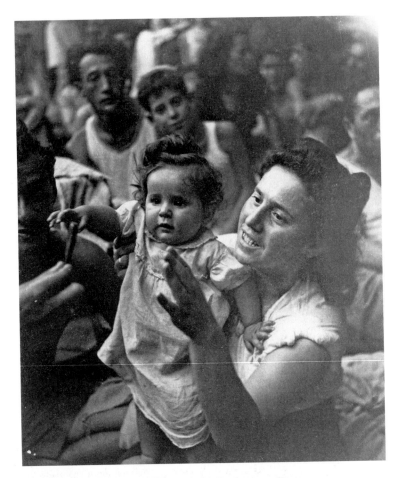

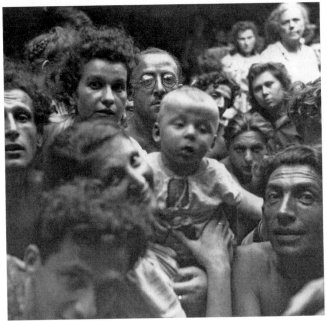

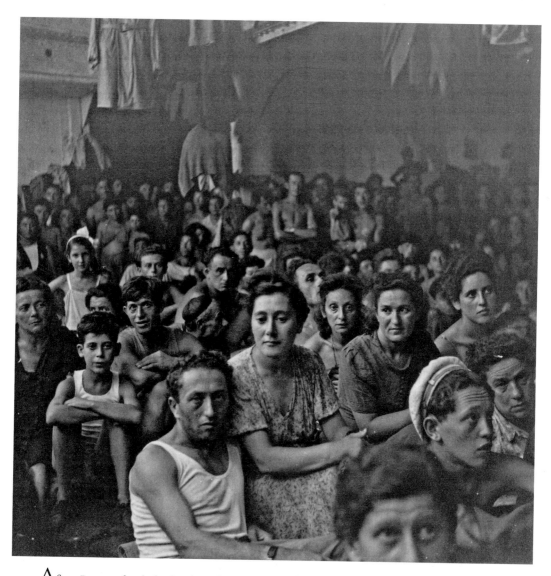

After I gave the baby back to her mother, the British officer who had brought me to the ship said, "You have to leave now. We're taking off."

He took me back to the harbor to rejoin all those other correspondents who had come from all over the world when they heard that the British were sending the Jews of the *Exodus* back to Germany, to the death land. In the launch back to the harbor I sat next to the British consul general in Marseilles. He saw that I was carrying a camera. On the dock he called all the reporters together, and that's when he focused on my camera and demanded my camera and film. I turned and walked away—with the camera and the film.

The Birth of Israel and
the War of Independence

1947–1948

After traveling for three months in the spring and summer of 1947 with UNSCOP, I settled in Switzerland, where the committee members were to spend another month arguing, disagreeing, and often flying home overnight to get instructions from their heads of state.

During those defining months of travel, the two Latin American members of the committee, Dr. Jorge Granados of Guatemala and Dr. Enrique Fabregat of Uruguay, became my best sources. Dr. Fabregat even asked me one day in June, while the committee was in Vienna, to be his guide and interpreter and take him through the Rothschild Hospital DP camp. "I want to see those terrible conditions you showed us in your photographs," he said.

Fabregat was shaking as we stepped around exhausted people lying in the street outside the hospital. He looked tortured as he leaned over children covered with dirt and sores. One hundred new DPs had just arrived from Romania, we were told, and there was no place to put them except on the street.

A young man in torn trousers stopped us. His eyes were bloodshot; his voice came up from his guts. "In Romania," he said, "they killed some 30,000 Jews in two hours. They took Jews to the slaughterhouse and hung them alive the way they hang cows, and they put knives to their throats and slit them. Underneath them, they printed a sign: KOSHER BEEF."

Neither of us could talk as we continued stepping over the people lying in the dirt. "Look at that couple over there sleeping"—a middle-aged refugee took my

arm with his left hand and pointed his right finger at the two people. "Look how they sleep. In the rain and in this hot sun. Soon it will be winter, and they will be sleeping this way in the snow."

"Let's go." Fabregat's eyes were watering. "We have to end these conditions. We have to get these people out of here, and take them to Palestine."

As the committee's work in Switzerland closed down, Dr. Fabregat and Dr. Granados confided to me that there would probably be a unanimous decision to partition Palestine into a Jewish state and an Arab state. I was so excited that I asked them if I could cable the *Herald Tribune*, revealing this historic solution.

"Absolutely," they said. "Just don't mention our names."

At the same time, the *New York Times* reported that the committee was in disarray and would probably be unable to make any decision. I knew the source for the story. It was Harold Beeley, the secretary of the committee, who later became Britain's ambassador to Egypt.

The *Herald Tribune* had it right.

November 29, 1947. The fifty-eight members who then composed the United Nations General Assembly began voting on partition. I sat at the edge of my chair in the press section as the delegates called their votes out loudly, "yes," "no," or "abstain." The vote was tallied: thirty-three members, including the United States and the Soviet Union, voted yes. The no vote was thirteen, made up largely of Arab states. There were ten abstentions, including Great Britain. It was a Solomonic decision.

The hallowed hall of the UN came alive as delegates, visitors, and even hard-ened journalists jumped up, yelling and applauding. I applauded, wishing I could jump ten feet. At last, I thought, the homeless survivors of the Holocaust will have a home.

My joy was dampened as I watched Azzam Pasha and Prince Faisal of Saudi Arabia stand up. Their faces were twisted with anger; their white robes and headdresses shook as they motioned to the delegates from all the other Arab states to follow them. At the door, in Arabic-accented English, Azzam Pasha shouted, "Any line of partition drawn in Palestine will be a line of fire and blood."

The Middle East burst into fire. Terror begets terror. Arab countries began

assembling guns, tanks, and planes. Ben-Gurion dispatched Golda Meir to the States to raise funds to buy weapons. In one week of impassioned speeches, Golda raised over $50 million. In several communities, we were asked to make speeches together. Golda always asked me to speak first. She knew no one would leave until they heard her speak, which she did with power and urgency.

It was easy to understand why Britain, having relinquished control of Palestine, would refuse to sell arms to the Jews to fight the Arabs. But why did the United States agree to allow Golda and others to raise money, knowing it was for arms and planes, and then put an embargo on selling them a single bullet? I was in the UN when our ambassador, Warren Austin, still trying to undermine partition, rose to make a last-minute proposal: to create a trusteeship for Palestine. Austin was stopped on his way to the podium by a journalist who read him the news: President Truman had agreed to partition Palestine. Truman had pulled the rug from under his State Department.

No matter how busy President Truman was and how many people he refused to see, there was one man for whom the door of the White House was always open. He was Eddie Jacobson of Kansas City, Missouri. Eddie and Harry Truman had been buddies in World War I, with Truman as captain of their unit and Eddie his sergeant. Returning to Kansas City, they opened a haberdashery store filled with attractive ties, shirts, and men's gear. The postwar depression bankrupted them. But both men worked hard and repaid all their creditors.

Saturday night was their poker night. Truman's favorite affectionate name for Eddie was "you bald-headed SOB." Eddie called Truman "Harry" until Truman became the president. After that, Eddie addressed him only as "Mr. President" and spoke of him only as "my friend."

In March 1948, I met Eddie and his wife, Bluma, while on a speaking engagement in Kansas City. After the talk, Bluma invited me to their home to meet their two young daughters, Elinor and Gloria, and then prevailed on me to leave my hotel and stay with them.

In their home, Eddie, a modest, soft-spoken mid-Western Jew, told me that several Jewish leaders in Washington had called him. They were in a panic that the UN vote on partition was in danger of being replaced by putting Palestine into a trusteeship. That would mean the end of a Jewish state and an Arab state.

They were pressing Eddie to ask the president to see Dr. Chaim Weizmann, who was president of both the Jewish Agency for Palestine and the World Zionist Organization.

Eddie told me that when he asked for the appointment for Dr. Weizmann, President Truman suggested that he come on Saturday, March 18. He told Eddie to have Dr. Weizmann arrive at the kitchen entrance of the White House. The British ambassador would be leaving through the front door.

This unusual arrangement worked out well.

Dr. Weizmann, seventy-four years old, frail and nearly blind but brilliant, charmed the president.

In the 1960s, I was interviewing President Truman in his office in Independence, Missouri, when he described that meeting. "I loved Eddie like my own brother, and I was so impressed with Dr. Weizmann," Truman said enthusiastically. "First he presented me with a Torah. Something I had always wanted. Then we went to my globe because he wanted to show me the Negev Desert and why the Jews needed that desert. That's why the UN voted to put the Negev Desert into the Jewish state."

The Negev was Ben-Gurion's dream. It was a natural unbroken southern frontier, leading to the ports and the Red Sea. It was one of Israel's gateways to the world.

Yet, despite Eddie's and Dr. Weizmann's efforts, our official State Department policy was to oppose partition. Secretary of State George Marshall tried to persuade Jewish leaders not to declare an independent State of Israel. Truman adored Marshall, but others in his State Department irritated him. On March 21, three days after seeing Dr. Weizmann, Truman wrote a letter to his sister, Mary Jane Truman, complaining that the "striped pants conspirators" in the State Department had "completely balled up the Palestine situation." But, he added, "It may work out anyway in spite of them."

On Friday afternoon, May 14, 1948, Ben-Gurion stood up in a small museum in Tel Aviv and read the world's newest Proclamation of Independence.

"The Nazi Holocaust," Ben-Gurion declared, "which engulfed millions of Jews in Europe, proved anew the urgency of the reestablishment of the Jewish State, which would solve the problem of Jewish homelessness by opening the

gates to all Jews and lifting the Jewish people to equality in the family of nations."

Israel was born.

President Truman became the first national leader to recognize Israel. He was followed by the Soviet Union and by most of the nations in the UN, while six Arab states attacked the newborn state.

Helen Reid telephoned me. "Ruth, we want you to go back to Israel and help cover the war."

"I'll leave immediately," I said.

Later I learned that L. L. Engelking, the city editor, had confronted Helen. "What does Ruth know about covering a war?"

"I'm sending her," she said.

Helen had another assignment. "Before you leave, I want you to talk tomorrow morning to the General Federation of Women's Clubs at the Waldorf-Astoria. I'd like you to tell them about some of your experiences in the DP camps."

I searched the faces of the women in the audience and saw boredom and restlessness. Whether the president of these clubs was annoyed that Helen Reid, one of the most powerful Republican women in the country, had asked her to rearrange the morning program and slip me in, or whether the audience was uninterested, I could not reach them. I felt it was the worst speech I had ever given.

The next day, I left for Israel aboard a small freighter carrying twelve passengers; airlines had canceled all their flights to Israel. On deck, I set up a small table and chair and spent each morning finishing a book called *Destination Palestine: The Story of the Haganah Ship "Exodus 1947."* I stopped typing only when the loudspeaker came on, giving us the war's progress. Each time Israel won a battle, everyone aboard shouted, "Hurrah! Hallelujah! We're winning!"

The ship docked in Haifa, and soon I was in a taxi headed for Jerusalem. The driver was enthusiastic. "You're lucky. You've come just in time. The UN has just declared a ten-day truce, but it's still not safe to take the regular highway to Jerusalem. There are Arab snipers who keep shooting even during a truce. So I'm going to take you to Jerusalem on the Burma Road."

"The Burma Road?" I repeated, wondering what the strategic road from Burma to China during World War II had to do with Israel's War of Independence.

He laughed. "Mickey Marcus—one of your Americans. He planned it. It's a secret road to Jerusalem. Jerusalem itself is surrounded by the Jordanian Army. But don't worry. I'll get you into Jerusalem all right. I know all the secret ways."

"I'm not worried," I said, as he drove carefully up the hills to Jerusalem and dropped me at the door of my friend Chana Ruppin. Chana, the widow of Arthur Ruppin, the founder of the kibbutz movement, embraced me.

"Look at you," she laughed. "You're covered from head to toe with dust. The first thing you're going to do is take a shower."

"Chana, you can't use up your precious water. I know how little water there is in Jerusalem. I'll manage."

Pretending not to hear me, she led me to the bathroom and helped me undress.

"See?" she said, filling a basin. "We use water four ways. First for cooking, then for showers, then to sponge the floor, and the rest for the toilet."

Clean and soon well fed, I left Chana and set off for the government press office to be photographed, pick up my press credentials, and meet old friends. The streets were calm. On my earlier trips to Jerusalem, the streets had been filled with British tanks and British soldiers; orange markers, called dragon's teeth, cordoned off whole areas of the city. Now all of that was gone. Jerusalem was, again, a beautiful city of hills, where the sun seemed to set not on the white stones, but inside of them.

As soon as the cease-fire ended, I began traveling with the Army, defending 650,000 Jews against an invasion by six Arab countries with a population of 40 million from Egypt, Syria, Lebanon, Jordan, and Iraq, with help from Saudi Arabia. (Yemen was officially at war with Israel but sent no troops.)

One of the first battles I covered was a stunning defeat of the Israeli Army.

With excitement and apprehension, a group of journalists and cameramen traveled in private cars and buses, following a small Army unit. We were headed for Latrun, a vital crossroads on the major highway between Jerusalem and Tel Aviv. It was the site of both a wine-making monastery of silent monks and one of Britain's prisons, built like a medieval fortress.

The Army unit was made up in part by a handful of seasoned soldiers and largely by newly arrived Holocaust survivors. Most of them had never held a gun until they enlisted.

The Arab armies were also disorganized and unprepared for battle, except for the Jordanian Arab Legion, who were trained and officered by the British.

The shooting began on both sides, but the Israeli Army unit was so outnumbered that soon they were ordered to turn back. The journalists followed them back to the Jerusalem government press office, where most of us sent cables describing the Israeli defeat.

A few days later, traveling with another Army unit as it prepared to capture an Arab village, I heard the captain order his troops, "We will not touch a single mosque." The soldiers obeyed his command. The village was captured, but the mosques were left unharmed.

The next morning, Joe Barnes, the foreign editor of the *Herald Tribune*, cabled me, "Your story of protecting the mosques changed the vote at the United Nations. They were going to censure Israel. But when the Israeli delegate stood up and read your article to the General Assembly, the debate ended."

The battle for Nazareth, where Jesus grew up, showed that even in the midst of war, armies can be humane. I decided to join a unit of the Seventh Armored Regiment of the Seventy-first Battalion when I learned that Nazareth was its mission. Its commander was someone I had met in Jerusalem. He was Joe Weiner, a red-haired former officer in the Canadian Army. I learned that Joe had sent orders to his troops: "I want no reporters and no photographers. If any show up, tell them they are barred."

Paying no attention to his orders, I hailed a jeep with a fellow photographer and talked my way up the line, telling the soldiers I was a friend of Joe's, and if he didn't want me, I would turn back. I reached Joe at the head of his unit. He was furious. "What are *you* doing up here? Don't you know I said no reporters?"

"Joe, this is a battle I want to cover," I said.

"Don't you realize you can get me into trouble? The Canadian government doesn't look with favor on anyone fighting for Israel."

"You can trust me, Joe. I promise I won't tell your name."

"Okay. Follow me."

In our jeep, the photographer and I followed directly behind him as he led

the convoy up a hill to the outskirts of Nazareth. Joe motioned to us to follow him. I watched him calmly knock on the door of an Arab home, calling out, "Open! This is the Israeli Army!"

"Don't shoot," the owner of the house pleaded with his arms upraised.

"We're not going to shoot you," Joe assured him. "Send two of your sons downtown and have them bring the mayor and the Muslim and Christian leaders up here to your house."

Soon, the leaders came up the hill, carrying a white flag. After talking without apparent fear or anger for several hours in the living room, the men, sitting around a table, signed the document of peace.

Joe and his soldiers had taken Nazareth without firing a single bullet.

I ran into him again a few weeks later.

"You kept your promise. You didn't reveal my name," Joe said. "But you described the captain as 'a red-haired Canadian.' All my friends in Canada recognized me."

"Do you forgive me?" I asked.

"Forgive you? You've turned me into a hero."

The war was moving swiftly. It seemed that each time Israel won an important battle, the United Nations declared a truce. The ten or more days without fighting gave both the Arabs and the Israelis time to bring in more ammunition and to give the fighters a respite. It also gave civilians and soldiers an opportunity to travel and to visit their families and friends.

I was at a dinner party in Jerusalem when Maj. Memi de Shalit, a member of one of Israel's founding families, told a small group of us, "I'm taking a convoy to Tel Aviv tomorrow."

"Can I go with you?" I asked. "There are some stories in Tel Aviv I want to cover."

Memi agreed. "Sure. You can even ride with me in the lead jeep."

The next morning, we drove at the head of a caravan of public buses, taxis, trucks, motorcycles, and private cars. When we reached the Latrun jail, Memi stopped the jeep. The whole convoy came to a halt.

Memi explained the delay. "This is no-man's-land. We have to wait here for a

UN military officer to take us past the jail and the monastery, so we can continue on to Tel Aviv. I have to go inside. I have some messages for the Father Superior."

"I'm perfectly happy to sit in your jeep," I said.

"Still, if you want to get away from this heat, you can come with me up this little hill. I'll leave you sitting on the porch, while I go to meet with the Father Superior."

"Don't worry about me," I said as I jumped out of the jeep and followed him up the hill, settling comfortably on the wooden porch. Below the porch was a small field of freshly trimmed grass.

Suddenly, at the bottom of the hill, an Arab, his face half-hidden in a red-and-white-checked kaffiyeh, began to climb the hill. He was moving on all fours with a shotgun in his right hand. As he approached, his shotgun began to grow until it looked like a cannon. He shouted in Arabic to me. I did not understand a word. His voice was so riddled with venom that it brought Memi out to the porch to see what was happening. The gunman motioned to Memi to sit next to me. Now both of us were under his gun.

He continued yelling until an intern—the only person except the Father Superior allowed to talk in this silent monastery—came out the door. I thought, with a brief sigh of relief, he's coming to save us. The intern began shouting at the gunman in Arabic, waving his arms wildly, motioning him to move back. But to no avail. The intern, who now looked as terrified as we were, dashed across the field and disappeared. The Arab looked more menacing than ever. I glanced sideways at Memi, wondering if this was our last day on earth.

Suddenly, a young British officer, standing up in a jeep, flew across the field and took command. He shouted at the Arab, who, still on all fours but now silent, crawled backward down the hill until he disappeared.

"Get in the jeep," the officer beckoned to Memi and me, "and crouch on the floor. You never know what these guys will do."

In the midst of all the excitement, I couldn't help thinking, "That officer is so gorgeous, he should be in Hollywood."

He drove us through the no-man's-land, past the monastery, to the other side of the Latrun jail. The convoy of buses and cars followed us. "You're safe now." The officers waved us out of his jeep. "Have a good time in Tel Aviv."

Two days later, the Israeli newspapers carried the story of a convoy from Tel Aviv to Jerusalem that had been attacked by a band of Arabs a few miles before Latrun. The papers described the ambush. The officer in charge had stood up in his jeep, shouting as loudly as he could, "Everybody, get out of your cars, jump in the ditch."

An American engineer, who had been working on the railroad, stood up, waving his American passport: "My wife will never forgive me if I don't see Jerusalem."

A bullet killed him.

The Arabs then attacked a young Dutch woman and killed her. She was the daughter of a Dutch banker. The Arabs fled.

I mourned for this young woman. I was filled with survival guilt. Why had I lived while she was killed? I had no answer.

Each time, as soon as the ten-day truce ended, the streets in Jerusalem, Tel Aviv, and Haifa became hazardous. In Tel Aviv one day, I was interviewing a family of Holocaust survivors in an apartment building when the sirens sent us racing down the stairs to the basement. It was serving as a bomb shelter with benches where we could rest.

Around us, parents with their children sat in silence and fear. It seemed to me I could hear their hearts thumping as loudly as mine when we heard the engine of a plane flying over us. A few minutes later, a bomb fell on the building. It dropped like a cannonball straight down from the roof to the basement, killing a rabbi on one floor and a mother and child on another. We were untouched. Sheer luck, but tears ran down our faces as we mourned the rabbi and the mother and her child.

A few days later, I received a cable from Joe Barnes: "Get an interview with Ben-Gurion."

I telephoned Ben-Gurion's young aide, Nehemia, asking him to set up an interview. He called back minutes later: "Come at six today."

The sun was setting in the window behind Ben-Gurion, throwing a golden

halo around his white hair as I entered his office. I showed him the cable from the *Trib*.

"You know I'm not giving any interviews," he said.

"I'm not going to ask you a single question about the war. I want you to tell me what Israel will look like when the blood has stopped flowing and the refugees have found a new home."

He shut his eyes. "There will be no more desert. There will be no more sand. Everything will be fertile. Irrigation will make everything bloom. There will be trees on every hill. The sky will be full of planes. The sea will be full of ships."

I wrote his words hurriedly in my notebook, while he stopped for a moment. Looking at him, I thought, "He is the Moses and the George Washington of Modern Israel." His eyes still shut, he went on. "We'll have towns and villages filled with flowers and trees and lots of children. Children are our future. Our children will have every advantage of education and modern science. We will develop science to the last degree. We will use our only advantage—brains. We will use our brains and science for creation, not for destruction."

I was in Israel when the war ended in 1949. The brilliant African-American UN ambassador, Ralph Bunche, arranged a separate truce between each Arab country and Israel. The only country that refused to sign the truce was Iraq.

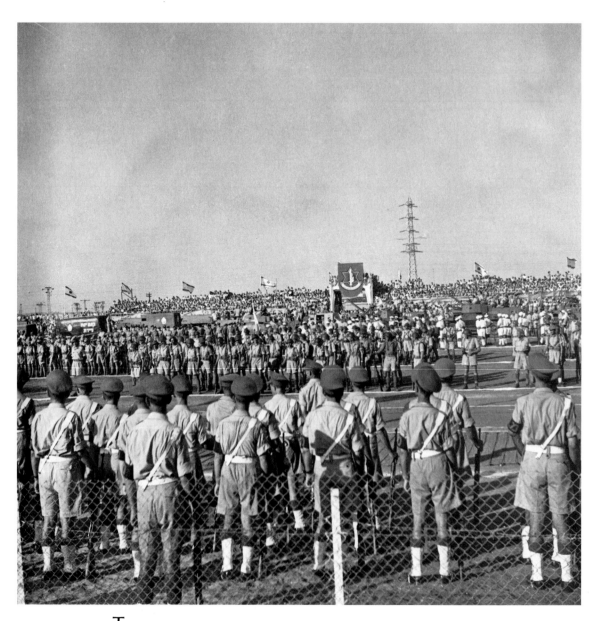

The first Independence Day parade and celebration, 1949. Every eighteen-year-old man and woman must serve in the Israeli Army. For many new immigrants, the Army was their major influence in becoming integrated into Israeli life.

The war was not all victories. I covered the defeats as well. The greatest failure was that the Israelis couldn't get Latrun, the monastery of silent monks on the road between Jerusalem and Tel Aviv. They were turned back by Arabs trained by the British. It was very important to the Jewish Agency—the shadow Jewish government— that they get that prison, but they failed.

Ben-Gurion was awakened at about four in the morning after he had made the speech declaring independence. His aides in the Army came and said, "The real war has started." The Egyptians had flown over and dropped bombs on a lot of the small villages but not on Jerusalem.

I was in an apartment building in Tel Aviv. Everyone was ordered to get into the bunkers. The Egyptians dropped a bomb on the building. It killed everybody in one line. Those of us who were down below were untouched. I could have been interviewing a rabbi or a mother and child who were killed; they were on my list of people I wanted to interview. When it was all clear, there was nothing left of that part of the building.

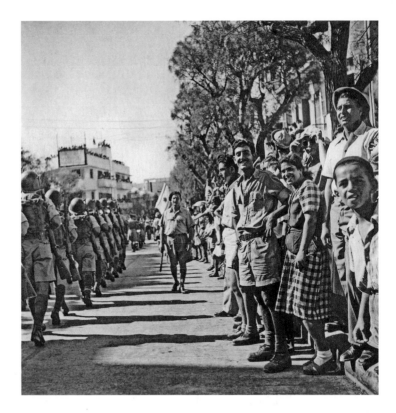

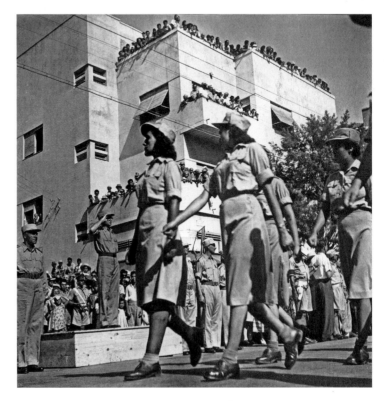

Dinah Blumenthal and her husband, Arnold, left Berlin and crossed Europe to Marseilles in 1947. Here, they waited for a truck to take them to the transit camp, Camp du Grand Arenas.

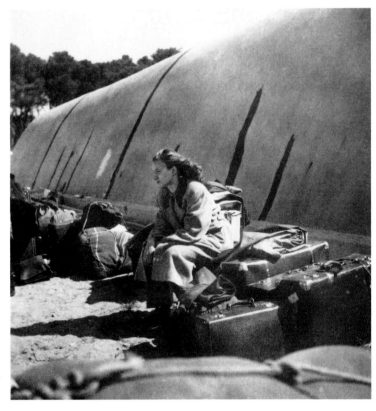

Camp du Grand Arenas is where the Holocaust survivors and DPs were brought on buses, trucks, cars, and trains. The refugees were kept there until they were sent to secret ports in southern France where "illegal ships" would break through the British blockade and take them to Israel.

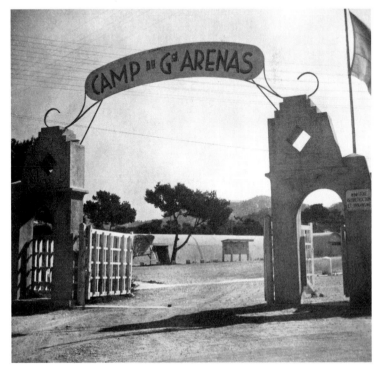

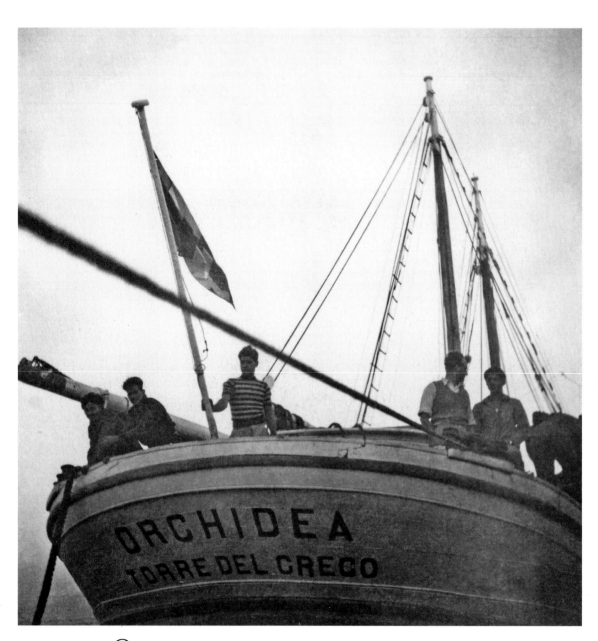

One of the so-called illegal ships, the SS *Orchidea*, was a fishing schooner that carried Holocaust survivors and other refugees attempting to break through the British blockade in 1949.

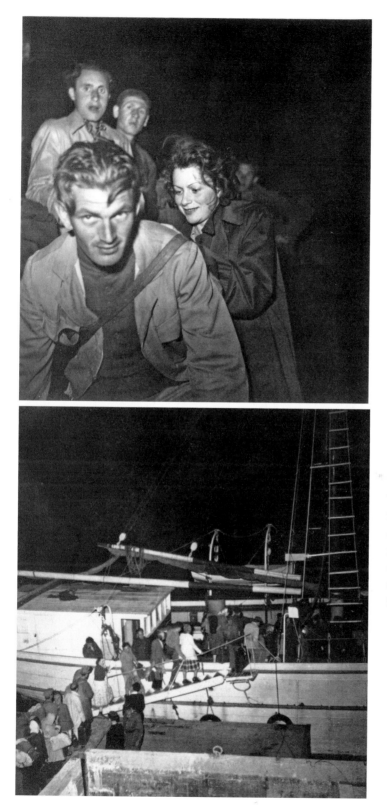

Marseilles became a jumping-off place for immigrants boarding "illegal ships" to Israel undercover at night, 1949. Security was always a problem.

The immigrants knew the dangers ahead. British warships had been instructed by Parliament to seize the ships, take the refugees prisoner to Haifa, and transport them to the detention camps on the island of Cyprus.

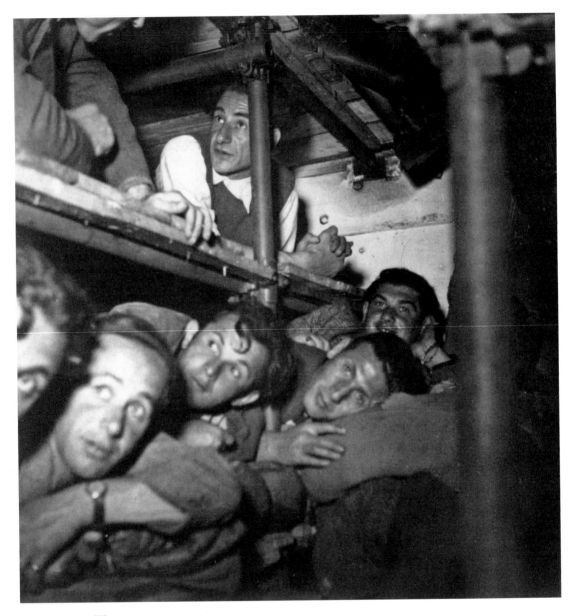

The dangerous passage from Marseilles to Haifa, often trailed by British warships, terrified some travelers; for others, it was a great adventure. Though crammed in the hold on tiers of bunks reminiscent of the German death camps, they were all hopeful that they would eventually reach the Holy Land.

Refugee children in Marseilles wait to board an "illegal ship" for Israel, 1949. Most of the children on the ships were orphans, unaware of the dangers that lay ahead. If they arrived safely, many would be placed in Youth Aliyah villages, where children lived together, studied together, and prepared themselves for the new life in Israel.

In 1949, a little bit of Brooklyn could be found in Tel Aviv.

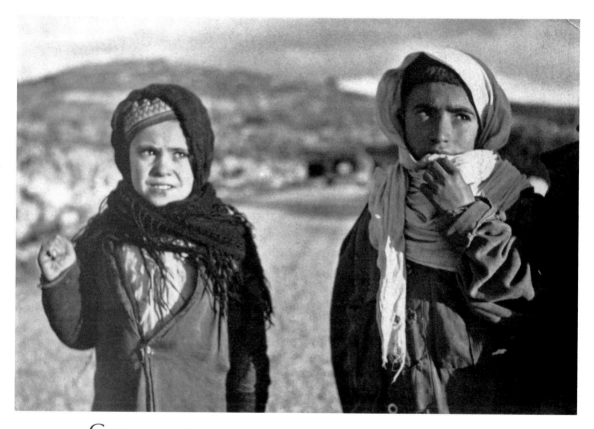

Galilee, 1949. The Druse people were a small, unique religious group who lived in the northern part of Israel.

The Yemenite Jews Fly to
Israel on "Wings of Eagles"

1949

In 1949, a year after Israel was born, refugees began to rush into the country on ships and planes. It was as if rivers of Jews were flowing to the sea that was Israel. They came from the DP camps in Germany and Austria. They came from the prison camps in Cyprus. They came from the Arab world. And an entire bloc of 50,000 came from Yemen—virtually the entire Jewish population of that Arab country.

For years, any Yemenite Jew caught trying to leave Yemen was sentenced to death. Then, in April 1949, the chief imam of Yemen made a startling announcement: all Yemenite Jews could leave if they paid a ransom for each human being, including newborn babies, if they abandoned all their belongings, and if they paid a tax on their treasured Torah scrolls—the Arabs knew that the holy scrolls were as precious to the Jews as their lives.

Often barefoot, the people fled down the mountains and crossed the scorching desert until they reached Aden, a British protectorate situated on the Gulf of Aden between the Red Sea and the Indian Ocean.

From Israel, I flew to Aden to cover the Yemenite "magic carpet" operation. At the Aden airport, an American working for the American Jewish Joint Distribution Committee (JDC) greeted me warmly, stowed my bag, camera, and typewriter in his car, and drove to the Hashid camp, where, earlier, refugees waited to be flown to Israel. His warmth changed to disbelief when I told him,

"I want to go to the land of the sultan of Lahej. I understand it's the last stop along their journey, where they pay ransoms."

"You're mad to go," he warned me. "Not one of us working here has gone there. It's barbaric country. Two years ago, they killed thirty Jews. It was an Arab pogrom. They might kill you."

"I'll be careful," I said as we reached the camp.

Dozens of people were milling around, the men in long white gowns and round white caps, the women in slim cotton pants beneath their cotton dresses. Many wore head scarves, others wore caps trimmed with a fringe. Among them were beautiful women with copper skin and delicately carved features.

With the help of an interpreter, Suleiman Mossa Tenami, a tall, fifty-year-old tailor from Lidan, told me his story: "My wife and our six-month-old baby," he explained, "we walked from our home for fourteen days to Sana [the capital of Yemen]. We were with thirty others. We felt traveling with a group would help protect us against Arabs who might rob and kill us."

He watched with interest while I scribbled his words, then he went on: "When we reached Sana, we waited another two weeks for more people. Then from Sana, we began another eight-day journey by foot through the mountains to Sayani. And from there, we crossed the Yemen border to Aden."

I left Suleiman in the camp, ordered a taxi, and called on J.W.T. Allen, the British agent in charge of the West Aden Protectorate. He was a weird-looking diplomat with long dark hair, white shorts, knee-high white socks, and a monocle. He studied my credentials, then telephoned the sultan, who agreed to let me enter his kingdom. Allen wrote out a pass and helped me hire a car with a pleasant young Arab driver named Mohammed, who became my interpreter and guide.

In the car, Mohammed made me feel so secure in this volatile area that I opened the notebook on my lap to read my notes describing the biblical Jews of Yemen. Their lives as Jews were marked by poverty and oppression. Many could neither work nor own land. Yet they were the artisans and craftspeople of Yemen, who had clung to their faith for over two thousand years.

I remembered how three years earlier, while traveling through the Arab world, I had interviewed a Yemenite official. He was one of the Arabs testifying

before the Anglo-American Committee of Inquiry on Palestine. In British-accented English, he told me how sad he was that 90 to 99 percent of his people were illiterate. He did not tell me—or perhaps he did not know—that the Jews of Yemen could all read and write Hebrew. They had teachers and rabbis who taught them, hoping that some day they would reach the Holy Land.

I shut my notebook and looked out the window. We were driving past herds of goats eating whatever few blades of grass dared to grow in that arid soil. There were white buffaloes, who seemed to be searching for food; some sickly-looking palm trees swayed in the hot wind.

At each outpost, guards stopped the car, and Mohammed, holding my pass, went inside an office to get permission for me to continue. The moment he left the car, guards pointed their guns at me. Mohammed returned, showing the guards the stamp on my pass. In the car, driving off, he said, "We're going to get away from these guys as fast as we can. Don't worry."

There were no thermometers, but the heat must have been something like 110 degrees Fahrenheit. My body felt ready to melt when we reached the modern stone-and-steel palace of the twenty-eight-year-old sultan of Lahej. Mohammed drove past the palace to a dark alley, where a group of Yemenite Jews were paying ransom to a barefoot Arab in a plaid loincloth, a white shirt, and a white turban, sitting above them in a high white chair. He had a sheaf of paper on which he wrote in huge Arabic numbers the amount of money that was being added to the sultan's coffers.

When he finished, he tied his money up in a sack and told us to follow him. He led us into a large open courtyard that looked like a Chicago slaughterhouse. More than a hundred people were standing close to the wall pressed against one another. There were no chairs, no tables, only the wall and the suffocating heat.

Many were trembling. They watched me with fear in their eyes until Mohammed explained that I was an American journalist. Immediately, they left the wall and surrounded me, shouting. "They're begging you," Mohammed said. "They're begging, 'Water! Water! Please, water!' " Children pulled at my skirt as they too cried, "Water! Water!"

I berated myself. Why hadn't I thought of bringing water and even food?

"Please explain to the people," I told Mohammed, " 'Tonight, you will have

water and bread. Tonight, we will be sending the trucks to take you to the Jewish camp where you will be safe. Tonight, you will have the food you love—fresh dates and milk.' "

After an hour or more in the courtyard, we returned to the camp. I spent the rest of the day meeting with the earlier arrivals and taking photos. After dark, we waited for the JDC trucks that were bringing the people from Lahej. For safety, the trucks traveled only at night. There had been a serious attack on the trucks a few weeks earlier. The people had arrived shaken. "The Arabs were looking for money," the truck driver explained, "but nobody had money, not even me."

At midnight, a small convoy of trucks arrived. The camp burst into activity. Those who had come earlier rushed to help the newcomers jump from the trucks. The sick carried the halt; the lame led the blind. We immediately handed them water and bread and dates and milk. Many were so undernourished they could hardly hold the food.

I spent a week in the camp among the people. There were rows of small single-room wooden buildings with one fairly sturdy building. It was the camp compound, where the staff lived and worked and where I was given a bedroom. In desert style, the days were blazing hot while the nights were freezing. Each day, a blinding sandstorm whipped through the camp. Each morning, I was awakened at three by a beautiful murmuring sound. I strode out, wondering where the music came from. It was men praying before the sunrise, keeping themselves pure and holy.

Since the seventh century A.D., these Jews had lived under Arab domination in mountain and desert ghettos in Yemen. Although in bondage, they lived by the Bible, generation after generation, with faith in the words of the Prophets.

One night, I was helping newcomers off a truck when a man came rushing toward me breathlessly. "The Arabs caught our group. They tried to strangle us." He put his hands to his throat. "They searched us for our money." His hands trembled. His head shook. "We had nothing. They tried to kill us." He clapped his hands swiftly. "We ran and ran. All the way we ran."

The people spent a week or more in the camp, where they were fed, and if they needed clothing, were given Western shirts, pants, dresses, and shoes sent from America, Britain, and Israel. They were so malnourished that the average

adult weighed about seventy pounds and a child of twelve weighed less than a youngster of four. The sickest ones were taken to the hospital. After the week of rest, they were ready to fly to their new homeland.

The American Flying Tiger plane, on which I was scheduled to fly with them to Israel, landed, with a jovial pilot straight out of Texas, in a cowboy hat, khaki shorts, and knee-high socks. We helped the refugees board the plane.

In the aircraft, with the help of an interpreter, I asked one of the older men, "Have you ever seen a plane before?"

He shook his head.

"Are you frightened?"

"Why should I be frightened? It's all written in the Bible." He quoted the beautiful prophecy of Isaiah: "But they that wait upon the Lord shall renew their strength; they shall mount up with wings as eagles; they shall run and not weary; they shall walk and not faint."

"For all these years," said the old man, "we waited upon the Lord and He kept renewing our strength. Now we're mounting up with wings as eagles. Only the Bible didn't say they would be American eagles' wings."

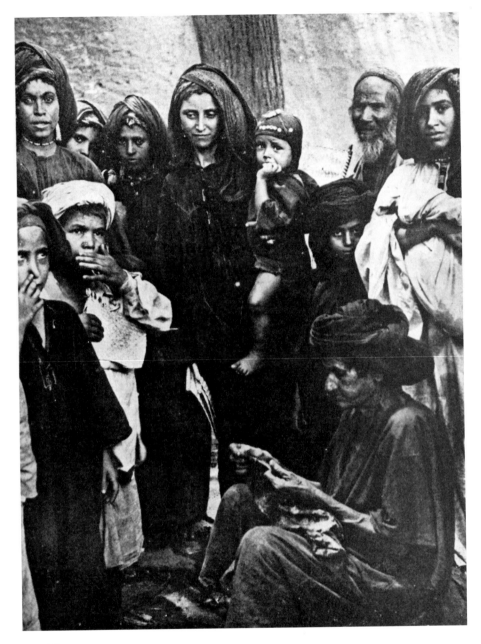

The Yemenite Jewish refugees came down from the mountains to the transit camp in Aden. Here they received food, shelter, and medical attention from the American Jewish Joint Distribution Committee until they were considered ready to fly to Israel. I stayed with them in the Aden camp for at least a week. I'd be awakened at dawn every day with the men praying and singing. They'd been doing this for two thousand years.

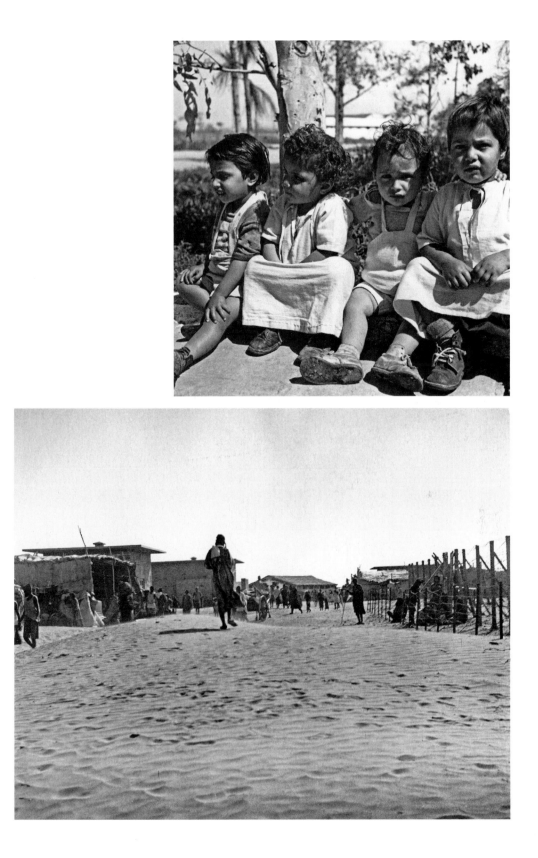

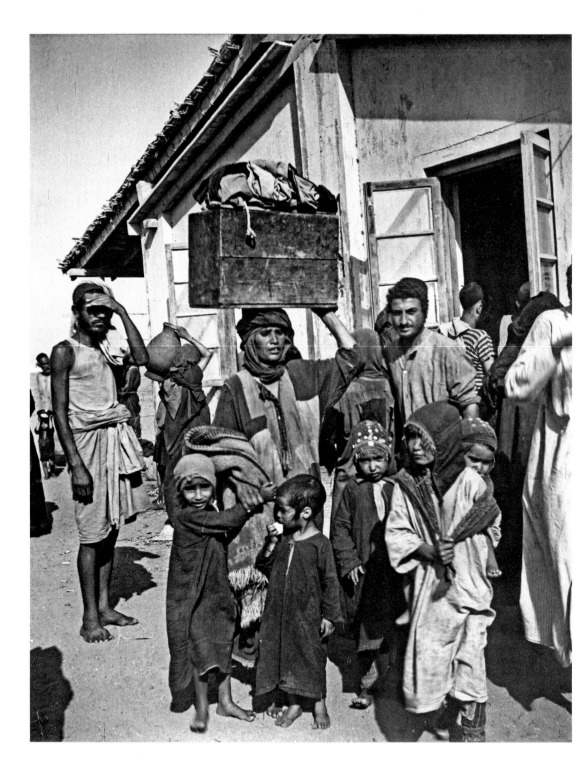

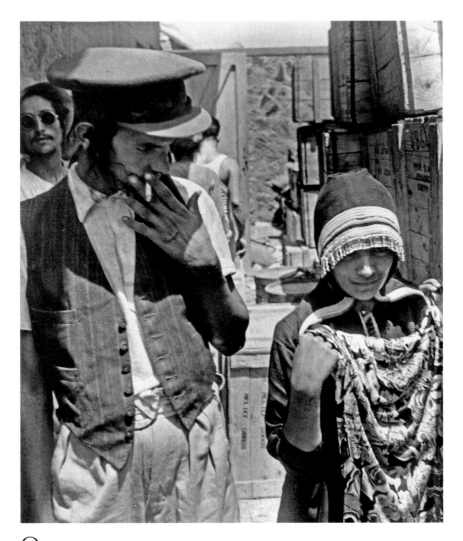

On the road to freedom with a stopover in the camp in Aden, Yemenite Jews often carried all their worldly goods on their heads. Once they were flown into Israel, they would be given Western clothes.

The convoys arrived at the transit camp in Aden at eleven o'clock at night. As soon as the Yemenite Jews got off the trucks, we brought them indoors and gave them milk and dates, and then showed them where they could sleep. I stayed with them. I realized they were biblical Jews.

Few people knew that there were so many black Jews in the world. The Yemenites were gorgeous. The women were beauties. Their favorite singer in Israel for years was a Yemenite, Shoshana Damari. Very often, we'd appear together. She'd sing, and I'd speak.

In the transit camp in Aden, the Joint Distribution Committee had a warehouse with clothes donated by American women. If the refugees wanted Western clothes, they were outfitted in the warehouse.

Choosing what to wear from the big warehouse of donated goods, refugees enjoyed mixing Western and traditional styles. The bride in a fringed Yemenite hood shyly displayed her Western silk blouse to the amusement of her husband. The clothes were donated by concerned Jewish communities from around the world.

The holy scrolls were precious to the Yemenites. Suleiman Mossa Tenami sang in rapture as he held the Torah.

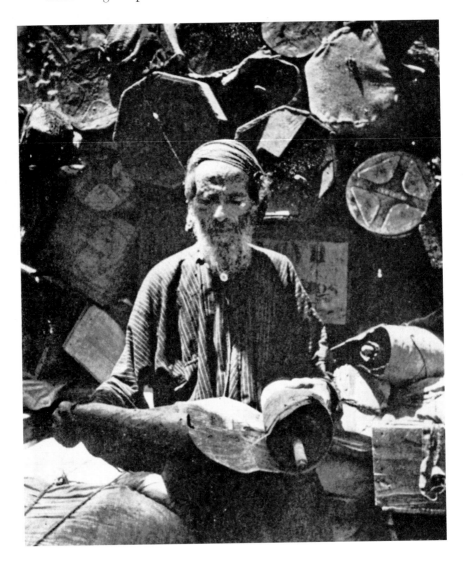

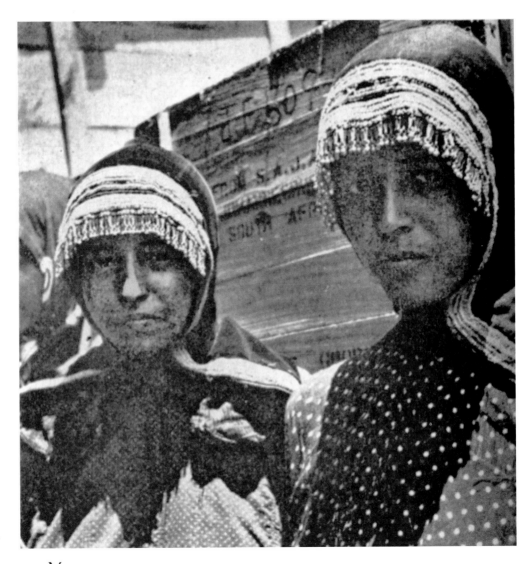

Yemenite refugees depart from the Aden camp, run by the JDC, for a new life in Israel.

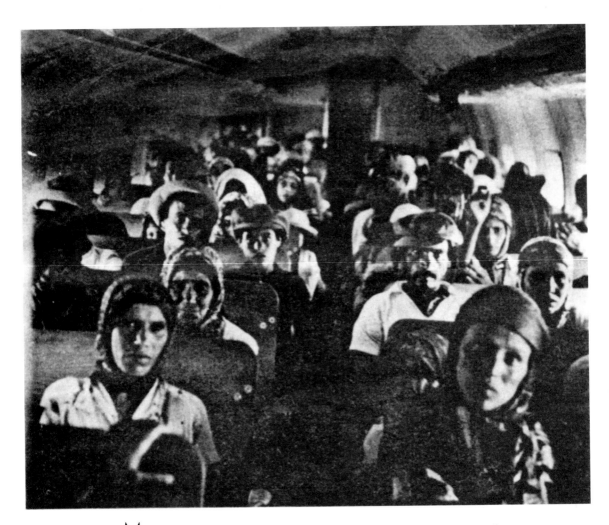

Most of this planeload of 140 Yemenite Jews had never seen a plane before. They didn't know what to do in a plane.

Because of years of starvation, they were so tiny that the plane could carry twice as many Yemenites as American passengers.

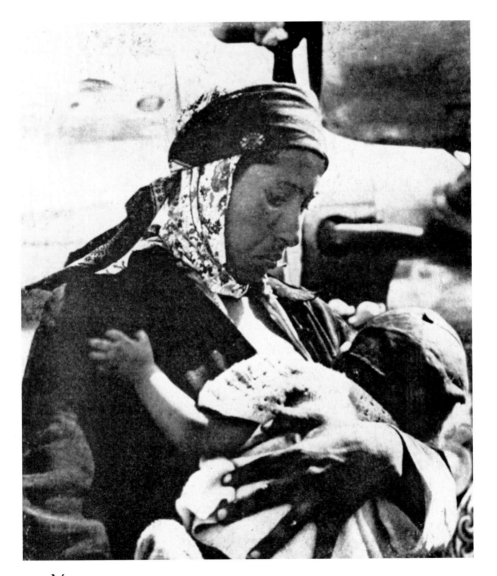

Yemenite Jews like this mother and child became citizens the minute they put their feet down on Israeli soil. From the airport they were taken to absorption centers.

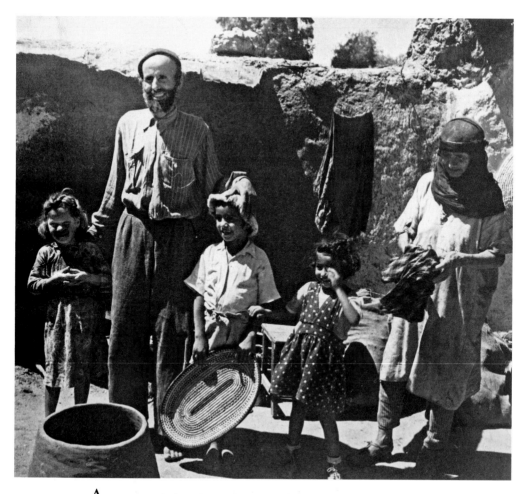

Avram Gamliel with his son Shalom and his three daughters. His wife Sa'ida is off camera to his right. Avram had flown from Yemen to Israel a few months after his family; he'd contracted tuberculosis during the long trek and could not work. His wife and his seventeen-year-old son earned the family's food by picking oranges and grapes in season.

They were bewildered; here they were, plunged into a modern world. They had never seen a country like Israel.

When I traveled with the Anglo-American Committee, each reporter selected one of the Arabs to interview, and I selected the Yemenite Arab leader. I asked him, "How many of your people know how to read and write?" He said, "Well, we try to teach them, but 99 percent don't know how to read and write."

But the Jews were all literate. Some of them only learned to read Hebrew upside down, because the adults and children would sit together in a circle to read the Bible, their only book.

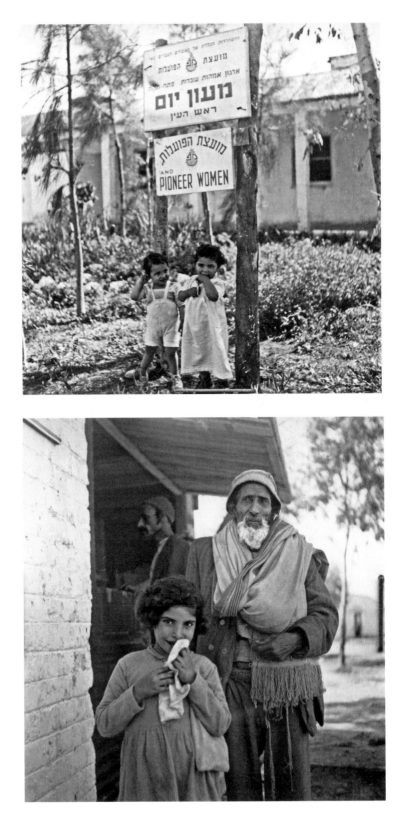

Rosh Haayim was a new town made up of Yemenite immigrants to Israel, shown here in 1951.

Operation Ezra and Nehemiah:
120,000 Iraqi Jews
Secretly Escape to Israel

1951

If I forget thee, O Jerusalem, may my right hand lose its cunning.

In 1951, I traveled through North Africa and the Middle East with my husband, Phil Michaels, on our honeymoon. We had met in 1948 in Puerto Rico during the inauguration of Governor Luis Muñoz Marín. Phil was a lawyer and social activist who had been invited to the inauguration in gratitude for helping the newcomers from Puerto Rico settle into life in New York. The governor, whom I met frequently while I worked in the Department of the Interior, had invited me as well. When Helen Reid heard I was attending the weeklong ceremony, she had said, "Cover it for us."

The governor introduced Phil and me at a picnic on Luquillo Beach. He put our hands together and said, "You two New Yorkers should get to know each other."

The *Trib* arranged for me to have a car and driver to cover the story. I invited Phil to join me. It was when we visited the slums of San Juan, where I saw his compassion and his determination to help others and make ours a better world, that I began to fall in love with him. We married in January 1951.

We were packing our bags for Israel when one of the leaders of the United Jewish Appeal came to see us.

"Ruth, we have a special request. A top-secret airlift is going to start shortly from Iraq to Israel. The Iraqi government is allowing nearly the entire Jewish population of 120,000 to depart. Both the Israeli government and American and

European Jews need to raise the money. We'd like you to speak in private homes raising funds as soon as you return from your honeymoon. Will you do this?"

"I would love to," I said, "but I have to live a story before I can write or speak about it. If Phil and I can watch the airlift, I'll do it."

In Tel Aviv, our first interview was with David Ben-Gurion.

"BG," I said, "I promised the UJA I would cover the Iraqi airlift and help raise funds for it secretly. I want Phil to join me. But I thought we'd better get permission from you, so that we'd have no problem at the airport."

He nodded. "You have it."

We chatted for a few minutes, said good-bye, and taxied to the airport. The airport director met us as we entered. I knew him from the hectic days in Haifa in 1946 and 1947 when he was in charge of the harbor where the so-called illegal ships carrying Holocaust survivors were docking.

The director led us to a cordoned-off area and wished us well. I hung my press card around my neck, put several rolls of film from my camera bag in the small pocket of my skirt, and gave the rest of the film to Phil, who stuffed it into the six or more pockets of his jacket and pants. I laughed. "One of the best fringe benefits of marrying you is that you have all those pockets!"

Knowing I would be running around shooting pictures, I told him, "You're on your own now. Let's plan on meeting back here in half an hour."

I hurried to the landing strip and aimed my camera at a plane just as it landed. I was delighted. Three buxom women in red silk gowns and purple chiffon capes came down the gangway, looking as if they had come straight out of *The Arabian Nights*.

After half an hour of excitedly taking pictures, I ran out of film. I returned to the spot where we had planned to meet, but Phil was nowhere in sight. I waited and waited, growing more and more impatient.

Finally, I decided to wait for him in the coffee shop. Soon, I was joined by the airport director. I was too embarrassed to mention that my husband had deserted me when an aide in uniform entered and whispered something his ear.

He stood right up. "Excuse me, Ruth. I must take care of an emergency."

A few minutes later, Phil appeared. His hair was disheveled. His face was ashen. "Where were you?" I demanded. "You had most of my film! I got a lot of pictures, but I could've shot so many more!"

"They arrested me."

"Arrested! Why would they arrest you?"

"Because I had no press pass."

"Oh Phil," I said. "I am so sorry. I completely forgot that you had no pass."

Phil took a deep breath. "The police picked me up and demanded to know what I was doing in the cordoned-off area. I told them I was with you and that Ben-Gurion had given us permission to come here. They didn't believe a word and put me in detention."

I felt even guiltier. "This is all my fault."

Phil tried to ease my conscience. "We couldn't have gotten here so fast if we had waited to get me a pass. We might have missed the whole scene."

He put his arms around me. I was forgiven.

Within the next few days, planes and buses secretly went back and forth to Iraq, carrying some 120,000 Jews whose entire belongings had been confiscated. I heard rumors that the Iraqi government had enriched its coffers by $200 million.

There were, of course, people who were reluctant to pull up roots. Rabbi Sassoon remained their leader, continuing to speak openly against Israel and against the Jews who had deserted their ancient homeland. But the lives of those who stayed became more and more endangered, until 1969, two years after the victorious Six-Day War. The Arabs were so inflamed by Israel's victory that they hanged nine Iraqi Jews in the marketplace in Baghdad.

In Israel, the Iraqis integrated swiftly into their new life, largely, I think, because they came with their leaders—their educators, doctors, lawyers, financial wizards, and social workers. Dr. Meir Sassoon came with his wife and family and soon found a job. Shlomo Hillel, who helped organize the secret rescue, was born in Baghdad in 1923 and came to the Holy Land when he was ten years old; he became minister of police, then speaker of the Knesset and a delegate to the United Nations. He and his German-Jewish wife, Temima, moved into my building, where our friendship began.

It was fascinating to see how many Iraqi Jews, like Shlomo Hillel, married German Jews in Israel. Though both groups integrated well, in the totem pole of immigrants they were a rung below the Russian and Polish Jews who had preceded them, until the schools and Army integrated them all.

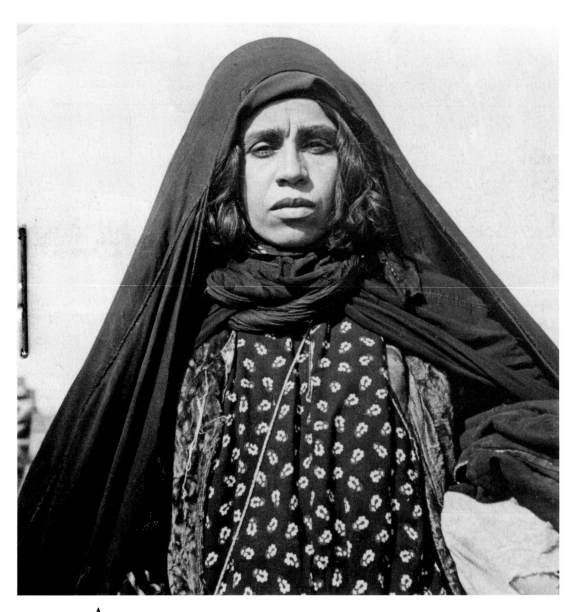

An Iraqi Jewish woman arrives in Israel on a top-secret airlift, 1951.

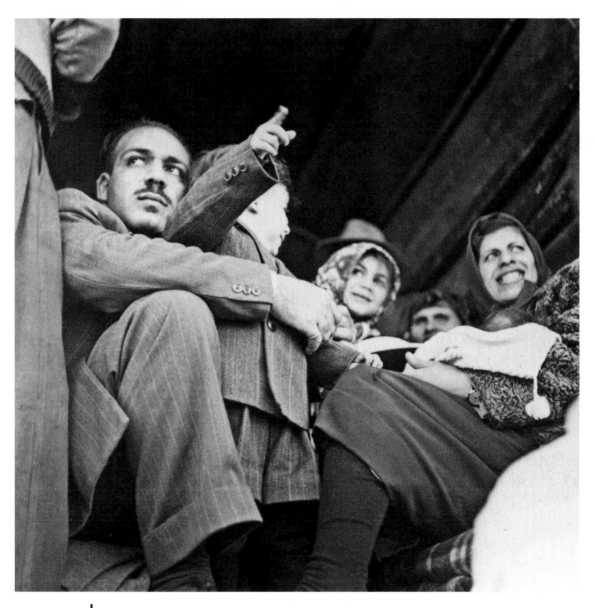

Iraqi Jews, living in Israel, patiently wait for their relatives to arrive.

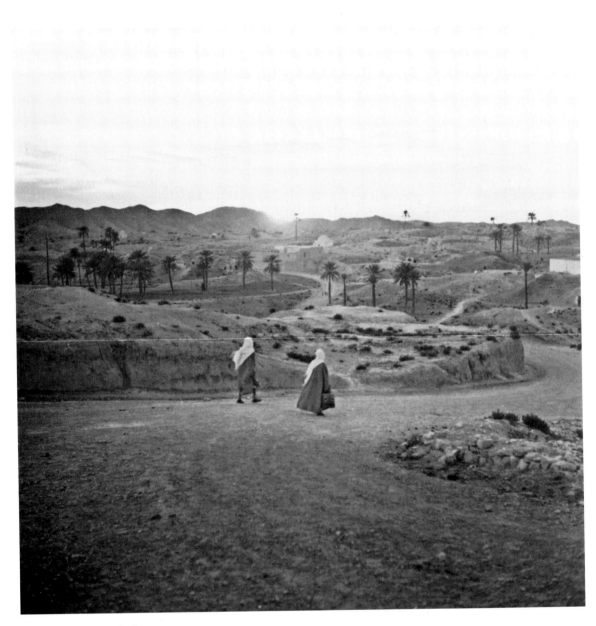

My husband, Phil, and I traveled through North Africa with an old friend, Lou Horwitz, the director of the JDC for North Africa, and with Rafael, a jovial multilingual friend of Lou's, who was both our interpreter and guide.

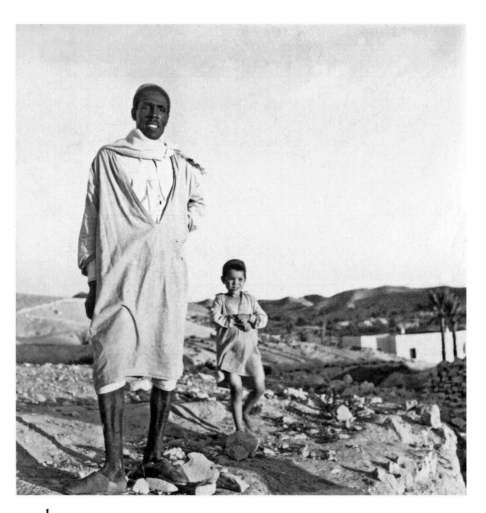

Just as we approached Matmata, Tunisia, a village where both Jews and Arabs lived in caves dug into the sides of hills, the gasoline line in our car became clogged. Rafael stayed to work on the car while we climbed up to the marketplace. Then Phil went into town to help Rafael bring up the car. He was gone barely five minutes when Lou and I were accosted by two long-robed, barefooted Arabs. One of them carried a police stick and a threatening knife. They motioned us to stand with our hands against the wall, and began yelling at us. With no one to interpret, I had no idea what they wanted.

Their yelling became louder and more menacing when suddenly bells began to ring from a mosque, summoning the devout to prayer. I took a deep breath. From the corner of my eye, I saw our captors reverently place

their weapons on the ground, kneel, rest their foreheads on the ground, and start praying. Around us, the sounds of donkeys, camels, and horses filled my ears.

Phil and Rafael returned with the car. The two Arabs motioned to Lou and me to get in the front of the car, and they then climbed into the back.

After talking with them, Rafael explained, "They're taking us up the mountain to the French military outpost."

"Are we being arrested?" I asked.

"I don't know," he said.

When we arrived, a young, slim-waisted commander of the French Foreign Legion in full pantaloons and gold-trimmed jacket met us. He listened to the Arabs carefully. "I apologize profusely for discommoding you," he said. "They couldn't figure out who you were. I think you may have frightened them."

He invited us into his office and then set us free.

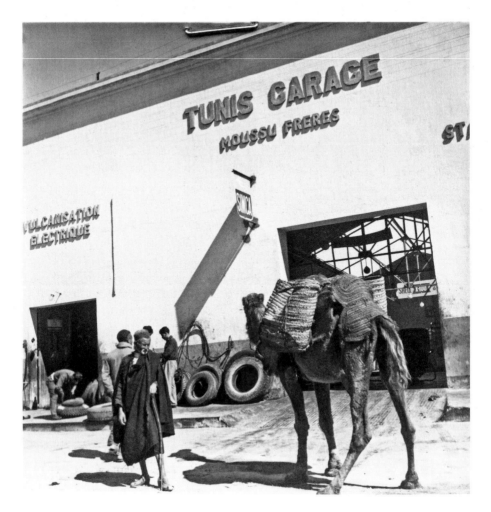

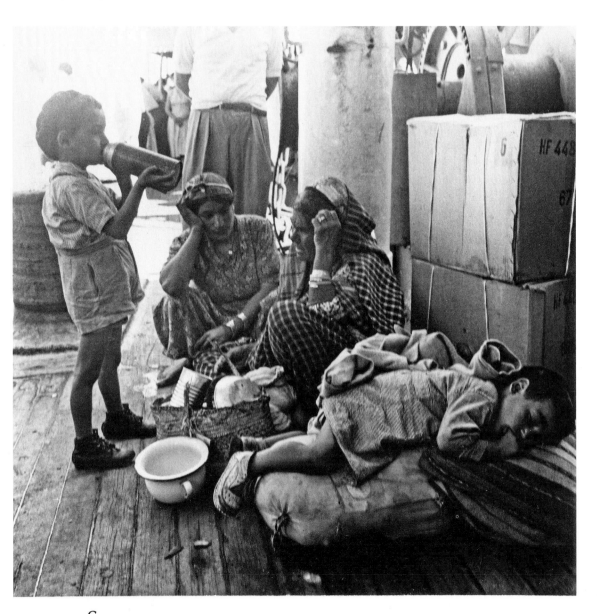

Some 4,500 Jews lived in an unbroken mirror of history on the island of Djerba, off the coast of Tunisia, 1951. Djerba was said to be the enchanted island whose perfumed lotus flowers made Ulysses forget his wife and home. Djerba residents prepared their children for the journey to begin a new life in Israel.

What differentiated that North African exodus from the others was that the leaders either went first or, like captains of a sinking ship, went last.

My husband, our friend Lou Horwitz, our guide Rafael, and I sailed to Djerba on a small fishing smack.

Waiting for us as we docked was Mrs. Trabelsine, a massive woman with soft skin, silky black hair, and huge eyes, wearing a red-and-gold-striped robe, earrings, bracelets, and great hooped anklets. Her bare feet were intricately tattooed with henna dye.

She led us to her home. The dominant note was timelessness. There was neither plumbing, nor electricity, nor movies to teach the islanders the odd ways of the outside world. The age of anxiety and confusion had not yet reached Djerba.

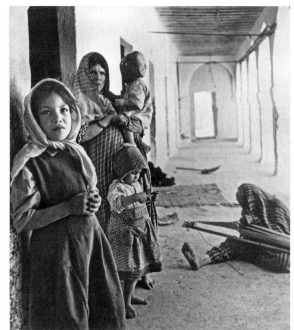

On Djerba, where the Jews filled two villages, there was no anti-Semitism. "Yet," Mr. Trabelsine told us, "at least 80 percent of the people here want to leave for Israel."

"Why?" I asked him.

"All around us are Arab countries. These countries hate Jews. We think the hatred will come here next. We have to leave while we can get out."

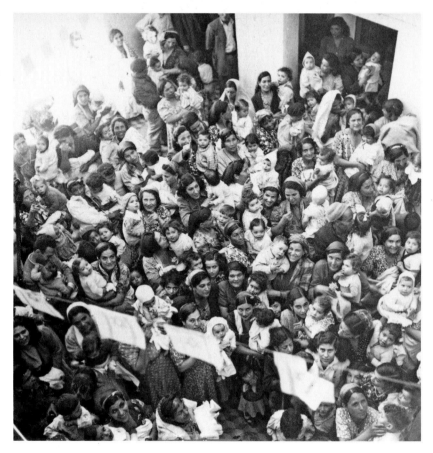

Mothers and babies assembled in a courtyard before they were allowed to enter a baby-bathing center in Tripoli, 1951.

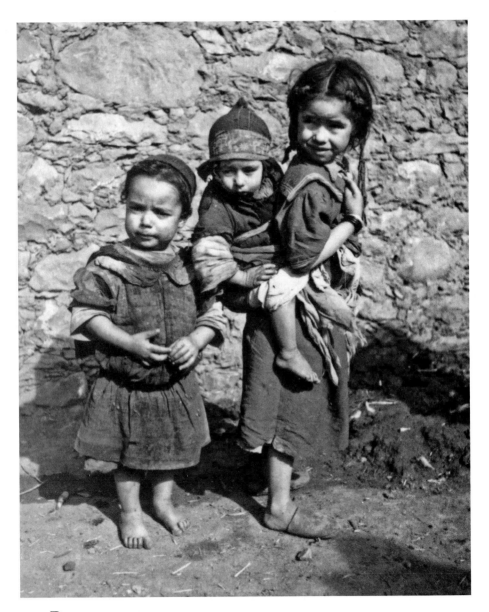

Phil and I traveled to Morocco in 1951, while on our working honeymoon. We visited schools, hospitals, workshops, marketplaces, and people's homes as we traveled from Casablanca through Rabat and Fez to Marrakech. This was Churchill's favorite vacation spot, where he painted landscapes. We were as enchanted by the Arab children we met as they were curious about us.

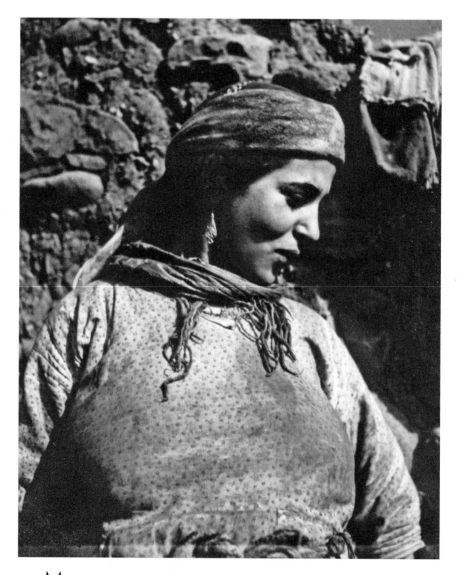

Marrakech, 1952. Arabs generally fled from my camera. This beautiful but modest Arab woman recognized that we were no threat and allowed me to photograph her.

Ourika, 1952. My thirst for adventure was tested one night in Morocco when our car broke down in the middle of the Sahara Desert. Suddenly, the sound of horses' hooves interrupted the dark silence. Arab horsemen were riding so swiftly that the earth trembled. The wind was blowing through our open windows when Lou whispered to me, "Unless someone happens to come by and find us, we're in serious trouble. I don't know how much money you and Phil are carrying, but I'll wager it's more than these Arab horsemen will make in a year. If they get any idea that Americans are in this car, the least they will do is rob us blind."

The sound of the horses' hooves was beginning to fade when a man driving by in a car discovered us. The driver stepped out, yelled at the horsemen in Arabic, and the horsemen rode off. The driver worked on our car and finally got it started. My heart stopped pounding.

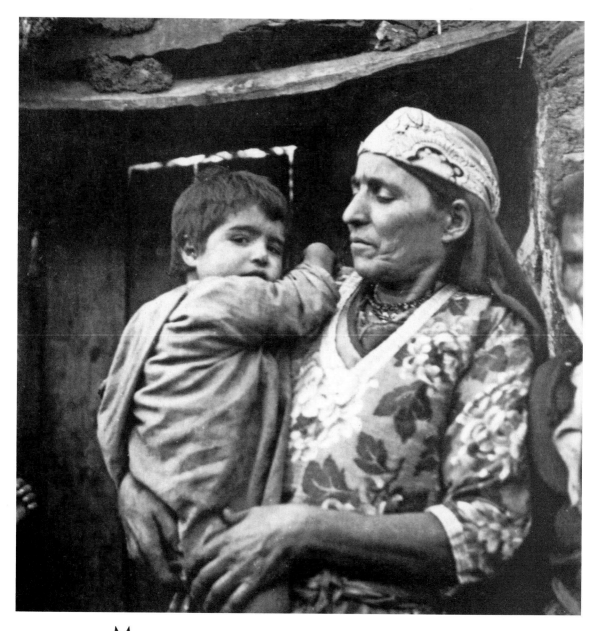

Moroccan Jewish women traditionally cover their heads with colorful scarves. Mothers rarely separated from their children.

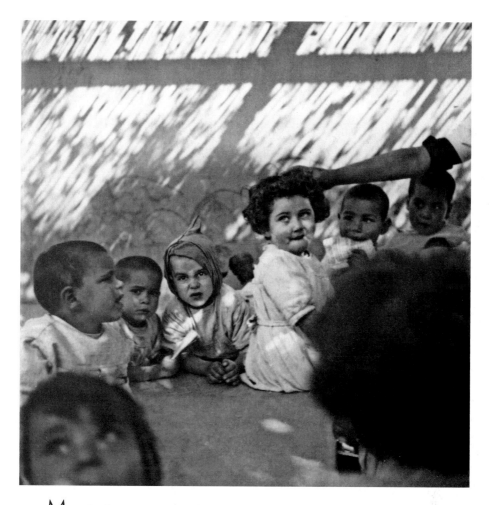

Marrakech, 1952. Everywhere we went in Morocco, we found people packing up, preparing to leave. Most of the wealthy people left for Paris; the others left for Israel. Often, I asked the people, "What do you hope to find in Paris or in Israel?"

Their answers were straightforward. A successful entrepreneur in the import-export business told Phil, Lou, Rafael, and me at a lavish dinner in his home, "We feel we are really French Jews. We will make a better life for ourselves and for our children in Paris."

"But you're doing so well here," I said.

He put his finger on his lips. "It is growing too dangerous to stay."

Another Moroccan Jew, who was leaving shortly for Israel, spoke passionately. "Israel is our land. Our people have lived in Israel for over three thousand years. The Lord gave it to us. It's all in the Bible. We were there long before Christians came and much longer before Muslims came. Yet we are still regarded as strangers. We belong in Israel."

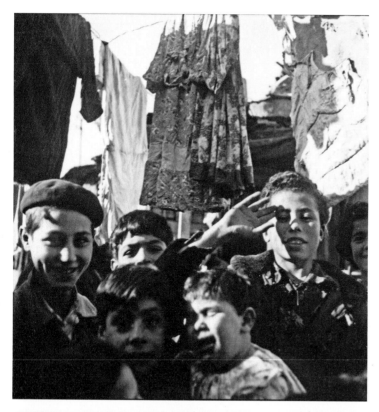

Unlike the adults, the children in the ghettos of Casablanca did not fear our cameras. They raced through the streets to be photographed.

Casablanca had recent historical meaning because Roosevelt and Churchill met there in 1943 for one of their summits. There were beautiful white villas for the rich Moroccans. The poor Jews had their ghetto; the Arabs had theirs.

During the war, many Greek Jews were saved by a Greek prime minister who said that they were not really Greek citizens but Sephardic Jews. He issued them special passports for travel to Casablanca, and they survived.

A boys' school, Casablanca, 1952. American Jews, through the JDC, sent teachers and doctors to help prepare the boys for the life they would soon lead in Israel.

Though "Casablanca" means "white house" in Spanish, the prevailing color of the town when I first visited it in 1944 was a dismal brown. The houses were brown, the donkeys were brown, even the dust-ridden air was brown. Only the djellabas, the long robes worn by men, and the kaftans, worn by women, were white. Only in the wealthier areas of Casablanca were some houses actually white.

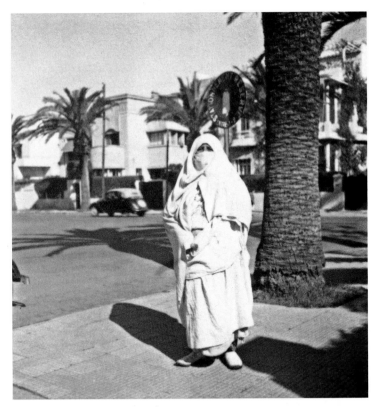

The boys receive instruction in the language and culture of Israel.

The Jewish university in Casablanca, called the Alliance Israelite University, one of the finest schools in Casa.

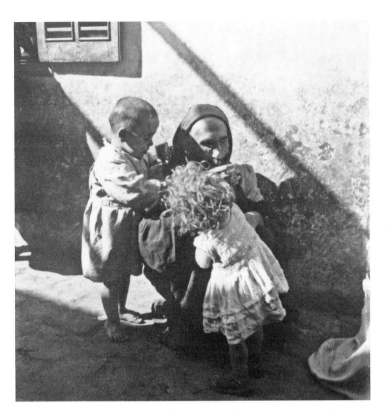

Caring mothers had to feed their children on mere scraps of food on the streets of Casablanca.

Catholics ran a boys' school in Meknes, Morocco, a city founded in the eleventh century.

Vocational training, here in a school in Fez, Morocco, was vital for rebuilding the world.

The Ingathering of Jews from Romania, the Soviet Union, and Ethiopia

1951–1986

"Our country is only three years old," Ben-Gurion told me at teatime with his wife, Paula, in the spring of 1951. He sounded as amazed as I was at the speed with which ships and planes were coming in loaded with immigrants. "We've already grown from 650,000 in 1948," he said, "to one million. If you come back in five years, we'll have five million."

There were no more hurdles in Israel, no more British warships barring this flood tide of immigrants. The very first law passed was the Law of Return. It declared that any Jew from any country in the world was welcome. No one asked if the newcomers were blind or sighted, strong or maimed, rich or poor. The moment they stepped on Israeli soil, they were citizens.

To meet a ship at Haifa or a plane at the airport, as I did frequently; to watch Israel's young women soldiers from the Women's Army Corps, called *Chen* (which means "charming"), run up the gangway to help carry babies in their arms or guide the faltering steps of the old or the blind; to catch a lump in your throat as you see families uniting; to watch strong men and women sob as they embraced parents they had not seen for ten years or more; to know that the years of running from anti-Semitic countries and Arab riots were over, to be safe in their own land—this was for the refugees, as it was for me, the essence of Israel.

I spent weeks breaking bread and drinking tea with the newcomers, visiting schools and youth centers, farms and factories, hospitals and clinics. It seemed obvious that a country that had so hurriedly rescued a million refugees could

solve all the problems of integrating them. There were thousands who needed public assistance. They were the unemployed and the unemployable—people who had eaten the bread and worn the clothes of poverty.

Eliezer Kaplan, Israel's first minister of finance, who laid the foundations for Israel's tax structure, told me at dinner one evening, "What we need mostly is money to help take care of all these newcomers."

"I know you need money," I said, "but what are the problems you have that money alone can't resolve?"

"Taking people from the fifteenth century," he said thoughtfully, "and teaching them to live in the twentieth. Taking people who have no skills and teaching them to work. Taking people who have no idea what a bathroom is for, no idea how to use knives and forks, and teaching them how to live. We are having a revolution here. A social, economic, technological, and, most important of all, human revolution."

With scarce housing, the Israeli government did what most countries do in a crisis: they opened huge camps and housed people in Army tents. One day, during a heavy rainstorm, I entered a tent outside of Haifa. A woman wearing the long skirt and blouse of Morocco, with a scarf tied around her head, pulled up her skirt to show me the mud and dirt that came up to her knees. I left her tent, determined to help her and others get decent housing.

As usual I telephoned Ben-Gurion's aide, Nehemia. "I have to see BG," I told him. BG was our favorite name for Ben-Gurion.

Nehemia called back a few minutes later. "He will see you at four p.m."

"BG," I began, sitting across from him at his desk, "I've just come from one of your biggest camps, the one near Haifa. A woman showed me that she was standing in mud up to her knees."

He sat up in his chair. "Yes? Go on."

I leaned forward. "Of all the countries in the world, *you* should not be putting newcomers into camps. Many of these people have been running away from camps. I was connected with a camp in Oswego in upstate New York. It was a former Army camp called Fort Ontario. It had real buildings, not tents. We gave those refugees everything they needed except freedom. They were only allowed to leave the camp for a few hours at a time. In your camps, the

people are free to go at any hour. But where can they go? They have no homes, no protection against the weather. In Oswego, I discovered that life in a camp can drive people to madness, even suicide. No matter where you set it down, a camp is a camp is a camp."

"Write me a report," Ben-Gurion said.

I spent the whole night writing a long report and ended it by saying:

> I learned that not one member of your cabinet has visited a single camp. Camps are never good for human beings. People deteriorate amid the abnormality of camp life. In the camps in Germany and Cyprus, at least there was hope—if they survived, the Holy Land lay ahead. In your camps here in Israel, there is no hope—unless action to shut them down is taken immediately.

I brought the report to Ben-Gurion the next morning and watched him read it, occasionally nodding his head. He called Nehemia. "I want this report translated into Hebrew. And I want every member of my cabinet ordered to visit at least one of the camps."

He came around his desk and shook my hand. "You are a *beria*. Do you know what that means?"

I couldn't resist laughing. "My mother is a *beria*. She's a good housekeeper."

He waved his hand, annoyed. "That's not what I mean! I mean, you did a good job!"

"BG," I said soberly, "thank you. I'm going to write about these horrible camps in the *New York Herald Tribune*. It will also run in the *Paris Herald Tribune,* and people all over America and Europe will know about these tents."

His answer was typically Ben-Gurion. "Good! I want the truth known."

A few months later, Moshe Sharett, Israel's foreign minister, and I were the keynote speakers at a United Jewish Appeal convention in Atlantic City. On the dais, Sharett, sitting next to me, whispered, "Because of you, I had to visit those terrible camps."

"Did you make any changes?" I whispered back.

"A good part of the government is working on it. We're building new development towns all over the country and planning 30,000 new homes."

The story of absorbing new immigrants continued to occupy me as I covered the Romanian Jewish immigration in the early 1950s. Ana Pauker, the Communist Jewish dictator of Romania from 1947 to 1952, considered by many to be the most powerful woman leader in the world, agreed to allow her Romanian Jews to sail from her ports to Israel. But pressure from the British, who did not want to jeopardize their relationship with the Arabs and their oil, forced her to shut down the emigration.

Fortunately, the neighboring state of Bulgaria opened its doors and most of the Romanian Jews, as well as Bulgarian Jews, sailed from Bulgaria to the promised land. Covering their arrival night after night, I focused my camera on their joy as they descended from the ships and flung their arms around the relatives waiting for them.

In 1952, Eleanor Roosevelt phoned me in the hotel in Tel Aviv where we were both staying. "I'd like you to take me to a new development town. I want to see how the new immigrants are being absorbed."

"When do you want to go?" I asked her.

"Tomorrow morning."

That evening, I visited the development town and met with some of the leaders, who had come primarily from Arab lands.

"Tomorrow morning," I told them, "I am bringing Mrs. Roosevelt, the widow of the great American president Franklin Roosevelt to meet you."

In Tel Aviv, in the morning, with an interpreter who spoke many of their languages, Eleanor Roosevelt and I drove into the development town. The people were all out on the road—there were still no sidewalks—and each woman held a plate in her hands with food I was sure Eleanor Roosevelt had never seen.

With her usual grace and her uncanny ability to reach people, she did what only she would do. She went from one woman to another, tasting the food, and through our interpreter, said, "It is delicious." The people began to ululate and then cry out, "The Queen of America has come!"

In the years I had spent getting to know her, I had never seen her so radiant. She talked to the people, asked them how they were living, if their children were in school—many of the same questions she had asked the refugees in Oswego in 1944.

Finally, it was time to go. In the car, she suddenly looked sad.

"Did anything happen?" I asked. "Did someone say something to hurt you?"

She shook her head. "I wish I had done more during the war."

I put my hand on hers. "You tried, but it was government policy that said, 'First we have to win the war, then we can take care of the refugees.' You couldn't change that policy."

Three years later, in July 1955, Helen Reid called me to her office. "I know you're leaving soon for Israel to cover the immigrant story. I hope you take a lot of photos. I want to meet you there and have you take me around."

"It would be a joy."

A few weeks later, at three a.m., she stepped off the plane at Ben-Gurion Airport. I ran to greet her on the tarmac. She hugged me. "You don't know how excited I am. I can hardly believe I'm here."

It was still dark as we drove up the Hills of Judea. "One always goes *up* to Jerusalem," I told her. "In Hebrew, it's called *aliyah*, the going up. The going up to the Golden City on the Hill."

"*Aliyah*," she repeated. "It sounds like a prayer."

Dawn was beginning to gnaw at the darkness as we entered Jerusalem. In that early morning light, the city spread before us with its ancient stone houses, narrow, winding streets, and crenellated walls. "I've been waiting to see this for years," she said. I thought I saw tears forming in her eyes.

After helping her settle into her suite at the King David Hotel, I joined her, sitting on the terrace. We were both silent, staring down at the Old City of Jerusalem. Finally, she spoke. "What are the plans for the day?"

"The government," I told her, "is bringing water to the Arab people in Nazareth for the first time in history. Would you be too tired to go?

"Absolutely not."

"We should be ready at eight this morning."

Exactly at eight, we were in the dining room. She had changed from her white Chanel suit into a cool white cotton skirt and blouse. On her head was a matching white beret made for her by Frederick, the most famous milliner of the day. The beret was her trademark.

After breakfast, we waited for Prime Minister Moshe Sharett, who had succeeded Ben-Gurion, to pick us up. The King David Hotel lobby was buzzing with visitors as we sat in comfortable armchairs. Helen, always the journalist, said, "Tell me something about the new prime minister."

"He's a well-trained, cosmopolitan diplomat. He came from Russia as a child and went to school here. He speaks seven languages fluently, including Arabic. His English is flawless, and he has made friends with leaders around the world."

In half an hour, Sharett, in a spotless white suit, appeared. "Mrs. Reid," he said as he took Helen's hand, "it is such an honor for us to share this day with you."

I watched Helen study his face as she accepted his welcome. He was handsome, with white hair, a carefully tended white mustache, and dark brown eyes shaded by heavy eyebrows,

"Your *Paris Herald Tribune*," he told her, "is our guide to what's happening in Europe and the Middle East."

She smiled graciously. "You're very kind." In minutes we were in Sharett's limousine, driving down the Hills of Judea. By midmorning we had reached Nazareth, the biblical Arab city where Jesus had grown up. Israeli flags were flapping in the wind as we entered a huge outdoor amphitheater. Arab men in djellabas and striped kaffiyehs sat on long benches, side by side with Jewish men in white shirts and blue shorts. Water, I thought. Water is bringing Jews and Arabs together in Nazareth.

Sharett led us toward the dais, a long table covered in a white cloth with bottles of orange juice and Israeli soda called *Gazoz*. He introduced us to his wife, Zipporah, who was as tiny as Helen, with a ruddy face and gray hair knotted in a bun. We met the Arab mayor of Nazareth, several Arab and Jewish dignitaries, and the first two Arabs elected to the Knesset. It was as if we were seeing the future we dreamed of, the future of cooperation and peace.

Sharett then escorted us down from the dais to chairs in front of the speakers'

table. I felt he wanted us to hear every word and to become a vital part of this unique day.

The speeches began. Sharett was first, talking of the water and the coming elections for the Knesset. He was followed by Bishop Hakim, a Greek Orthodox bishop, who quoted Genesis.

An attractive Arab woman in a fashionable blue-flowered dress walked to the microphone. In perfect English, she said, "I am a housewife. No longer will we have to go to the Well of the Virgin to draw water. Now we will have water in our taps. No longer will we have to carry water on our heads. Now we will be able to go to the beauty parlor and get permanent waves."

Sharett waited for the laughter to subside, then walked toward a large wheel decorated gaily with blue-and-white crepe paper. Helen and I jumped up, the better to see him turning the wheel. A torrent of water rushed through three giant steel pipes. Arab and Jewish children ran to the water, shouting and drenching themselves under the miraculous spray.

The next ten days flew by as we traveled across the country, interviewing people and shooting rolls of film. Each day was a new adventure. We were in Haifa one evening at the Megiddo Hotel when Haifa's mayor, Abba Hushi, dropped in.

"Is there anything special you would like to see?" he asked.

"I know your elections are coming up," Helen said. "I would like to see how you vote."

Early the next day, the mayor drove us to a polling place where Arabs and Jews were voting together, putting slips of paper into boxes marked for the parties they favored.

"Many of these Arabs and many of the new immigrants," Abba Hushi said, "are learning the essence of democracy."

"Some of them," Helen observed, "look as if they're entering a sacred place, a place of worship."

Abba Hushi was pleased. "It is sacred. We are the only democracy in the Middle East. In Haifa, we have very good relations with our Arab neighbors. We live next to each other in harmony."

We spent the next hours visiting schools, hospitals, the oil refinery—the fabric of a carefully run city.

Helen shook Abba Hushi's hand to say good-bye. "Come to America," she said, "and I will make you mayor of New York City."

Helen's stay was winding down when we drove to the Sharon Hotel in Herzlia, a modern city outside of Tel Aviv. Ben-Gurion and Paula were vacationing there.

Knowing this would be the most important of all the interviews Helen had held, I stuffed my bag with a fresh notebook and rolls of film that later, printed up, filled a whole album.

BG and Paula were waiting for us on the hotel deck. Helen extended her hand to BG, vigorously. "You must be so proud of all you've done in seven years," she said.

He shook his head. "It's just a beginning."

"But you've done so much."

"We had to," he said. "It was a question of life."

I sat beside her, writing their words in my notebook. A waiter arrived and took our orders for tea. "Before the state," BG said, "we had to bring our people into the country under the restrictions of the British mandate. Then, in 1939, the British White Paper stopped all Jewish immigration. So we brought them in on all kinds of ships. We had ships like the *Exodus 1947* and we had to fight not only the Arabs, but also the British warships."

"Do you think you will have peace with your Arab neighbors?" Helen asked.

Ben-Gurion lowered his head as if the problem of peace weighed heavily on him. Then he looked at Helen. "We *must* have peace. But there is no one to negotiate with in Arab lands. They have military dictatorships like Egypt or feudal cliques like Iraq. But little by little we will get there."

Helen went on, "I understand that you have decided to live in the Sde Boker village in the Negev Desert. I wonder why."

"I did it for Paula's sake." He looked at his wife. "I felt it would be good for her health."

Paula, a former American nurse, interrupted. "For me, a woman of sixty-one, Sde Boker in the desert is a very hard life. Not for him." She looked at BG. "He sits, he writes."

"Paula," I said, "he couldn't do what he does without you."

"Don't be silly," she insisted. "I made him already. I made him long ago. Now, he can do whatever he wants."

Helen laughed, then turned to Ben-Gurion. "I have one more question. What can you say to the American people?"

The Mediterranean sun shone on his white hair. "What can I say to the American people?" He mulled over his answer. "Preserve three things: your strength, your wisdom, and your goodwill toward all nations."

Helen shook his hand. "This has been the best journey of my life."

In the summer of 1974, I took my twenty-two-year-old daughter, Celia Michaels, to the Soviet Union. Thousands of Soviet Jews were fighting for the right to leave Russia, a country that did not want them, while they yearned to take refuge in Israel, a country that did.

Learning that we were going to the USSR, Clive Barnes, the American dance critic, asked us to bring medicine to Valery Panov, the premier dancer of the Leningrad Kirov Ballet.

"He's not allowed to dance or work," Barnes told us. "He's been in jail. His crime is that he's a Jew. He's sick, and the Russians won't give him any medicine. Right now, he's on a hunger strike."

Celia and I filled our bags with the medicines Barnes had given us and then added our own assortment of Bibles, prayer shawls, books, and magazines to give to the dissidents and to assure them they were not forgotten. Friends warned us that we might run into trouble with the Soviet customs, but we felt that carrying medicine to a sick dancer and bringing Bibles and prayer shawls to people no longer allowed to work was worth the risk. We had no problem.

In Leningrad, a trusted friend of the Panovs escorted us into the shabby courtyard of a Leningrad apartment complex. "There's a special signal that Valery has," he told us. "He only opens his door if you give him the signal."

The friend spoke the secret words, and the door opened. A slim, slight figure of thirty-four, with dark curling hair, a well-trimmed mustache, and a handsome Vandyke beard, stood in the doorway. Behind him stood his twenty-three-year-old ballerina wife, Galina Rogozina, a tiny blond woman, poised and graceful.

They led us to chairs in a small bright room, whose walls were hung with photographs of the two of them in ballet flight. The hunger strike had taken its toll. They both had the pallor of starvation on their faces.

"More than a thousand dancers, actors, and artists all over the world," Celia told them, "have signed petitions asking the Soviet government to allow you to leave."

"It doesn't help," Panov said. "The government never answers their petitions. They are squeezing me to death."

For more than a year and a half, Panov told us, they had been harassed, bugged, and followed by the KGB, the Soviet secret police. His telephone had been cut off, his mail was read, censored, and often confiscated. The moment he announced that he wanted to leave Russia, he was fired, forbidden to dance, forbidden even to go near the Kirov Theater. His rearrest was always imminent, because as a nonworker he could be charged with parasitism.

Galina, who was not Jewish, was implored by the Kirov director and the Communist Party official in the ballet company to divorce her husband and continue as prima ballerina. Instead, she resigned as an act of protest.

Months later, the petitions and pressures won. The Panovs were given permission to leave for Israel, where they were welcomed, given an apartment, and were soon working again in Europe and America.

In 1989, the collapse of the Soviet Union opened the floodgates. Now there are close to one million Russians living in Israel. I have not included any photos of them because, in order to obtain a visa in 1973, I had to describe myself as a housewife, not as a journalist who had written and lectured about the desperate plight of Jews yearning to be free.

For years, there had been a trickle of black Jews from Ethiopia. Many were sent to the Holy Land by Emperor Haile Selassie to be educated, then return to Ethiopia as teachers. But the mass exodus of Ethiopian Jews began in earnest when, in the early 1980s, young people secretly trekked out of isolated villages in the highlands. They risked their lives on the long journey, crossing mountains and rivers to reach Sudan. Along the way, Ethiopian soldiers, police officers, and bandits tracked them down. Some were captured and held as slaves; others

were killed. The fortunate ones made it to Sudan, where Israeli planes flew them to Tel Aviv.

I was determined to learn more about this top secret rescue. It took weeks of knocking on the doors of leaders in Jerusalem, to no avail. A friend in the Foreign Office told me why I was being barred from covering this story of rescue: "You must understand our need for secrecy. No one is allowed even to see them land here. The Marxist government under Mengistu Haile Mariam, following Russia's example, has barred all emigration. Any publicity can end the whole rescue operation."

In the end, it was Prime Minister Shimon Peres who gave me the permission I needed to watch the Ethiopian Jews enter Israel. I promised him I would not publish a single word or photo until the story could be told. I rushed to the airport, was escorted to the cordoned-off area, and stood in awe as 250 black Jews, wrapped in huge white-and-desert-colored shawls, came down the gangway, as if they were walking out of Genesis and Exodus.

I then made two trips to Ethiopia in 1985 and 1986 with a group led by Barbara Ribakove Gordon, the founder and executive director of NACOEJ—the North American Conference on Ethiopian Jewry. The first trip was during the drought that killed millions. The second was during the rainy season, when we climbed mountains, slipped down in the rain and mud, and kept climbing again until we reached the Jewish villages in northern Gondar province. There, we distributed medicines, notebooks, ballpoint pens, clothes, and money to keep the people healthy and alive until they were rescued.

Elsie Roth, a Midwestern nurse, trained several of us to become paramedics. We learned how to squeeze antibiotic drops in the eyes of mothers and children to prevent them from going blind with trachoma. Soon women and children came from neighboring Christian villages, pointing to their eyes and asking to be treated also. We turned no one down.

Before coming, our NACOEJ group had stopped in Israel to take photos of the young people who had succeeded in escaping from Ethiopia. I promised to find their families in Ethiopia and give them these photos. In one of the villages, a mother held the picture of her daughter against her chest and told me sadly, "She is in Israel and I will never see her again." But within one year, mother and daughter were reunited in Israel.

The Ethiopian exodus continues even today. Now there are more than 100,000 living in Israel without hunger and without fear. Of all the nations in the world, Israel alone has sent white men and women to bring black men, women, and children out of Africa, not to be sold, but to be saved.

A few weeks before Ben-Gurion died on December 1, 1973, I went to see him in Tel Aviv. Learning how close he was to death, I wanted to record his last words of wisdom. The modest house in Tel Aviv was staffed entirely by young soldiers in uniform. I could understand his wanting the military to take care of him in these last days. This was his Army. These were the young men he loved. They were his family.

A young soldier escorted me up to Ben-Gurion's room. He was lying on a narrow bed, under a high white quilt. The room was bare save for a small table and chair. It was as if the life had already been sucked out of this room. Paula had died in 1968 and was buried in their Negev village, Sde Boker. His grave beside her was waiting.

"Sit down," he commanded me.

I pulled the chair closer to the bed.

He caught sight of me testing my tape recorder. "Put that thing away!" he barked.

"But I want to have your voice," I protested.

"You don't need my voice. I hate those things."

I dutifully closed my tape recorder and put it back in my bag. I also decided not to photograph him in these last days of his life. Filming him dying would be repugnant to him. So I pulled out a fresh notebook and pen and got ready to write. He looked relieved.

"Master," I asked, "will there ever be peace between the Jews and the Arabs?"

"Yes," he said.

"Where will it come from?"

"Egypt."

"Egypt," I repeated. "That's where the Faydayeen [Egyptian terrorists] come from. They throw bombs in day-care centers and people's homes!"

"Forget that." He brushed my words aside with his hand. "A whole generation is rising. They know that we can live together. They have diseases we cured fifty years ago. Their women give birth to a thousand babies a year, and eight hundred of the babies die. Our doctors can help keep their babies alive. And they have minerals in their soil that we need."

"Peace, BG," I repeated. "Will there ever be peace?"

"Not in my time, but in yours and your children's. There will be peace."

I printed those words on my brain. I sat there in silence, looking at this dying leader. Thoughts rushed through my head. How much I owed this short, gray-haired dynamo. By his actions he had shown me how a truly idealistic leader can change his country, change the course of two thousand years of history, and change the world.

His legacy to me was that he promised there would be peace in my children's time. Despite terror and missiles and war, I still hold to that vision.

A Youth Aliyah village in Natanya, Israel, offers a boarding school for children in need, 1951.

Seated at the right, Moshe Sharett, Israel's first foreign minister, signed documents that became the law of the land in 1951. In 1954 Sharett became the second prime minister, succeeding David Ben-Gurion.

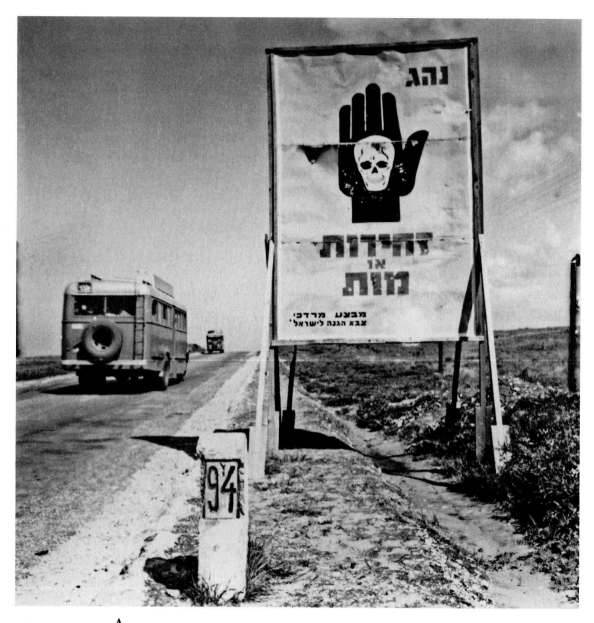

A$_n$ alarming sign in Israel warned of dangerous road conditions ahead, 1951.

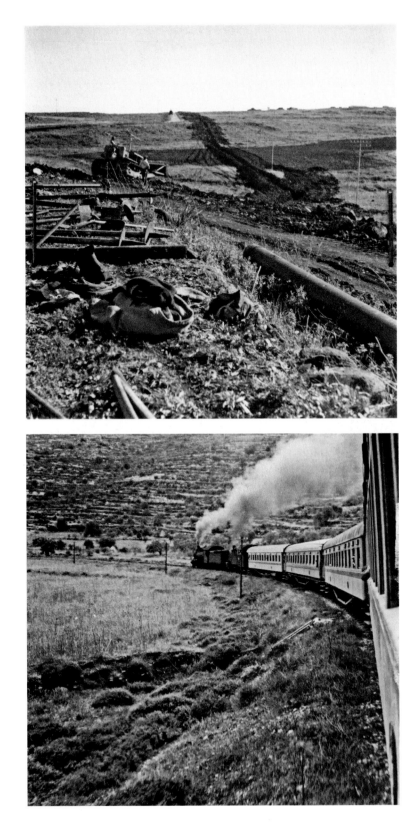

Pioneers laid pipes in the Galilee, the northernmost villages in Israel, in 1951.

Railroads were reestablished by 1951. I was in the Galilee when Arabs were throwing rocks, bombarding the villages. Everybody had to build a safe place underground with beds and food.

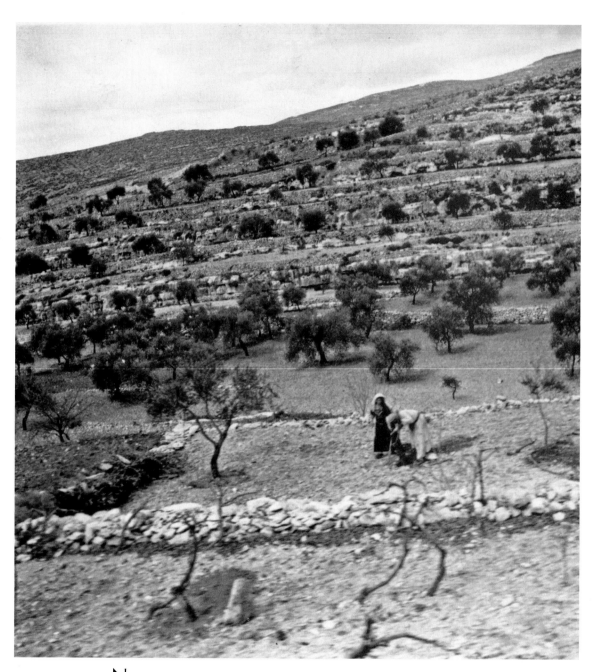

Nomadic Bedouin Arabs, photographed from the train going from Jerusalem to Beersheba, 1951. Many Bedouins moved to Beersheba, where their children could be educated and their sick could be healed.

The Weizmann Institute of Science in Rehovoth, pictured here in 1951, has become one of Israel's most prominent institutions for research in preventing diseases. When the members of UNSCOP were in Israel, they were invited to Rehovoth by Dr. Chaim Weizmann. Dr. Weizmann had his office there. He asked me and several members of the committee to stay for lunch.

He was his usual charming self and a great host. He said, "Ruth, stay on when they go back to the King David Hotel." In his office he said, "Do we have friends on the committee?"

I said, "Dr. Weizmann, the two South Americans don't have an ounce of anti-Semitism. They couldn't be better friends."

He patted me on the back. "My child, there is no such thing. Every goy carries anti-Semitism on his back in a pack."

I said, "Dr. Weizmann, I worked for two people in my life. One was Harold Ickes. The other was Helen Reid. They don't have an ounce of anti-Semitism."

He shook his head. "Dig deeper."

I did. I'm still convinced neither was anti-Semitic.

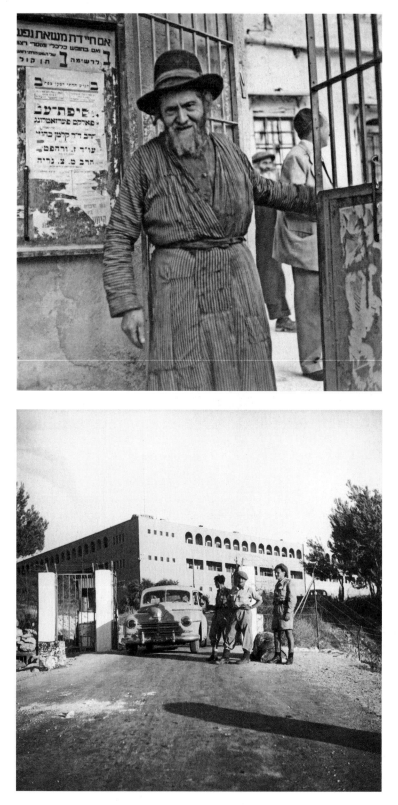

An Orthodox Jew greets me in Safed, one of Israel's holiest cities, 1951.

A typical prison fortress built by the British in Israel, 1951.

Families from Romania reunited in Haifa, 1951. Some had not seen each other since the beginning of World War II.

Romanian immigrants arriving in Israel, 1951.

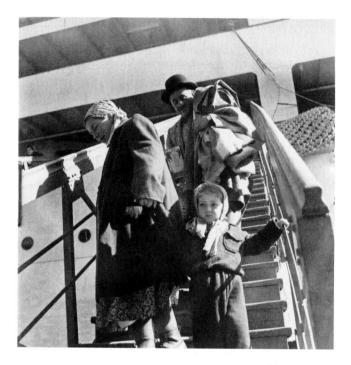

Many children prospered in Nitzanim, a Youth Aliyah village. Several in this 1951 photo grew up to be officers in the Israeli Army.

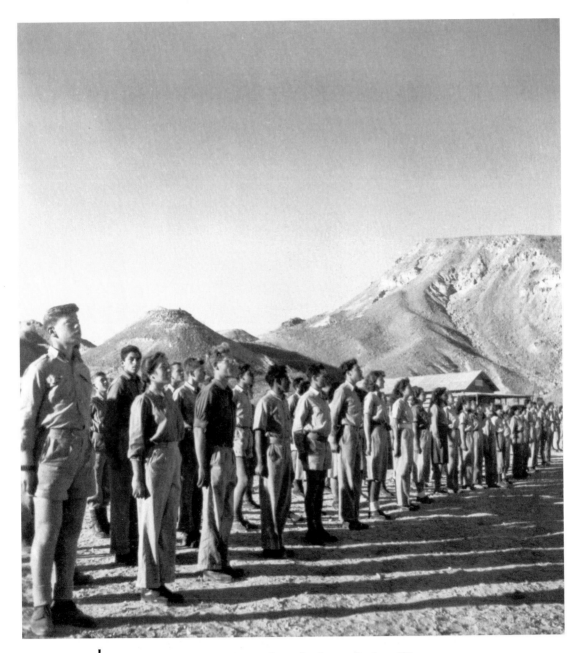

I asked Ben-Gurion one day, "What's the future for Israel?"

He answered, "Go to Beer Ora in the Negev. You'll see pre-Army young-sters learning to become soldiers."

I lived among them. They shared their food and water, and I watched them become soldiers.

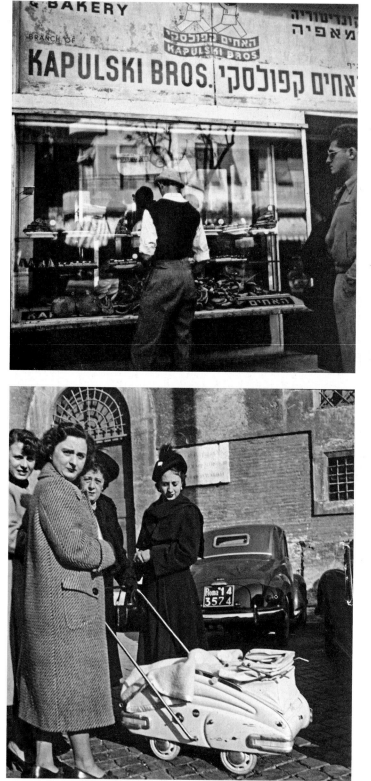

Tel Aviv, 1952. The Kapulski Brothers Bakery, near the Hadassah Hospital, was famous for its cookies. The doctors went there to buy cookies and to sit and chat.

Tel Aviv, 1952. Some fashionable women meet for lunch.

Tree seedlings are grown for distribution to towns and kibbutzim, 1952.

I wrote an article for the *Herald Tribune*'s Sunday paper called "Israel Has Yankee Ways." An American I spoke to who made raincoats said he would send money to his favorite kibbutz, Kfar Bloom, which was made up of many young Americans. In gratitude for how they were making this kibbutz a showcase, he sent them pink satin blankets.

The Kibbutzniks debated for weeks: should they sell the blankets and use the money to build up the kibbutz? They sold the blankets. In the article I said something about how modern they were but they still didn't have flush toilets. Every time I was in Israel, I would visit my friends in Kfar Bloom and they continued to be hurt by that observation.

So they said, "Wait till we show you what we've done." Each cottage now had a little bathroom with a toilet. I said, "Oh, let me in."

They replied, "Come back next year. There will be water."

An Israeli farmer brings his produce to market, 1952.

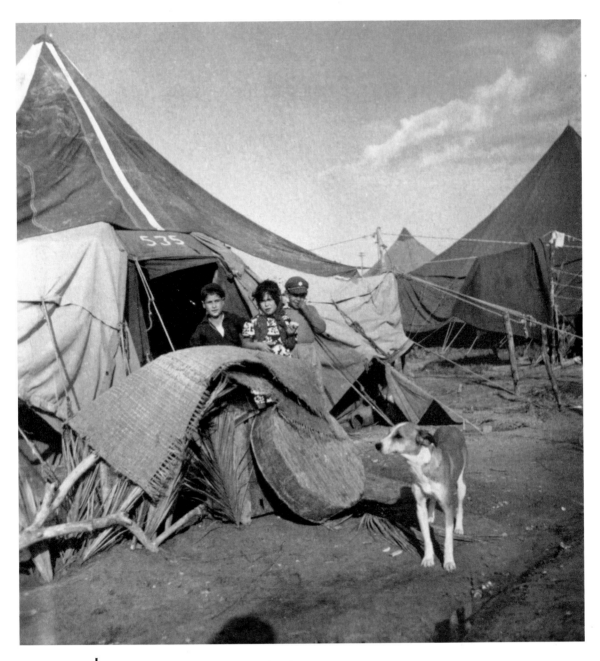

Iraqi Jews settle in a temporary development town, 1952.

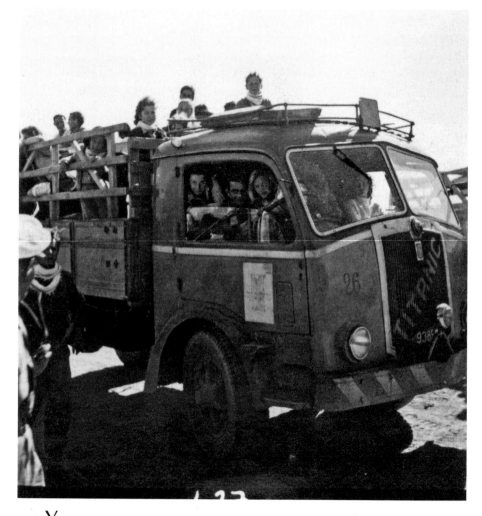

Young people from a kibbutz on an outing in a truck ironically named "Titanic," 1952.

David Ben-Gurion talks with Helen Rogers Reid, owner of the *New York Herald Tribune,* and Paula, BG's wife, at the Sharon Hotel in Herzlia outside Tel Aviv, 1955.

Helen Rogers Reid, wearing her trademark beret during her 1955 visit to Israel.

Gen. E. L. M. Burns, Prime Minister David Ben-Gurion, Golda Meir, and UN Secretary General Dag Hammarskjöld met in BG's office in 1956.

The Israelis bought arms and aircraft from Czechoslovakia; even non-Jewish pilots were flying over Czechoslovak planes. The Czechs remembered what the Germans had done to them.

Ben-Gurion made Golda the first minister plenipotentiary to the Soviet Union. It's almost an ambassador. When she arrived there, the Jews went on holiday—every Jew in Moscow wanted to meet her. Ben-Gurion gave her high positions. She later became minister of labor (1949–56), foreign minister (1956–66), and prime minister (1969–74).

Hadassah, the Women's Zionist Organization of America, opened a clinic in Beersheba, which saved the life of Golda's daughter, Sarah. The clinic got a call from a small village about a young woman who was very sick. She was pregnant, and no one knew what to do. The doctor asked, "Do you have a car?" "No, but we have a truck." "Well, put her in. We'll drive from Beersheba, you drive from your village, and we'll meet halfway."

When they met, he examined her and realized that the pregnancy was ectopic. The fertilized egg had lodged in a fallopian tube instead of the uterus, and the chances of her survival were slim.

They rushed her to the small hospital in Beersheba. A handsome young man said, "I'm Sarah's husband. Can I call her mother?" He was a Yemenite Jew. The hospital worker said, "Of course," and gave him the phone. That's when it became clear to the hospital that this young woman was the daughter of Golda Meir. "I'm stopping everything," said Golda. "I'm coming right to Beersheba."

When Golda got there she was told to wait. "We'll tell you when you can see her." Golda—a woman of granite, a tough, hard lady—sat on a bench in the courtyard, weeping. She stayed awake all night. They tried to give her food while they kept working on Sarah.

Golda was finally told that she could see her daughter. The doctors in the Hadassah hospital had saved her life.

A soldier guards the road outside Beersheba, 1956.

Golda Meir, then foreign minister, arrives at a government meeting, 1956.

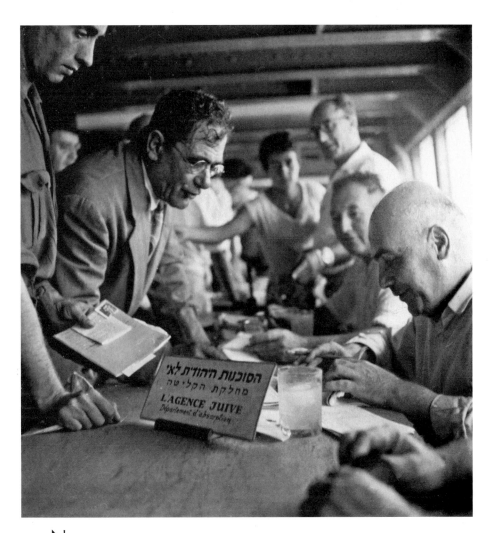

Ｎew immigrants from Europe received their ID cards aboard a ship about to reach Haifa in 1956.

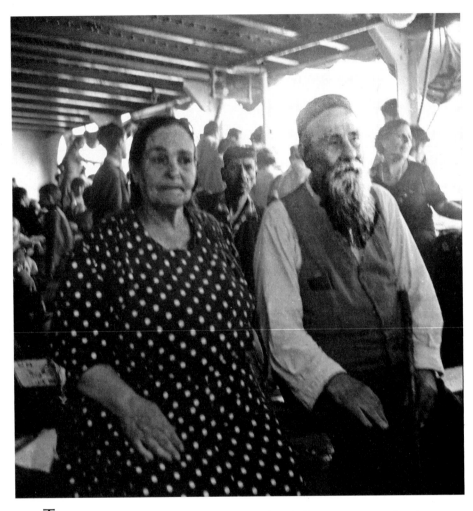

The immigrants, old and young, sick and well, kept pouring in by ship, 1956. They voluntarily gave up their homes, their countries, their languages to become citizens of Israel.

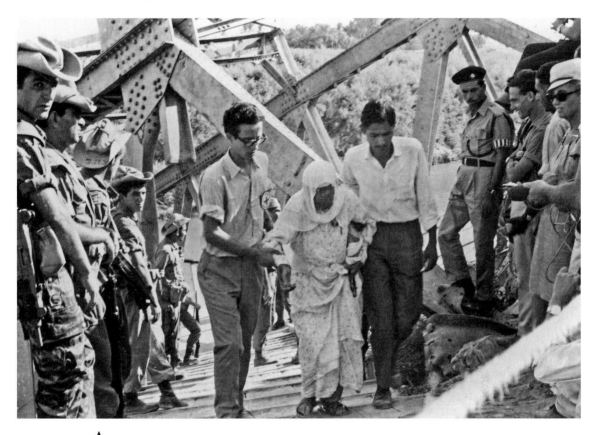

Arab refugees returned to the Arab town of Nablus to be reunited with their families, 1967.

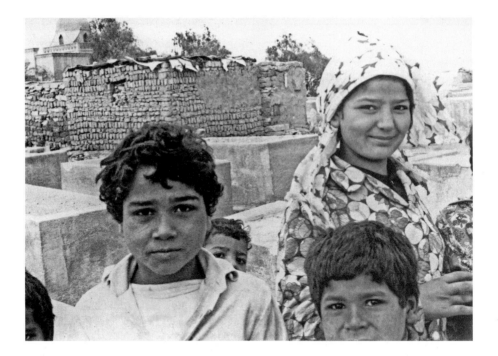

Cairo, 1977. Families lived in hand-constructed homes within this cemetery. They built schools in the cemetery, and spent their days and nights living in communities inside the cemeteries. It was a city within a city.

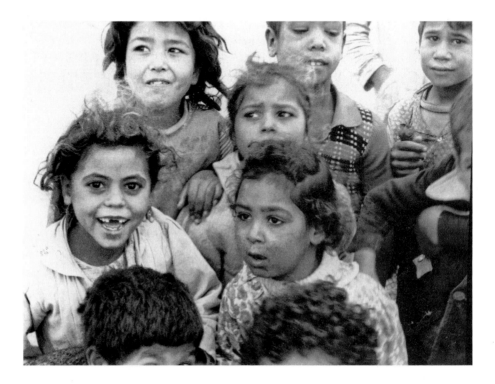

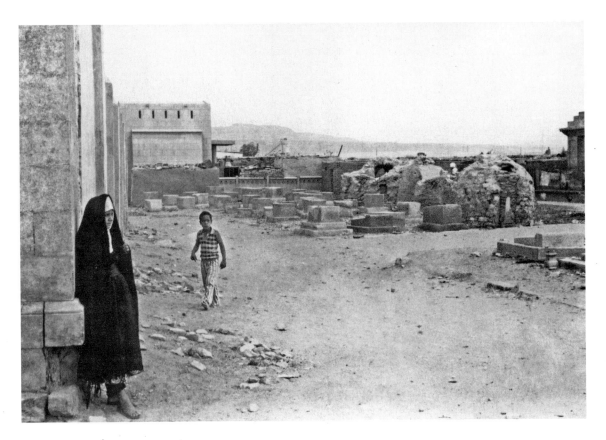

A nun visits the Jewish cemetery in Cairo, 1977.

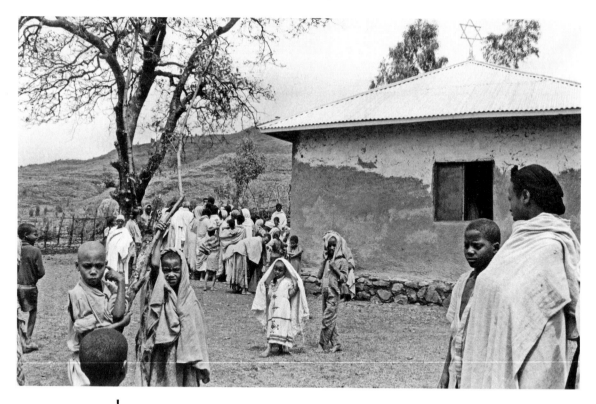

In the highlands of Ethiopia, men and women gather outside the synagogue in Weleka after the Sabbath service, 1985. The name *falasha*, meaning "stranger," is derogatory. I prefer to call them Ethiopian Jews.

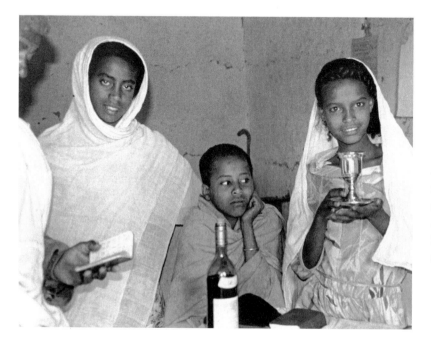

At the Friday night service in the Ethiopian village of Ambober, the Jewish congregation welcomes the Sabbath queen with prayers and wine, 1985.

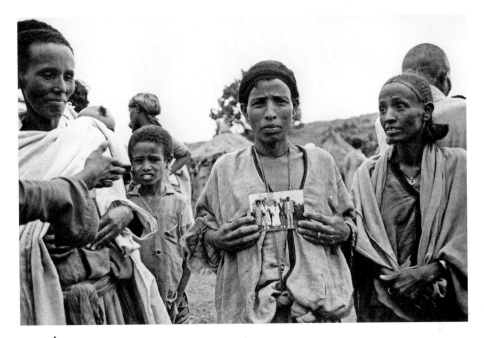

An Ethiopian Jewish mother held up a photograph of her children, who had already migrated to Israel, 1985. She asked, "Will I ever see my children again?" A year later, they were reunited in Israel.

Of all the countries in the world, Israel is the only one that sent white men and women into Africa to bring out black men, women, and children—not to sell them, but to rescue them. Learning of the secret rescue, I went to Shimon Peres, who was then the prime minister, who said, "We aren't allowing any reporters." I said, "Shimon, I promise I won't write a word until you tell me every Ethiopian Jew is safe. But meanwhile, I want to see it now, while it's happening."

I learned that a group calling itself NACOEJ, North American Conference on Ethiopian Jewry, had gone over to try to help the Ethiopians. I went to their president and said, "I'd like to go with you."

When I arrived in Ethiopia, beautiful women and men wrapped in huge white shawls surrounded me at the airport. They were living in huts, which they called *tukels,* made of mud and straw. Young people were risking their lives to get out of Ethiopia. Some were caught by Arabs and put into slavery. Those who managed to make the whole trip from the highlands of Ethiopia down to Sudan were housed by representatives of Jewish agencies.

I went back to Ethiopia the next year. The first year I was there was the famine. The second year was the floods. We were climbing those hills,

falling down, getting up to the top. We told the people, "You haven't been forgotten. We're going to get you out." And we did. And we are doing it to this day. From the handful who were there when I made my first trip in 1985, there are now more than 100,000 Ethiopian Jews living in Israel. They became part of that Jewish community made up of an ingathering from all over the world.

A NOTE ON THE TYPE

This book was set in Caledonia, a typeface designed by W. A. Dwiggins (1880–1956). It belongs to the family of printing types called "modern face" by printers—a term used to mark the change in style of the type letters that occurred around 1800. Caledonia borders on the general design of Scotch Roman, but it is more freely drawn than that letter.

Composed by North Market Street Graphics,
Lancaster, Pennsylvania
Printed and bound by R. R. Donnelley & Sons,
Harrisonburg, Virginia
Designed by Anthea Lingeman